HISTORIC HAUNTS OF LONG ISLAND

Books by Kerriann Flanagan Brosky

Delectable Italian Dishes for Family and Friends, co-authored with Sal Baldanza
Huntington's Hidden Past
Huntington's Past Revisited
Ghosts of Long Island: Stories of the Paranormal
Ghosts of Long Island II: More Stories of the Paranormal
The Medal

HISTORIC HAUNTS OF LONG ISLAND

GHOSTS AND LEGENDS FROM THE GOLD COAST TO MONTAUK POINT

KERRIANN FLANAGAN BROSKY

FOREWORD BY JOE GIAQUINTO

Haunted America

Published by Haunted America
A Division of The History Press
Charleston, SC 29403
www.historypress.net

First published 2015

Manufactured in the United States

ISBN 978.1.62619.668.1

Library of Congress control number: 2015943190

To my good friend and fellow author John P. Cardone, who encouraged me to write this book. His support and guidance have been invaluable.

AUTHOR'S NOTE

A few of the ghost images mentioned in some of the chapters were magnified to a level that could not be reproduced properly in print form. The following images can be viewed online at www.ghostsoflongisland.com: Villa Paul Restaurant shadow figure, Ketcham Inn apparition of a little girl in a window, Winfield Hall apparition of a woman in a window and Country House Restaurant at night surrounded by orbs. Additionally, please visit the website to listen to the EVP (electronic voice phenomenon) recordings as well as the "ghost" box recordings.

CONTENTS

CONTENTS

FOREWORD

I first met Kerriann Flanagan Brosky at the old Conklin Barn in Huntington in 2005 when Kerriann was giving a historical lecture. Since then, we have successfully investigated nearly one hundred places between her two *Ghosts of Long Island* books and her current book, *Historic Haunts of Long Island*.

When I began researching paranormal activity over thirty years ago, it was a magical adventure. I felt I was taking part in one of the short stories about ghosts I had read as a child. Every dark street corner, every old mansion and each candle that flickered inside a carved pumpkin on a chilly Halloween night fulfilled my desire to experience something beyond the physical world. It was that same adrenaline rush most paranormal researchers feel when they experience their very first bump in the night.

Through all my adventures with Kerriann, from gnarly wood, brick and stone mansions with great portraits hung on the walls to woodsy, spooky walks in places where ghosts once fired muskets during the Revolutionary War to cozy taverns whose former owners still haunt present-day patrons, our professionalism and enthusiasm have never waned. As ghost investigators, we have dealt in the spooky and unprovable—the subjective lore of told tales, handed down from generation to generation from one property owner to the next.

During these adventures, Kerriann and I have always stated that we were not trying to prove or disprove anything. Yet, everything we wrote and recorded was cemented with proof from our firsthand experiences and faith in the evidence we gathered through interviews, photos and audio recordings.

Our journey has evolved; our beliefs have become stronger. So I feel this aspect of credible proof is one of the strengths in Kerriann's books and why they are such a good read.

For starters, the people she interviewed are highly respected individuals. As a historian, Kerriann's background research is rock solid. Because each ghost story has similar connective elements, the experiences become more normal than they are paranormal. This enables the reader to accept the premise of the book's journey. It also gives the book an appeal to a large audience.

For lovers of Long Island history, *Historic Haunts of Long Island* will provide well-researched reference material. Preserving history is a challenging task with evidence in many forms, such as oral accounts and physical evidence. The diversity of history found in Kerriann's research provides a depth not found in other ghost books that are simply filled with urban myths.

For lovers of true tales, Kerriann's book will provide an entertaining anthology. Ten of the most popular stories were taken from each of her first two books on ghosts. Ten new investigations were added to delight her current fans with new material.

For the adventurous crowd, Kerriann's book will serve as an exciting journal of two people's mysterious and exhilarating trek through the veil. The reader will get to walk with us as we explore each place. It's a surprising ride worth taking.

For paranormalists, the book will serve as a ghost hunter's how-to guide. It will enhance evidence gathering and problem solving skills. It will show how to select the right tools, and it will make the case for using evidential mediumship to corroborate your evidence.

Mediumship enhances your ghost hunting tools: you gain the same evidence from multiple sources. You can talk directly with the spiritual presence doing the haunting, which provides greater satisfaction than the simple thrill of gathering random evidence. During several investigations with Kerriann, I used my mediumship—I think you'll enjoy reading how I acted as my own ghost-hunting device!

As you read *Historic Haunts of Long Island*, you'll experience the joy of life and the mystery of death. There is nothing more certain than our mortality. Abraham Lincoln once said, "In the end, it's not the years in your life that count. It's the life in your years."

Kerriann's book is a storytelling of the human spiritual experience. Some of her stories are happy, while others are tragic. Yet all are a compelling, must-read for those yearning to know about the soul's journey and how spirits communicate with us.

—Joe Giaquinto
Medium and Paranormal Investigator

PREFACE

It has been known to me that spirits could manifest themselves into mortals, and that they have always held communion with their brethren in the flesh is not new to me. The law is as natural as gravitation and like it, I presume, will endure forever.
—William Sidney Mount

Having studied, researched and investigated close to one hundred "haunted" locations over a period of ten years, I, like Long Island genre painter William Sidney Mount, have come to understand that life exists beyond this one. Not only do I believe there is a heaven, but I have also experienced firsthand the ability to communicate with those who have crossed over. We are never alone. Those who have come before us, whether they are historical figures or our own loved ones, share in our spiritual journey and guide us along the way.

Historic Haunts of Long Island: Ghosts and Legends from the Gold Coast to Montauk Point is not your typical ghost book. It is a journey into Long Island's fascinating history, from our Native American past to the American Revolutionary War and beyond. Through uncovering history, I have unearthed the spirits from the past who have shared their stories.

I have taken the reader on a quest of discovery, joining Joe Giaquinto and me on our actual investigations. Through these investigations and extensive interviews, you will read live accounts of people's experiences with the unexplainable. Other stories are pure research where history will come alive,

and the ghosts from the past will reveal themselves. What you will read on these pages is an exploration into the world that lies beyond this one. You will learn the difference between ghosts and spirits, death and communication and just how "normal" the so-called paranormal world has become.

This book also serves as a commemorative work. It combines ten of my best stories from my two *Ghosts of Long Island* books with ten brand-new stories and, of course, all of my photographs. It delves deep into history and the spirit world, and you will find out what it has been like for me to explore amazing places while meeting the most remarkable people.

The more I have written about the paranormal, the more I have learned and experienced. My goal is to protect, preserve and keep our history alive while helping people gain a better insight and understanding into the spirit world.

I hope you will read this book with an open heart and an open mind. I'm simply putting out what I have learned while giving you information to ponder. If nothing else, you will learn about local history and enjoy a good ghost story or two.

We are all on our own journeys. Thank you for taking the time to share in mine.

ACKNOWLEDGEMENTS

A big thank-you goes out to all the people I have interviewed who have shared their remarkable stories with me and also to all those who assisted me with historical research. I am most grateful.

Amanda Peppard; Andrea Crivello, curatorial assistant, Planting Fields Foundation; Barbara Kirschner; Barbara M. Russell, Town of Brookhaven historian; Brian Karppinen; Carlton Edwards; Carol Malkush, member of the board of trustees for the Cutchogue–New Suffolk Historical Council; Charles and Cheryl Pensa; Cristen Pensa-Simpson; Dee Bonner; Feliciano Guzman-Hernandez; Gary Melius; Gerard Fioravanti; Gwendolyn L. Smith, past curator, Planting Fields Foundation; Henry J. Joyce, director, Planting Fields Arboretum State Park; Irene Dougal; Jack and John Murray; Jim Patterson; Joanne Graves, museum guide, Old Bethpage Village Restoration; Kelly Melius: Kristy Lopes; Linda Ringhouse; Lisa Argentieri; Lisa Farmiglietti; Margo Arceri; Mark Cattano; Maryellen Kobrin; Mary Studdert, press department, Eisenhower Park; Meagan Flaherty; Megumi Mase; Michael Malkush, president of the board for the Cutchogue–New Suffolk Historical Council; Nancy Melius; Paul Silansky, vice-president of the Cutchogue–New Suffolk Historical Council; Richard Gisonda, seasonal guide, Old Bethpage Village Restoration; Roni Epstein; Rick Bellando; Scott Bellando; Therese and William Brewster Seydel; and Zachary N. Studenroth, director of the Cutchogue–New Suffolk Historical Council and the Southampton town historian.

Thank you to all the people I have interviewed and who have assisted me with the twenty preexisting stories from my *Ghosts of Long Island* books. Your wonderful stories live on.

To my commissioning editor at The History Press, Whitney Tarella Landis: thank you for pursuing me and for your unfailing belief in my work.

To Darcy Mahan, production editor at The History Press: thank you for your editorial skills and for making my manuscript the very best it can be.

To my mother, Deanna Flanagan, who allowed me to pursue my dreams.

To my sons, Ryan and Patrick, who are always so proud to have an author for a mom.

To my husband, Karl, who has given the ultimate support, from lugging books to events, to technical support with my photographs, to formatting, reading manuscripts and more. I know it's not easy living with an author, but at least life is never boring.

Lastly, to Joe Giaquinto, my partner in crime. Thanks for agreeing to take on another project with me. It's been a blast.

Villa Paul Restaurant

HAMPTON BAYS

History, ghosts and good food abound at the Villa Paul Restaurant located on West Montauk Highway in Hampton Bays. Strange and unexplainable phenomena have been reported from many eyewitnesses who swear the family-run restaurant is haunted by several ghosts, both human and nonhuman. Despite all the paranormal goings-on, the restaurant, which serves up deliciously prepared continental cuisine, is a well-known fixture in Hampton Bays. Villa Paul is famous not only for its ghosts but also for its signature Long Island duck, veal dishes and fresh seafood.

Paranormal investigator/medium Joe Giaquinto and I set out to visit Villa Paul Restaurant to learn about its history and ghosts from longtime married owners Cheryl and Charles Pensa, who were happy to share their stories.

The history of Villa Paul restaurant dates back to 1804. Phebe and Joseph Brown had built a log cabin on the site where Villa Paul now sits. Census records indicate that Joseph was a farmer with four children who had been born in the house. The house has been expanded several times, but the current men's and ladies' restrooms are part of the original structure. It is said that this older part of the building served as the "borning room," also known as the birthing room. It was very common during that time period for children to be born in the home. These birthing rooms were also used during times of sickness and in death. Entering and exiting this world all took place within the home.

It is unknown how long the Brown family lived there. Records indicate there was a value of $2,200 placed on the house in 1850. Whether it was sold

at that time is unclear, but the next set of owners were believed to have been Phebe and Albert Williamson. Many old-time residents claim that a man by the name of Oscar Goodale owned it after the Williamsons. Following Goodale, the famous Judge Edward Lazansky and his wife, Cora, are listed as owners.

The Lazanskys lived in Brooklyn and used the Hampton Bays house as a summer home. Cora was an interior decorator, and it is believed that the house was expanded during their stay there. Judge Lazansky was a busy man. He was a Democratic candidate in 1903 for the New York State Assembly. He then went on to serve as New York's secretary of state from 1911 to 1912, and he was a delegate to the Democratic National Convention in 1912 and 1916. Judge Lazansky also served as justice of the New York Supreme Court from 1920 to 1940.

A very strange tale abides regarding Mrs. Lazansky and the sale of the house shortly after her husband's death in September 1955. Mrs. Lazansky wanted to sell the Hampton Bays property. There seemed to be little interest in anyone purchasing the house, and the sale was taking longer than expected. Mrs. Lazansky believed that people did not want to buy her house because a cemetery was located next door. Apparently, she ordered the stones in the cemetery to be removed. The citizens of Hampton Bays were up in arms. How this ever happened remains a mystery. The stones were never replaced. The bodies remained, but the exact location of who is buried where is unknown. If you drive down West Montauk Highway today, you will see a well-maintained grassy piece of land to the left of the Villa Paul property. The cemetery with unmarked graves remains.

Paul Villa, a successful restaurateur from Cinque Terre, Italy, eventually made his way to the United States and purchased the abandoned judge's home. He renovated and transformed it into a beautiful Italian restaurant known as Villa Paul, and it has been a residence and restaurant ever since.

Remnants of days gone by still remain. The main dining room at Villa Paul was Judge Lazansky's library. A painting from Paul Villa's village of Vernazza still hangs over the fireplace.

Paul Villa owned the restaurant for nine years. In 1965, Domenico Pensa, a distant cousin of Paul's, was visiting. Paul was looking to sell the business and offered it to Pensa, who decided to purchase it. Since then, Villa Paul restaurant has been owned and operated by three generations of the Pensa family.

"I grew up here when my parents were running it," began Charles Pensa. "It was a huge place. We had lived in a small house, so coming here was

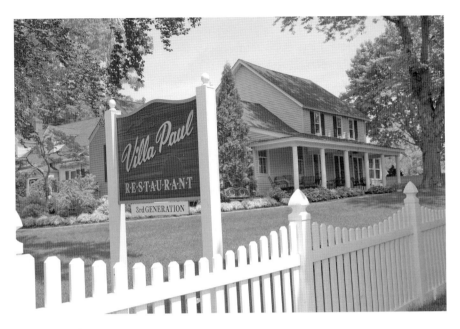

Villa Paul.

pretty wild. It was beautiful. I always enjoyed it. I lived upstairs; in fact, that's where Cheryl and I live now."

Cheryl and Charles took over the business in 1979 and co-owned it with Charles's brother and sister-in-law. They ran the business together for twenty-five years. Today, Cheryl, Charles and their daughter, Cristen, own and run Villa Paul.

Joe and I were interviewing Cheryl and Charles at a small table in the bar area. Within ten minutes into our interview, Joe announced, "There is someone walking around right here. An apparition just went by, and my shoulder is getting chilled. And I just felt a cat. Did you have a cat that passed here?"

Charles replied, "No, a dog."

"A small dog, right here," said Joe.

Cheryl's face went white. "Two people have seen a dog here at separate times," she said. "People who work for us."

"It was a small dog?" asked Joe.

"They said a small dog, like a tan color," said Cheryl.

"A dog just passed through. I think it's coming right out of this wall," Joe pointed.

"Yes, that's where it came out of. That's where they saw it come out. That used to be the birthing room," said Charles.

"One of our chefs is a waiter also, and one night, a busy night, he's coming through with a tray and he saw a dog come out of here," Cheryl points to a large refrigerator that used to be a closet. "The dog ran here and then ran in the kitchen."

I confirmed the story with the chef at a later date during a telephone interview. He said, "I saw this dog running from the refrigerator into the kitchen. I asked the staff, 'Did you see that dog?' They thought I was crazy."

Continuing with our interview with Cheryl and Charles, Joe said, "I saw a figure of a man, maybe medium height, and then I saw the dog. So maybe the dog and the man were connected. Someone who's passed. I feel it's good energy though."

"Yeah, we have to say, Charles and I have never had an experience, and we live here. We're always here, and he grew up here. I would like to experience something, but I never have, but many other people have," said Cheryl.

It's interesting to note that a few months after Joe and I were there, Cheryl sent me a video. It was footage from a surveillance camera that was running one night in the room reserved for private parties. Several slow-moving orbs (light anomalies believed to be spirits) could be seen floating around the room, coming in and disappearing. It was just remarkable.

"I think they [the spirits] respect your business. They don't want to disrupt your work," said Joe. "They don't want to take away from what you do here."

Cheryl continued, "A few months later, a waitress saw the same thing [a dog] coming through. She dropped her tray."

"How much time had gone by between the two incidents?" I asked.

"A couple of months. It's been a few years now," Cheryl replied.

"The one thing I remember as a child," said Charles, "is that when I was playing out back, there were two dogs buried there. They had nice gravestones, Buddy and Rags. The judge's wife may have buried the dogs. There were also other tombstones laying around back there. We used to play around them. They were just lying there on the ground."

"I wonder if they were the gravestones that were once next door. The ones that were removed," I said.

"It could have been," said Charles. "The property has been split now. The restaurant is on a little over an acre. Apartments were built back there. I don't know what ever happened to the tombstones."

"What other things have you heard? I asked.

Cheryl and Charles began to tell us about their manager, Jim Patterson, who had been a non-believer until he had three experiences at Villa Paul. I spoke to Jim on the phone, and this is what he told me:

I've been the manager, head waiter, bartender and maître d' for thirty-two years. I've had three incidents over a period of five years. The first was when I was walking down the hall toward the kitchen. All of a sudden I saw a dark shadow figure. It didn't have much shape. It passed in front of me, and I followed it into another room where it disappeared. The second time I saw an elderly man wearing a blue sweater. He could be seen only from the chest up. I saw him in the same hallway [where] I saw the other figure. It only lasted about three to four seconds. The scariest time was when I was in the hallway by the entrance to the basement. Out of the corner of my eye, I saw something in the stairwell. I turned and saw a woman there, as if she was coming up the stairs. I was so startled that I jumped back. Her eyes were wide, as if I startled her as well. She jumped back, and she went down the stairs. I said to the waitress, "Did you see that?" I looked down the staircase and turned on the light. There was no one there. The waitress said to me, "I'm glad I didn't."

Talking again with Cheryl and Charles, Charles told us about some customers who have had experiences while dining at the restaurant. They became friends with one couple, and the woman, who wanted to remain anonymous, told me her story when we spoke by phone.

"I was dining there [at Villa Paul] with my husband and daughter, who was nineteen. All of a sudden, I saw a woman, not fully formed, from the chest up. She was wearing old-fashioned clothing. It lasted maybe three to four seconds. My husband saw my face and asked me if I was okay. I told them what I saw. It was eerie. I was doubting myself that I saw it. Even my daughter felt something in the ladies' room, but I kept doubting. To this day, I still wonder what happened."

Another longtime customer told me about her experience, which happened over thirty years ago. She said, "I was in the main dining room on the left when you come in, and I was having dinner. It was late at night, and I was one of the last tables. I looked straight across the room and saw Jim, the manager, with his tray. I kept calling to him, but he didn't answer. I found out later that Jim had not been in that room at all."

"I'm impressed with how many people have seen apparitions here," Joe commented. "It's a rare occurrence."

While we were talking to Cheryl and Charles, their daughter Cristen came and joined us. We asked her if she had experienced anything unusual.

"For me, it's always the shadow out of the corner of my eye. I've never just stared and seen it specifically," said Cristen.

"And where have you seen these shadows?" I asked.

"Everywhere, all day long," she replied.

"And you see it out of the corner of your eye, and then you turn and it's gone?"

"Yes."

"That's a phenomenon known as shadow people," I said. "You never see them flat on. It's always a passing shadow, but you know something is there."

As we were having our discussion, Joe saw an orb fly right past him, and I felt an instant cold spot. When I was transcribing the interview weeks later, I discovered at that moment an EVP (electronic voice phenomenon) on my recorder. It was a woman whispering. I could not make out what she was saying, but it was definitely the voice of a female softly whispering.

Cristen told us that her husband has also seen things out of the corner of his eye and that he is sensitive to these things. In the older part of the basement, he set up a video camera and captured several orbs in motion.

Cheryl said to me, "I have a photo for you to look at. I was taking a photograph for the *Dining Out* guide, so I came in [the main dining room] and took the photo. A couple of days later, Cristen said to me, 'Why did you take that picture with somebody in it?' I said to her that nobody was here at the time. So she brought the photo up on the computer and showed it to me, and there was this…" Cheryl pointed to the image of a man with no facial features standing in the back on the right. "So then I'm thinking, could somebody have been here? I started second guessing, but I knew no one was here at the time. I couldn't understand how that got in the photo."

Joe replied, "There is nothing to disprove. You captured it."

We discussed the photo for a few minutes longer. When I was transcribing that section of the interview later, I could clearly hear the voice of a man whispering into the recorder saying, "I'm the photographer." I almost fell off my chair when I heard it! It was definitely not Charles or Joe, or anyone else for that matter. I later confirmed this with everyone.

Besides the two EVPs I received, Joe had communication on his "ghost box." The ghost box is similar to an EVP recorder. It is a means for spirits to communicate. As Joe explains, "A ghost box is simply an AM radio where the wires have been cut so that it keeps scanning the stations on the radio without stopping. You ask the spirits questions, and as you're going from station to station, the scanner stops long enough for the spirits to take a piece of a word. The spirits can monkey with it to make class-A EVPs. It's an actual person talking. It's not just voices on white noise."

Joe started the communication on the ghost box by saying, "Hi spirits. Hi."

A spirit said, "Hi."

Then I asked a question: "Is there a dog here?"

A voice replied, "Yes. One."

Joe replied, "We got it!"

After our interview, we toured the restaurant and took some photos. As we were wrapping up our time with Cheryl and Charles, I asked them what they thought about all of this.

"The part that's been okay with us," said Cheryl, "is that there has never been anything threatening. There has never been anything negative."

"So they [the ghosts] are welcome to stay," Charles laughed.

RAYNHAM HALL

OYSTER BAY

Raynham Hall's interesting history began in 1740, when Samuel and Sarah Townsend, descendants of the British Townsends who owned Raynham (meaning river home) Hall in Norfolk, England, purchased six acres in what is now downtown Oyster Bay.

The current twenty-two-room house had only four rooms originally. As the Townsend family grew, four more bedrooms were added along the back.

Samuel Townsend became very prosperous and well known in Oyster Bay. He was a successful merchant, served as town clerk and justice of the peace and was also elected to the New York Provincial Congress in 1776. His son Robert followed in his father's patriotic footsteps. During the American Revolution, he became one of General George Washington's chief spies, working under the code name "Culper Jr." Raynham Hall became not only the center of local affairs but also a headquarters for the British during the war, because the Townsends were Quakers and they were willing to bury both American and British soldiers. However, with Robert acting as a spy, the Townsends ultimately betrayed the British.

A British major, John André, often visited the house while it was under occupation. During one of his visits, one of the Townsend daughters overheard Major André and Lieutenant Colonel John Graves Simcoe talking about a plan to pay Benedict Arnold to surrender his troops. Robert "Culper Jr." Townsend was given the information by his sister and then reported the plan back to George Washington. Major André was quickly captured and hanged, but Benedict Arnold escaped.

After three generations of Townsends had lived in Raynham Hall, the house was purchased by Julia Weeks Coles in 1914, and she lived there until 1933. The house had been enlarged by the last Townsends to live there, in 1851, and was elegantly furnished in the Victorian style of the day.

According to *Raynham Hall's Haunted History*, a pamphlet published by the Raynham Hall Museum in 2005, it is said that in 1930, "an overnight guest of Julia Coles awoke to the sight and sound of a ghostly white horse and rider outside her bedroom window." This ghost was believed to be that of Major John André, and it is one of the first ghosts documented at Raynham Hall. On another occasion, Julia's sister, Susan Coles Halstead, "sighted the spectre of an elderly man descending the Victorian stairway." She believed it was Robert Townsend, the Patriot spy, examining the new Victorian wing.

After 1933, the homestead was operated as a tearoom, and by 1941, Julia Coles had given Raynham Hall to the Oyster Bay Chapter of the National Society of the Daughters of the American Revolution. They maintained and repaired the historic home until 1947, when it was deeded to the Town of Oyster Bay. The town, along with the Raynham Hall Advisory Committee, members of the DAR chapter and Friends of Raynham Hall, added to the restoration and maintenance of the historic home, which was dedicated a Town of Oyster Bay Historic Site in 1953. Since then, the home has been open to the public for viewing as a historical museum.

It is believed that the ghost of Robert Townsend was seen at least two other times. In January 2000, a Raynham Hall Museum staff member claimed to see a ghostly figure at the top of the Victorian staircase. The man was dressed in a waist-length blue woolen jacket. He appeared to be looking out a window and was only visible from the waist up.

Another figure was seen again a month later, but this time he appeared in the Victorian hall at the base of the staircase and was clearly visible. He was described as "a sad-looking man in his late thirties, with dark brown hair, prominent sideburns, and a drooping mustache. He was dressed in a long, dark coat and matching trousers. He walked across the hallway and stood beside the grandfather clock, then vanished."

Although other areas of the house are presumably haunted, the Victorian hall and staircase seem to generate the most activity. Ghost-hunting professionals claim that the hallway may be a ghostly vortex, or portal, in which spirits or objects can manifest themselves from some other realm into our world. Supposedly, many photographers have captured balls of light, known in ghostly terms as orbs, on their film. It is said that in most cases,

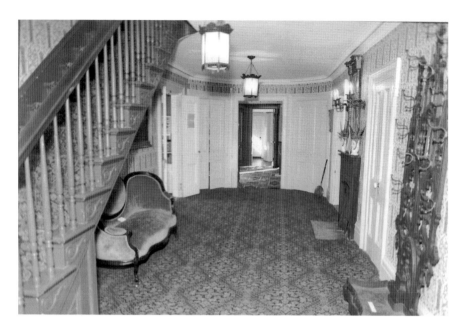

Inside Raynham Hall, in the area known as the "vortex."

ghosts prefer to take this form of manifestation because it requires too much energy to become a full, visible apparition or another distinct form.

In the spring of 1999, a visitor walking past the staircase reported hearing footsteps and the swish of petticoats. When she turned to see what it was, a portion of a female figure appeared dressed in Victorian clothing. The figure drifted past her and went down the hallway toward the back of the house. The woman remains unidentified. In the summer of that same year, a staff member who was opening up the museum for the day claimed to hear heavy footsteps that followed him into the front hallway from the Victorian portion of the house. Turning around, the staff member saw nothing, and the footsteps had stopped. They were heard again once he reentered the home.

Walking through the hallway, one will pass the Victorian dining room. Cold spots and smells of apple and cinnamon have been reported in this area of the house, as well as in the pantry and kitchen areas. A staff member claimed to see "a black caped form with a hood" enter the pantry and kitchen. Also seen here was another ghostly figure of a man standing in the doorway of the pantry. A museum volunteer heard the pantry door open, and when she turned, she saw the man. The apparition was so lifelike that

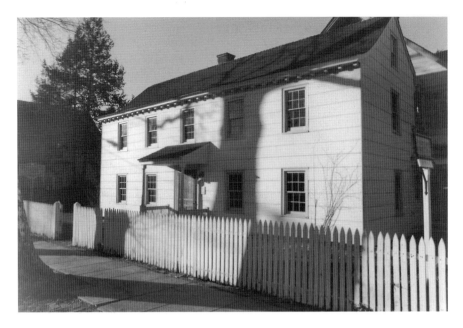

Raynham Hall Museum.

the volunteer actually believed it was another member coming to help set up a display. When the volunteer called out to a staff member that someone else had arrived to help, the man slipped back inside the pantry and the door closed. Thinking the person was an intruder, the museum director searched the building, but no one was found. All the doors and windows were locked, and no alarm had sounded.

This figure is believed to be the ghost of an Irish immigrant servant named Michael Conlin, who lived with the Townsends and worked in the house during the 1820s. During a Halloween tour of the house in 2001, a guide told visitors the story of Michael Conlin while in the Education Room/Gallery on the first floor. The room had once been part of the servants' quarters. Suddenly, while the guide was speaking, the door slowly opened, hit the guide's hand and then closed again. The visitors believed it was part of a Halloween trick, but the guide was terrified. Was this the ghost of Michael Conlin making his presence known? Smells, such as the scent of roses or women's perfume, have also been reported in this room for reasons unknown.

When one heads up the haunted staircase to the second floor, the presence of Sarah "Sally" Townsend has often been felt, especially in the eighteenth-

century children's chamber. Sally Townsend, a spinster, lived in the house for eighty-two years until her death. As the story is told, Sally, who was one of three Townsend sisters during the Revolution, fell in love with the British soldier Lieutenant Colonel John Simcoe. Simcoe lived at Raynham Hall for a year and gave Sally the first documented valentine in America. The letter was quite lengthy, and he expressed his love for her. However, when the war ended, Simcoe went back to England and never returned, breaking poor Sally's heart. Rumor has it that because Sally died in an upstairs bedroom, her lonely soul roams the house, especially in the children's chamber, because she never had children of her own.

During our investigation of the house, Joe Giaquinto recorded several EVPs, mainly from the second floor. Cold spots were felt in the dining room, and the creaking sound of a pantry door opening was heard when no one was there.

ST. JAMES GENERAL STORE

ST. JAMES

As soon as you step onto the well-worn porch of the St. James General Store and open its large old doors, you'll feel as if you've stepped back in time. Lining the original wood counters are everything from candles to porcelain to household decorations, old-fashioned children's toys, fudge, glass-bottled root beer and cream soda and a huge supply of "penny" candy in jars.

As you venture toward the back room, you'll see all sorts of sundries, including ladies' hats, more toys and silk flowers. The upstairs offers one of the largest selections of books on Long Island history by local authors, as well as art and nature books, children's books, artwork and photography. A small seasonal room with changing décor is located just past the book room, where author events are held on occasion. The store has everything you can think of, including a ghost or two.

Coming in from the cold on a Saturday morning in January, Joe and I were warmed by the smell of fresh-baked cookies. We introduced ourselves to the woman behind the counter, who was dressed in a Gibson Girl outfit, and told her that we were scheduled to meet store manager Karen Sheedy.

The woman looked at us a bit strangely and then said, "Follow me." Joe and I followed her toward the back office. Midway there, she abruptly stopped and said, "You'll have to forgive me. I was a little surprised. You don't look like ghost investigators. You're just not what I expected." Joe and I laughed.

As we arrived in the back, we were greeted by Karen Sheedy, who was ready for our interview. She began by telling us that the Suffolk County

Parks Department has owned the building and property since 1990, when the department purchased it from the Oakley family, and has also managed it since 2004. Karen has been the store's manager since June 1999.

"The store was started in 1857," she said, "by Ebenezer Smith, a descendant of Richard 'Bull' Smith. He lived within the hamlet of Smithtown known as Sherawogge, which is now St. James. In the early 1850s, when he heard about the gold rush in California, Ebenezer left Long Island with his mule and supplies and headed out west. Having had some success, he returned to Long Island and built the General Store along Moriches Road, which was the hub of the community at the time. Eventually his son Everett Smith inherited it and took it over.

"From what we've heard, the original store was this back room and the adjacent back area," Karen continued. "This is what the historians believe. Then somewhere in the late 1800s to early 1900s, this area was moved back from the road. What you see from the road now is the two-story addition that was put on as the store became more successful.

"From the beginning it was set up as a general store. From what I understand, the Smiths lived in a house next door. Everything could be bought here: kitchenware, medicine, groceries, hardware, horse supplies and tobacco. It was the site of the first post office in town, and it was also the place with the first telephone. It soon became a local gathering place where the townspeople would come for their mail and catch up on local gossip," said Karen.

"A lot of theater people used to come here," Karen told us. "Ethel and John Barrymore, Lillian Russell, Maude Adams, Irving Berlin…The old store ledgers also show Mayor William Gaynor, who lived at Deepwells down the street, architect Stanford White and heavyweight boxing champion James Corbett. Generally though, farmers, fishermen and tradesmen of the town frequented the store the most. Because this was a central part of the community, they would start the parades from the front porch. It is also said that people on horseback would ride up to get their mail, but sometimes they didn't feel like getting off the horse, so they rode right in."

Additional information stated that Ebenezer's son Everett had to run in and out of the store many times to give mail to women outside who did not want to dismount. So he finally posted a sign that read, "People on horseback must enter the store for mail"—and taking this literally, the women on horseback rode right in.

Stanford White came here primarily to use the phone, which apparently was how he conducted much of his business. On one occasion, a terrible

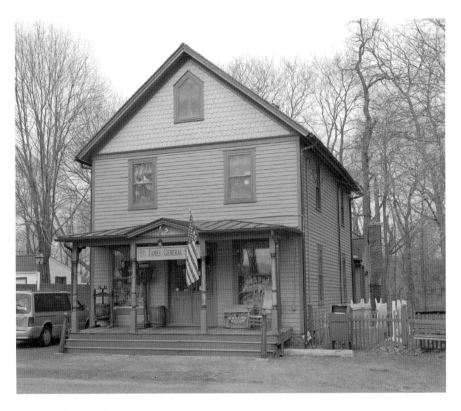

St. James General Store.

storm came out of nowhere. As soon as White had hung up the phone on the front porch, a lightning bolt came down and struck the phone he had just used.

As mentioned, Everett Smith took over the store upon his father's death. When Everett passed away in 1940, his father-in-law, Karl Ericson, maintained the store until he was ninety years old.

The store almost became a residence until Louise and Andrew Havrisko saved it and maintained its integrity. By 1980, John and Eleanor Oakley had become the proprietors and continued to maintain its historic nature. Before long, the store was placed on the National Register of Historic Places and once again became an integral part of the community, serving as a piece of living history.

The structure itself has not changed since 1894. The wood counters and cases are all original, as is most of the flooring, the potbelly stove, tea canisters and coffee grinders, along with other items used to decorate the store.

"I could show you the groove in the countertop out front where the men used to strike their matches," Karen revealed. "It was said that Ebenezer wasn't happy that the men kept doing that all the time and wore a groove into his countertop."

"What else do you find unusual about this place?" asked Joe.

"The thing that really hits me the most when I come to work on certain days, mainly in the summer, is the smell," Karen answered. "The way it smells and feels. From when I first started working here it always had a special quality, but when you've been here a while, you get to be more intimate with the building and know everything about it. So there is a smell every so often that just reminds me of the quintessential general store."

"Have you ever considered ghosts?" I asked.

Karen paused before answering. "I haven't felt anything, but one of the gals who works in the store feels cold spots often. She says when it happens, it's unmistakable. I consider myself a skeptical person," she said. "I thought about it when I first started working here because I'd get a little spooked at night when I was closing up. It was dark, and I was still getting to know the building and the sounds it made—the noises. I've come to know certain sounds now, so I can find a reason for them. I feel comfortable staying here, but there's always that voice in the back of your head saying, 'What if?'" she laughed.

"One of our past employees has the most interesting story," she continued. "Her name is Grace, and even though she had been working with me the day the incident happened, she didn't tell me for a year because she was really spooked by it. She was locking the front door at the end of the night when she thought she saw something out of the corner of her eye. She turned and saw the face of a little girl. I'm actually getting goose bumps just talking about it." Karen shivered. "She said if she could find a picture of her, she could definitely say that this is the person she saw. It was that clear to her: little girl, old-fashioned clothing. She turned and did a double-take and then she was gone."

Karen added, "The woman, Doris, who felt the cold spot upstairs…she said she also heard in the stairwell—when nobody's in the store—the sound of a child crying."

"Is there any one area that you feel is spookier than another?" I asked.

"One of the girls says she senses something in the front of the store," Karen replied. "There's one corner where she always had a sense there was something there…the back corner on the right-hand side as you enter, and that is the one spot, when I'm here by myself and the lights are out, that gives me a little pause before I leave."

Before we took a tour of the building, Karen gave me a list with several names and numbers of current and former employees I could speak to. I thanked her and said I would definitely contact them, and then Joe and I gathered our cameras and recorders. I decided to take my electromagnetic field indicator (nicknamed the "ghost meter") to see if I'd pick up anything. It had been quiet the entire time we were in the front room. It was the same thing as we entered the back room.

"I'm going upstairs," I said to Joe, who was talking with Karen. As I reached the staircase landing and put one foot on the first step, my ghost meter went wild. The indicator was at its highest level and beeping like mad. Joe and Karen came over.

"Is there anything electrical behind this paneling?" I asked Karen, trying to find a logical explanation for the meter going off.

"No, not at all," she replied, bewildered.

As I continued up the steps, it finally stopped. It had been an area of about three to four feet where the meter had gone nonstop. It didn't make a sound anywhere on the rest of the staircase.

The book room was also quiet. It wasn't until I approached the little seasonal room at the back that the meter went off again, in the area that separated the two rooms. I looked at Joe. Again, no explanation. The seasonal room itself was quiet, but when I left it, the meter went off as it had when I entered. The same thing happened when I got to the base of the staircase. This was the area Karen had told us about where the woman had heard the sound of a child crying.

A few weeks went by before I had time to phone the people on Karen's list. The first person I spoke with was Madeline, a current employee.

"When I first started there, I was an assistant manager working three days a week," Madeline told me. "I was the first to arrive and the last to leave. I would be upstairs in the book room, and I'd turn off all the lights. When I arrived in the morning and went upstairs, there would be books all over the floor. They didn't just fall off the shelves; they were all across the room—almost like they were flung. They were lying open."

"It wasn't anything scary," she added, "just mischievous. It happened three or four times in the fourteen years I've been here. I also experienced something upstairs, a cold spot by the fireplace in the seasonal room. I'd never in my life experienced anything before working in the store." She laughed.

Next I called Doris. She was the one who had heard the sound of the child crying in the stairwell. I asked her about it. "I was alone in the store, in the

front room by the cash register," Doris told me. "I heard a child crying from the back room by the stairs, the lower landing. I went to look, but nobody was there. I even looked outside, thinking maybe it was coming from there, even though I really knew it was coming from the stairs. It happened a few years ago, and I only heard it one time."

She continued, "Once, upstairs, I walked through a cold spot. We were closing; I turned off the lights in the seasonal room and walked through the book room to turn off the lights. As I went past the counter, I walked right through a cold spot. It got freezing, like ice," Doris explained. "In my head I said, 'Whoa!' I didn't look back and went quickly down the stairs. This happened about a year after I experienced the child crying. It was really freaky. There was no air conditioner on, and even if it had been on, it's regulated. It happened right between the glass cabinet and the register. I never experienced it before or since. I have to say, I am a true believer."

Another former employee, Joy, told me, "I always had a sense at the register on the first floor that somebody was there. I would actually turn to tell the person that no one was allowed behind the counter, but no one was there. I would see it out of the corner of my eye. Everybody who worked there had a sense that something was going on." Joy continued, "A customer came up to me once and told me he felt a presence by the fireplace on the

The upstairs book room where paranormal activity has taken place.

first floor. I don't know what he wanted me to do, but this wasn't new news to me. But I have to say that despite the ghost, it was a lot of fun to work there."

I spoke with Aria next. Although she had never experienced anything when she had worked as a cashier at the General Store, the first thing she said to me was, "Oh, my God, it's haunted!" She had heard many stories and rumors over the years.

The last person on the list was Grace. She was the former employee who actually saw the apparition.

"It was pretty bizarre," she told me. "A little boy had just left, and I was closing up the store. I was closing the two old-fashioned throw latches, and as I turned around, for a split second I saw this little girl. She was in the opening to go behind the counter. She made a face like she was scared, and then she was gone. I got an adrenaline rush. I was thinking, 'Oh my gosh! Is there a child left alone here?' I went behind the counter, and she wasn't there. I looked around—nothing. There was no one. It was only a split second that I saw her but enough for me to see that she had long, dark hair and brown eyes. This happened several years ago. I had heard about the ghost but had never thought anything of it until then.

"There was also a psychic in the area who came in here a lot," Grace continued. "He told me that it was a little girl named Sarah, and that she was stuck there. He claimed she died in the store, fell down the stairs or something. I don't remember the whole story now because it was many years ago. He also told me that Ebenezer Smith, the first owner, was there. As far as the little girl was concerned, the psychic said that supposedly her mother [in spirit form] tried to get her but she wouldn't come.

"I always found the store to be calm and relaxing," Grace continued. "Although I didn't like being alone for a while right after the incident. But after a while it didn't really bother me anymore. I never felt threatened there."

CHAPTER 4
THE SHOPS AT SUITE PLACES

HUNTINGTON STATION

Passengers began to arrive by railroad in Huntington Station as early as 1867. The area was rural, with nothing surrounding the small station but open space or farmland. As the years went on and the area began to develop, it became important to start building hotels where travelers could stay. Because of the proximity to the railroad station, several small establishments were constructed.

The Venice Hotel was built sometime between 1906 and 1916, and it remains the only existing hotel structure in Huntington Station. Located on New York Avenue, just a short walk to the railroad station, the Venice Hotel is now a multi-dealer antique store known as the Shops at Suite Places. Its history—and ghosts—are "alive" and well.

I did a lot of research on the Venice Hotel back in 1997 when I was writing my book *Huntington's Past Revisited*. It was known for forty years as the home of Yankee Peddler Antiques. I had interviewed the owner, Anne Peace, who spoke to me about the building's remarkable history. The topic of ghosts came up, and several people I spoke to at the time claimed to have heard footsteps walking, running or shuffling up and down the stairs. The strong scent of a woman's perfume was also reported, while others claimed they felt like they were being watched. I had heard many rumors over the years that the place was haunted, so I decided to revisit the old hotel with Joe Giaquinto and see what we could find out.

The Mascaro family is believed to be the original builders and owners of the Venice Hotel. It is unknown exactly when the name was changed

to Mascaro's Bar and Grill, but the family continued to run the place as a hotel, restaurant and bar until 1979. At that time, it was sold to Mrs. Gloria Smith, who turned the building into a ten-thousand-square-foot antique center where she sold antiques for fifteen years. Gloria then sold Yankee Peddler Antiques, and the building, to Anne Peace in 1994. Twenty years later, Anne was ready to retire and found a buyer for the building. However, the new owner had no desire to run the antique business. As luck would have it, one of the antique dealers who set up shop there had an interest in taking it over. It was a dream come true when Amanda Peppard was asked to take over the business.

"The first day I walked in here I felt this real connection with the building, and I saw massive amounts of potential," states Amanda. "I had a vision of each dealer having their own personal space and feel. I wanted all these little shops at this one big space, and I wanted to create a destination for people to come to. It's a unique approach combining old and new."

The Shops at Suite Places has twenty antique dealers and thirteen resident artists spanning its three floors. Two original staircases lead to the second floor, while another staircase leads to the basement.

The basement is an unusual place and is often referred to as the "spookier" part of the building. There is an area off to the left when you head down

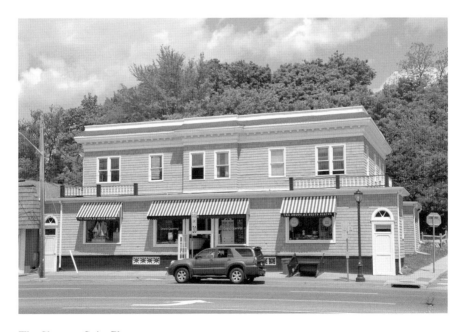

The Shops at Suite Places.

the stairs where old painted murals can be seen. They are believed to have been painted sometime between 1914 and the 1920s. The murals are quite disturbing in nature, and just who the artist or artists were is unknown. Legend has it that black chauffeurs would hang out in the basement of the Venice Hotel before taking passengers via horse and buggy to nearby homes. Another story suggests that those who passed through painted the murals in exchange for a night's stay or a free beer at the bar.

One mural shows an image of a devil leading six smaller devils who are carrying a coffin. Behind them is a pig with a devil's face and horns. Another mural depicts a man hanging by his neck from a tree while two men standing nearby laugh. A third painting is of four African Americans wearing top hats and long black coats socializing around a table. Under that image a caption reads, "A Gentleman is a gentleman, regahdless [sic] of color and always pays for his drinks." The murals have greatly faded over the years, but the mystery of who painted them remains.

It is believed that at one time this area of the basement was a segregated bar for chauffeurs and hired help. There has also been a rumor that during Prohibition it was used as a speakeasy because an old outside entrance and stairway was discovered years ago during a renovation.

On the day of our interview and investigation at the Shops at Suite Places, Joe and I entered through the large, old-fashioned doors that were once the main entrance to the hotel. We met up with Amanda Peppard and some of her employees who were willing to speak to us about the ghosts.

"With all the antique objects you have, they all have their own energy. They all have their own story," Joe began.

"Absolutely," Amanda replied. "I haven't really had any particular ghost experience, but I've had quite a few customers who have been in the building with me and have said that they really feel something. I had a customer in this room [Amanda's office], and she told me that she felt something back here," Amanda pointed. "This was an area she felt had spirits. She was a medium, and she said it wasn't anything bad, and that I didn't need to worry about it. She said they were good spirits. I'm a scaredy cat. I don't watch ghost stories, I don't watch scary movies—so sometimes I feel if you're not open to that, then you kinda won't be exposed to it. I definitely believe in it, no doubt about it, but I just remove myself from it. I don't really think about it, and I've been in this building until very late at night by myself. I've always felt very safe here."

"I think the spirits like what you've done here," I said.

Amanda then went on to tell us about two other customers who had felt something strange in the building.

The basement, with a hand-painted mural on the left and speakeasy back entrance.

"One customer I was working with said, 'I have to stop you. There is something that is pulling me over here.' She was really getting a very strong feeling. A mother and a daughter said to me, 'I don't like that basement. How do you go down there? It just feels uncomfortable, like something happened down there.' We hear a lot of that about the basement. Back in the day before the renovation, I could understand why. It was dark and dreary, and furniture was piled everywhere. I really think we've done a fantastic job of brightening it up, but…" Amanda paused. "Probably something happened down there."

"The basement could have remnants of what happened when it was a hotel," said Joe. "It's called an imprint or place memory, and that's what could be adding to that creepy feeling."

Joe and I spent a few minutes talking to John Murray. He and his father, Jack, have worked in the building for decades.

"We've always heard it was haunted," said John, who is the manager at Shops at Suite Places. "My father, who is also a manager here and who worked for the previous owner, will probably tell you that there's always been a story about a lady and perfume. You could always smell perfume. I never really believed it, but ever since Amanda came, I've spent more time here

later at night, like 7:00–7:30, and I'm by myself. One night I was putting paint away in the front section [of the building], and I heard someone running down the stairs. The back door is loud. I heard it open and close. So I figured it was the guy across the street who was helping me, and he forgot his jacket downstairs. I'm literally fourteen feet away. I put the last can of paint up and walked over there by the stairs and looked down. The basement was pitch black."

John continued, "All right, I literally walked back, grabbed my stuff, locked the door and walked over to the deli, all the while looking back over my shoulder. This never happened to me before. I was just like, 'Wow!' I was telling them over at the deli, and they were all freaking out," John laughed. "Turns out the guy I thought came in [to the building] was at the deli. I'm accustomed to hearing people coming and going. I know when they're coming through the back door. I know when someone goes upstairs—but that night I was alone, and I heard this."

"Did that make a believer out of you?" I asked.

"It made me think. Absolutely. Without a doubt," John said. "It happened maybe a year ago, and nothing has happened since."

Joe and I continued on with our walkthrough of the building. We visited the artists' studios upstairs, the main floor and the basement where we saw the strange murals and secret back entrance. Joe decided to try out his ghost box. Here is an excerpt of some brief communication we had with a spirit:

> Joe: "Hello."
> Spirit: "Hello."
> Spirit: "Hey!"
> Joe: "Hey."
> Joe: "How are you?"
> Spirit: "Hey."
> Spirit: "Good, man."
> Amanda: "Hello!"
> Spirit: "Hi."
> Spirit: "Jeff's so sweet."
> Spirit: "Donde este una pregunta?" [Which translates loosely to "Where is your question?"]
> Kerriann: "We don't speak Spanish."
> Joe: "Question!"

It was simple communication, but it was communication nonetheless. Upon my arrival home, I called Lee, an artist who had worked upstairs for two years. She gave me an interview over the phone and told me about her experiences.

"When I first arrived two years ago," Lee began, "I felt something. I couldn't explain it. I felt some kind of presence. Soon afterwards, paintbrushes would fall off the table for no apparent reason. They'd just dump out on the floor. It was the same for the canvases. They would fall off the easels. I would put paintings up on the peg boards. They would constantly slide down for no reason. I felt there was a spirit in the room, and after a while I felt like I had to make peace with it." Lee continued, "When I accepted it and acknowledged it, things quieted down. I sense a female energy. I did some of my best work in that studio. Once I accepted it, the spirit would work with me."

Whether or not there are spirits at the Shops at Suite Places, Amanda Peppard says, "I feel safe here, and my dream of owning this business has come true. And that's really all that matters."

CHAPTER 5
MONTAUK MANOR

MONTAUK

It was Carl Fisher's dream in the summer of 1925 to create the most fabulous summer resort ever imagined in the western world. Fisher was a multimillionaire industrialist who was responsible for the development of Miami Beach, Florida. He envisioned Montauk as having a beach club, a yacht club, polo fields, a golf course, a ranch and a health spa.

His centerpiece would be the Montauk Manor, a two-hundred-room luxury resort hotel. A magnificent English Tudor–style "castle on the hill." It would be built on a piece of land known as Signal Hill. In 1927, part of Fisher's dream became a reality when the manor was officially opened. The rich and famous flooded its grand ballrooms, played croquet on the rolling front lawn, drank tea on the veranda overlooking the manor's ten thousand acres and ate in the finest of restaurants.

What the guests did not realize, however, was the sad yet amazing history that lay beneath the massive structure. While the Roaring Twenties rolled on at the manor, unsettled spirits lay trapped deep in the earth below. As legend has it, the beautiful Montauk Manor is said to be haunted by the ghost of an Indian chief.

Archaeological excavations have shown that Montauk was inhabited by Native American Indians more than three thousand years before any white man set foot in North America. The tribe called the land Montauket, meaning "hilly country." The tribe itself was known as the Montauks, and the Indians were called the Montauketts. They were a peaceful tribe who fished the waters and farmed the land.

By 1620, Chief Wyandanch had become known as the greatest chief in Montauk history. Unfortunately, his friendship with Lion Gardiner and his tribe's involvement with the British settlers would ultimately cost the Montauk tribe their land.

Wyandanch and Gardiner became so close that they went through a traditional blood-brother ritual and helped each other whenever they could. The Montauketts lived in peace with the white men, but they were almost constantly at war with more aggressive tribes from New England, the Pequots and the Narragansetts. These tribes would quietly sail across Long Island Sound in their canoes and launch an attack once they hit land.

In 1642, the Narragansetts organized and led an uprising of the other New England tribes against the British settlements. The Montauketts fought side by side with the British, and Wyandanch stayed loyal to his blood brother. This left the Montauketts completely isolated from other Indian tribes, and they became more dependent on the white settlers.

In 1653, the Narragansetts once again set foot in Montauk, waging a surprise attack on the Montauketts. The fierce warriors nearly destroyed the Montauk Indians in one of the worst attacks ever made on the tribe. The ambush took place at the foot of the present-day Montauk Manor. Because of the terrible losses inflicted on the Montauketts, the low-lying land just east of Fort Hill next to Signal Hill became known as "Massacre Valley."

At least thirty Montaukett Indians were killed, and fourteen others were taken captive, including Wyandanch's daughter, who was celebrating her wedding feast that night. It is said that his daughter, named Quashawam (Heather Flower), watched in horror as her new husband was massacred in front of her, but there is no historical record confirming that his death actually occurred. Quashawam was taken by the Narragansetts, who held her for ransom. When Wyandanch could not come up with the rest of the ransom, Lion Gardiner traveled to Rhode Island to pay the additional money, and Quashawam was released.

Next door to the manor is Fort Hill Cemetery, which was established by East Hampton Town during the 1980s. It was named Fort Hill after the fort the Indians once had there. Some Native Americans believe that Wyandanch is buried somewhere at the top of the hill, which overlooks Massacre Valley. There are many Indians buried in this area, although the graves are not marked. It is said that there are a few, probably hidden under brush now, which are marked by a circle of stones. At the time the manor was built, many of the graves that could be seen were probably moved. The entire area was disrupted during the manor's construction.

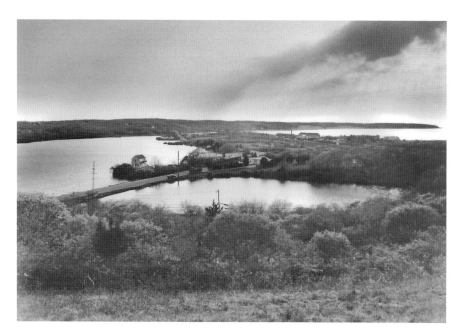

The area once known as "Massacre Valley."

The Montauketts weren't the only ones who died on the land. During the late 1890s, many of Teddy Roosevelt's soldiers came down with yellow fever. It spread among the troops so quickly that Roosevelt decided to lead them up to the sacred site on the hill. The route they took was up the present-day road, located next to the Montauk Playhouse, and which leads up to the manor. The hill was steep, and the soldiers struggled in their weakened conditions to climb it. It is said that over three hundred men died en route. Some died in a detention hospital that was set up near the present manor. The soldiers were temporarily buried above Indian remains, both at Fort Hill and nearby at Lake Montauk. Eventually, most of their bodies were exhumed and sent home. Neither of the makeshift cemeteries was marked.

"Before I started working here, I had heard the stories about the Indian chief," said Janice Nessel, Montauk Manor's longtime general manager. "There were a lot of rumors around town. I've never seen him personally, and I've been here a lot of years. But I've had guests who didn't even know the story come up to me and say that they saw an Indian in full headdress, kind of floating by."

Janice continued, "One man, and I would say he knew nothing about the story, was a corporate guest here on business. He said to me, 'I think I had

too much to drink last night.' He said he saw an Indian in full headdress float across near one of the duplexes on the first floor."

Around the same time, News 12 did a documentary on the manor being haunted.

Janice continued, "No one has reported anything recently, I mean, it's an old building and things happen—noises and things like that—but no one has reported seeing the Indian chief in a while. Everyone has always said that he haunts primarily the fourth floor, but any guest who reported it in the past, other than a local person, has seen him on other floors."

Montauk Manor maintenance engineer Jimmy Hackett has been working there as long as Janice has and believes he may have captured the ghost on film one time.

"A couple of years ago, I was painting the restaurant, and I took before-and-after shots," said Jimmy. "When I got the film back, one of the photos had this hazy, white light going across it. It definitely wasn't there when I was taking the photo."

Jimmy and his wife lived in one of the rooms on the third floor for a while, and they would always hear a lot of noises directly above them on the fourth floor. Jimmy couldn't understand what was going on. He knew the man upstairs very well. He was a local, and he was living at the manor full time.

"One day I couldn't take it," Jimmy recalled. "I went up there and knocked on the door. I waited, and no one answered. Because I had all the master keys, and I knew the guy, I opened the door to see what was going on. No one was there, but the closet doors were all open, lights were on. Things like that would happen when he was in the room, too. Finally he chose to move out."

Janice remembered a time when a group of Native Americans came to her with a request.

"It was a busy Labor Day weekend, and we were booked. I received a call from some Indian chief, I don't remember who it was, but he told me his tribe was having a bicentennial celebration. He asked if he could put to rest the soul of a past Indian chief. He said they wanted to erect a teepee in the parking lot and light it on fire. They felt that this property was his burial ground and that the manor was built over it. He said that if they performed this ritual his soul would be put to rest."

Janice continued, "At that point, I had to tell him the town would never allow it. It's against all the fire codes. And it was Labor Day weekend, of all times. The man told me that the teepee had to be x amount of feet from

the building, and it had to be done right away during their celebration. They wanted to do it here in the parking lot. I never heard anything more about it."

According to the Montauk Community Message Forum, which addresses local questions and concerns over the Internet, the Montauk Manor has been the topic of many a conversation. There were several mentions of the Indian chief being seen. One stated that a young man from New Jersey, who was staying at the manor with two other men on a golf package tour, awoke in the night and saw an American Indian in feathers standing at the end of his bed. His screams apparently woke the other two men he was sharing the room with, and they saw the specter as well. In an instant, it was gone.

Another story mentioned a cleaning lady. The woman was cleaning the men's sauna downstairs when she heard the door slam. That noise was followed by a baby's cry. Terrified, she ran to the management and said she would never work there alone again.

A nine-year-old girl who lived next door to the Fort Hill Cemetery claimed to have seen an American Indian in full headdress perched on top of the hill two years after the new cemetery was established. Before she could show anyone, the man was gone.

Another person on the Forum claimed that four ghosts, not Native Americans, appeared to her frequently while she was living on the first floor. They looked like smoky apparitions, and they threatened to kill her.

The Montauk Manor has seen its share of hard times. When the Great Depression hit in 1929, Carl Fisher and his Montauk Beach Development Corporation went bankrupt, and the manor was barely surviving. By the late 1930s, the American economy began to improve, and the manor thrived once again, with guests arriving by stagecoach from the Long Island Rail Road station below. Once World War II began, the army and navy took over most of Montauk, including the manor. The army used the manor as barracks for the duration of the war. Once peace was declared, middle-class families began coming to Montauk on vacations. They would stay in motels by the beach that were built during the 1950s. The motels were simple and convenient and were right in town. These types of vacationers had no interest in an elegant luxury hotel like the manor. By 1963, the Montauk Manor had closed and was subjected to vandalism.

For two decades, the manor remained empty, its property overgrown. No one could afford to fix it up, yet no one could destroy it either. A developer was reportedly interested in it once and had plans to demolish it. He later found out that the building was so well constructed that it would have cost a

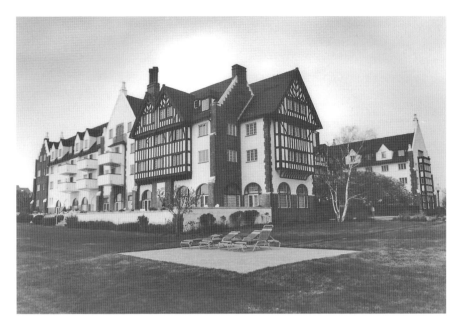

Montauk Manor.

small fortune to knock it down. During the 1970s, it was suggested that the building be turned into condominiums, but due to inflation and the oil crisis, the plans did not go through.

In 1985, the Sybedon Corporation purchased it and spent $15 million renovating it and turning the rooms into 140 different kinds of apartments. Sales lagged after the 1987 stock market plunge, but two years later, the J.E. Robert Company took over marketing and advertising, and the remaining units were sold.

Now on the National Register of Historic Places, the Montauk Manor is a wonderful reminder of days gone by. Perhaps the spirit of the Indian chief has finally been put to rest.

CHAPTER 6

EXECUTION ROCKS LIGHTHOUSE

KINGS POINT

I have always been fascinated with the sea, with lighthouses and the mysterious tales that surround them. The infamous Execution Rocks Lighthouse is located on a dangerously rocky reef a mile north of Sands Point, in the middle of the western part of Long Island Sound. Through my research, I stumbled upon all sorts of grisly tales surrounding this abandoned lighthouse. I soon went on a quest to get there and see it for myself.

The channels I went through to accomplish this were complicated but well worth pursuing. After several weeks of phone calls, I was put in touch with Petty Officer BM1 Adam Nigro, at the Coast Guard Station based at the U.S. Merchant Marine Academy in Kings Point. I told him of my project, and he said he could arrange for a few officers to take Joe and me out to Execution Rocks.

Our trip depended on the weather, the moon and the tides. It was imperative that we went out at high tide and returned before low tide. A date was finally arranged, and we set out on our journey with the Coast Guard on a warm and beautiful day in May.

Execution Rocks Lighthouse has not been maintained due to lack of funds and is therefore not open to the public. For now, it is owned and operated by the U.S. Coast Guard.

We arrived at the Merchant Marine Academy campus at exactly 9:30 a.m. and checked in with the guard. The grounds of the academy are beautiful, having once been part of a huge estate. We drove to the end of the road, overlooking Long Island Sound. The Coast Guard has been stationed there

since September 11, 2001. An officer at the door checked us in, and there we met Petty Officer Nigro, who introduced us to the three young officers who would be taking us out to sea.

We walked with them to the boat docks, where we boarded a twenty-five-foot Homeland Security Response Boat. Our crew's main mission is search and rescue. Joe and I were given Coast Guard life vests and were seated in the small cabin. We were joined by Petty Officers BM2 Mark Phillips, who piloted the boat; SN Stephen Fournier; and MK3 Kyle Harper. From the beginning, the Coast Guard truly went above and beyond for us, making our trip comfortable and informative. It was a smooth twenty-minute ride across the sound, which carried us out to depths of 107 feet.

As we approached the lighthouse, Officer Phillips, knowing I wanted photos from the water, slowed the boat and positioned it so I could get some great shots. The depth abruptly changed to twelve feet the closer we got, and Officer Phillips had to be careful of the many unseen rocks. We pulled alongside a gray stone slab, where a single-rung steel ladder would bring us up. Sea birds of all kinds quickly took flight at our arrival, and the smell of the place is one I will not soon forget—a mixture of bird dung, clamshells and rot. I shivered as I recalled the stories I had read about these rocks.

Officer Harper swiftly ascended the ladder. Removing our life vests, Joe and I passed him our cameras and equipment. I pulled myself up the ladder until I came face to face with Officer Harper's shoes. I had reached the ground level. Joe followed me, as did Officers Phillips and Fournier.

I looked up at the sixty-foot conical white stone tower. A large brown band was wrapped around it halfway up. A two-and-a-half-story stone keeper's house was attached to it on one side. The lighthouse was granite with a brick lining, and it stood on a dressed stone and timber foundation that was now enclosed by a government barbed wire fence. Beyond lay the treacherous rocks. Large birds' nests, many containing eggs, were intermingled among the boulders.

It was on these rocks that the unthinkable may well have occurred. As the legend has been told, during the Battle of Long Island in the Revolutionary War, British soldiers rounded up "American rebels" in order to put them to death. Because they did not want to "fuel revolutionary passions," they quietly took the Americans away for brutal torture and execution.

Since the British had come in by ship, they were familiar with our waters. They knew of the treacherous Hell Gate where the East River, Long Island Sound and the Harlem River merge, creating something like a whirlpool, with 5.2-mile-per-hour currents and strong crosscurrents. Once past this

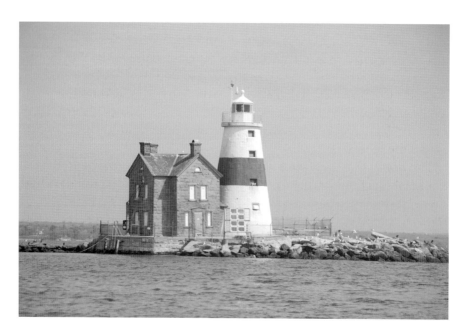

Execution Rocks Lighthouse.

difficult stretch of waterway, the sound was before them. They knew of a remote area where a large group of rocks jutted out of the water, which splashed around it violently. This grouping was very large but often unseen in fog or darkness. Many a shipwreck had taken place there. It was this area of rocky reef where the British troops' plans for the rebels unfolded.

It has been said that the British secretly took them to this island of rocks and beat them, then drove spikes into the rock reef and chained them to the rocks at low tide. As the tide rose, the American prisoners drowned beneath the icy waters.

Other tales reveal that many of the prisoners met their fate by hungry sharks that happened upon a free meal. As if this wasn't enough, the newly captured were chained next to the skeletal remains of their former comrades—a way of torturing them mentally before they met their own watery demise.

There's a line in the Declaration of Independence that reads, in part, "the murders they commit on the inhabitants of these States." According to my research, several historians believe that this line refers to accounts of the brutality that took place on Execution Rocks and that the line was included in the Declaration as a memorial to those who died there.

It is said that the ghosts of the condemned prisoners remained. There is even one legend that suggests the ghosts sought revenge against the British. Not long after the hideous acts had taken place, a shipload of British soldiers were sent to pursue General Washington while he retreated from Manhattan to White Plains. The ship was wrecked at the reef, killing all the redcoats aboard. Many people have claimed that the ghosts who haunted the reef caused the shipwreck.

The stories that took place during the Revolutionary War are the most commonly told tales, but I did come across some others similar in nature. The earliest stories came from an article in the *New York Times* of June 18, 1893. It spoke of the 1600s and dealt with the infamous pirate Captain Kidd. It reads:

> *The pile of stones between what are now Sand's Point on Long Island and New Rochelle in Westchester, was not always as large and well-regulated as at present. It was an unsightly pile, forbidding in aspect and dangerous to the navigator, away back in the sixteen hundreds, when Kidd sailed up Long Island Sound and made harbor at Oyster Bay before sailing over into Rhode Island waters.*
>
> *There are strange stories of how Kidd took summary vengeance upon some of his crew and ornamented the pile of stones with dangling corpses of dissatisfied shipmates. There never was any treasure-hiding there; it would have been hard digging for the hardy freebooter and his men, and there wasn't much acreage in the grim old pile of stone for hiding chests of ill-gotten possessions.*

In the same article was other nautical lore. The keeper of the light at the time the article was written was W.H. Tooker. He and his assistant, Richard S. Ray, claimed that the name of Execution Rocks is derived from the execution of some Spaniards many years ago. The article goes on to say, "This legend serves the purpose of the present well enough. Whether it was Kidd or the Spaniards from whom the name comes."

In still other stories, it has been said that Indians took colonists there, where they met their demise in a similar fashion. I couldn't help but think of all these tales now, as I stood among the outskirts of these very rocks.

Officer Phillips unlocked the huge steel door of the lighthouse keeper's dwelling. We all stood behind him silently, not knowing what lay on the other side. The door made a loud sound as he pulled it open, letting light into the room. I peered over his shoulder. Huge pieces of peeling paint and

asbestos clung haphazardly to the crumbling walls and ceilings. Windows were boarded up, and railings and rungs were missing on various parts of the staircase leading to the second floor. Dust, debris, bird droppings and unrecognizable substances littered the old wood floors. The stench from the birds was worse than outside, but still, something beckoned us to go in.

Seeing how dark it was inside prompted Officer Harper to go back to the boat for a flashlight. Walking among the ruins, I thought of what it was like when first built.

It was under the presidency of Abraham Lincoln that plans were made to erect a lighthouse atop the dangerous rocks that had claimed the lives of so many. On March 3, 1847, $25,000 was appropriated to build a lighthouse on the reefs. An architectural designer named Alexander Parris was hired to design it, and a man named Thomas Butler had won, by lowest bid, a contract to construct it. His efforts were less than desirable, however, and the bulk of the work ended up being done by subcontractors. Because of this, the lighthouse was completed a year behind schedule.

When first built, it was all white, and there was no lighthouse keeper's house. The keepers of the light lived in the circular room on the lowest floor of the structure. Through an easterly window, the keeper would ring a bell to warn passing ships traveling through the fog. Whether they heard the faint ring of the bell is unknown, but it is unlikely. Later, a trumpet operated by steam from a second-floor boiler took the place of the bell, before the onset of the siren. Following the siren was the foghorn.

As for the light, it was lit in 1850. The keeper of the light was Daniel L. Caulkins, who was also the keeper for the Sands Point Light. He did not live there. Instead, one of Caulkins's assistants and his wife took up residency in the small circular space, which only measured twenty-six feet in diameter at the base.

Congress had stated, "Any keeper assigned may at any time request that he be relieved without prejudice since from this time on no man shall ever feel chained to Execution Rocks."

About a year later, in April 1851, William Craft became head keeper, and he lived in the tower with his assistant. The keepers' dwelling was not erected until 1868, sixteen years later. It is hard to believe that two people could have lived and shared the same tiny space in the conical tower.

Other changes to the light occurred in 1856 when a Fourth Order Fresnel lens was refitted and installed. The distinctive brown band around the midsection of the tower was added in 1895, and the concrete oil house was added sometime between 1910 and 1920.

The lighthouse also survived two fires. The first was on December 8, 1918. The tower was singed by the blaze, and the stonework on the north and east sides of the tower was badly chipped, but no structural damage was done. The damages totaled $13,500. The engine house and all the machinery inside were destroyed, the brickwork on the oil house sustained damages and the windows, gutters, eaves and woodwork were severely damaged. The origin of the fire was never discovered.

A second fire in 1921 was caused by an overheated exhaust pipe that set the engine house's roof on fire. Fortunately, this fire was much smaller and more contained, and the damage was primarily to the lens and the clockworks from smoke.

Now here we were, walking among this history, walking amongst the ruins. The first floor had a center hall with a staircase. To the right was a hallway that led to what once was a kitchen. Officer Harper shined the flashlight along the walls and boarded-up windows. There was another way out of the kitchen that led to what probably was a living room. That led back to the main entrance and to the staircase. Directly to the right of the main entrance was a small arched walkway with a few crumbling steps leading down. This was the passageway to the tower.

Officers Phillips and Fournier waited outside as we continued our journey. Slowly we walked up the dusty, creaking staircase toward more darkness. Three small rooms and what once was a bathroom occupied the second floor. The conditions of the rooms were the same as on the first floor.

Officer Harper found another tiny staircase that led up to the third-floor attic. Although the steps were few, they were built at a steep, winding angle. As Officer Harper got to the top, his flashlight began to get dimmer. I stopped at the top of the staircase with Joe right behind me. It was complete blackness up there, and I could go no farther. From the top step, I blindly took photos with a powerful flash. It was only after I viewed them digitally on the back of my camera that I was able to see what it actually looked like there. Luckily, we all made it safely down. As we checked out one of the second-floor rooms again, the three of us heard a very strange sound—a ghostly sound.

"What was that?" Joe asked.

Officer Harper replied, "Probably them [the other officers] opening the door. I don't know."

"That's—" Joe said and then stopped because we heard the wailing sound again, echoing within the building. For a minute, we stood still, and none of us spoke.

Finally Joe said, "It sounded like—didn't it sound like—was that them?"

"It could have been anything, from a bird…" Officer Harper said. "That's the thing about here. You have openings everywhere, so you don't know what you're going to come across—a bird, maybe?"

"A bird?" Joe asked.

"A bird," answered Officer Harper.

"Kerriann, did you hear that?" Joe asked.

"I did hear that," I replied.

"It sounded like a voice. A woman's voice? Or a young…" Joe trailed off.

"It almost sounded like a 'wail' kind of a sound," I added.

"A wailing sound, like, 'Oh, my,'" Joe contemplated that. "Well, maybe we'll pick it up [on the recorder]."

Several hours later, when Joe was back in Hampton Bays, he e-mailed me the clip from that moment. The "wailing" sound could be heard clearly. We discussed the possibilities. We determined it definitely wasn't a door. The other two officers were outside. They would not have closed the big steel door while we were inside; it was giving us our only source of light. There were no other doors in the building.

As for the birds, seagulls could be heard screeching in the distance, annoyed that we had entered their territory. As soon as our boat arrived, all the birds had flocked and none remained on the reefs. To me it didn't even sound like a noise a bird would make. We also saw every part of the building. We would have noticed if an animal was trapped inside. Lastly, it was a quiet Thursday morning in May with no boat traffic. We determined that there was no explanation. It very well could have been a ghostly wailing sound.

After we heard the sound in the old keeper's building, Joe and I and Officer Harper made our way back to the first floor, where we met up with Officers Phillips and Fournier.

All of us then went down the small passageway into the tower itself. From the size of it, I couldn't imagine anyone actually living in it. We climbed the circular steel stairs to each level. There were three flights in all, and as we climbed, each room became smaller. By the time we reached the top, it was only thirteen feet in diameter. Officer Phillips climbed the steel ladder that led to the light and pushed open the steel trapdoor. Each officer hoisted himself up and into the small opening, making sure everything was safe for us. They stood outside on the circular balcony as we once again passed them our equipment.

I took a deep breath, pulled myself onto the ladder and climbed up. My head popped through the opening, and the massive light was right there on my left.

When the lighthouse became automated on December 5, 1979, a VEGA lantern, which is a white, flashing modern optic, replaced the old Fresnel lens. U.S. Coast Guard keeper Stan Fletcher was the last keeper of the light. He retired from Execution Rocks in 1970, and the keeper's dwelling was left vacant.

It was tricky trying to maneuver up there. I was finally able to stand somewhat, but I still had to go through another small space to get onto the little balcony. I decided that crawling was the best method and was relieved when I finally made it outside. Officer Fournier handed me my camera. I watched as Joe tackled the same obstacles, and before long we were all outside and looking over the sound, which was breathtaking. There was a good view of the rocky reefs below, which looked even more dangerous from above. We talked to the officers about the many shipwrecks that had occurred here.

There's another story as to how Execution Rocks may have gotten its name. On British Admiralty charts during the pre-Revolutionary eighteenth century, the rocky reef was noted specifically as "Executioner's Rock" because the rocks "executed" so many ships. Poor lighting and heavy ship traffic added to the many wrecks that occurred here.

Perhaps the most famous story is about the steamer *Maine*. On February 4, 1920, the steamer, which was constructed in 1892, ran aground on the rocks due to high winds, a full moon tide, snow and ice. It is said that the ship crashed stern first and almost hit the lighthouse. Luckily, all on board survived, including fourteen horses that had been traveling with them. Because of the severe weather, however, they were not rescued from the rocks until three days later. The lighthouse station's drinking water had run out, so snow had to be melted for the people and horses to drink.

From the top of the lighthouse we could see Long Island, New York City, Westchester and the Throgs Neck Bridge. All of a sudden, we heard a helicopter headed straight for us. It was from the Nassau County Police. They came extremely close and circled around; we could actually see them inside. I assumed that all was well, since we were with the Coast Guard. Evidently they saw activity at the lighthouse and were just checking to make sure everything was okay. We all waved, and the officers in the helicopter waved back before making one more circle around the tower. I looked at Joe, who was laughing. "Wow! It's like being on *Magnum P.I.*," he said.

After about fifteen minutes, it was time for us to take our downward journey. Fortunately, it was easier getting down than going up. When we

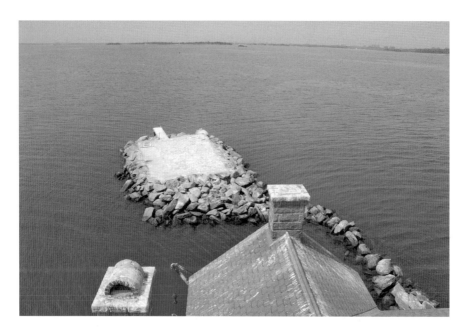

View from the top of the lighthouse, looking down on the rocks where Patriots were executed.

arrived at the bottom of the tower, I asked Joe what he thought. Had he picked up anything that would suggest the place was haunted?

He replied, "I mainly felt in the inside structure there was a lot of sadness and loneliness. It seemed to be concentrated in the main room when we first walked in and went straight ahead where the kitchen used to be. I felt that was the heart of the spirit energy there. I didn't pick up too much outside, although knowing the story, it is creepy with the rocks here."

Joe paused and then talked about the sound we had heard upstairs in the lighthouse keeper's house. "It could have been the guys talking or seagulls or something, but it really sounded like wailing to me— like somebody wailing in sadness—like somebody had been killed or somebody was going to be executed."

Joe continued, "I think in general, the lighthouse is not as creepy as I first thought. However, we're here in broad daylight. I can imagine the atmosphere changes dramatically after dusk. I think there's more energy inside the building and then also on the rocks. When we first got here, I felt a wave of frustration, and I'm not sure where that's coming from."

We spent some more time looking around and photographing through the confines of the barbed wire fence. So much had taken place on the

very ground we were walking on. I looked up at the lighthouse, half expecting to see some ghostly figure up in the tower. It has been said that the average tenure of a lighthouse keeper at Execution Rocks was only six months. Apparently, when the keepers were assigned duty there, they were under a unique contract, one that was different from any other lighthouse. There was no set length of duty. Their service was "for as long as they were willing to stay." The contract read, "No lighthouse keeper was to ever feel chained to the reef." If the lighthouse keeper requested a transfer, it was instantly granted.

Was it the ghosts who tormented the keepers or loneliness? It has been said that many a keeper at Execution Rocks was awakened in the night by screams from those who had been chained to its reefs.

The last of the lighthouse keepers claimed there were no ghosts there, but throughout the years there have been reports of spectral sightings. Local fishermen have claimed to see the ghosts of the men who died there walking among the rocks.

We boarded the Coast Guard boat, and Officer Phillips started the engine. Our time at Execution Rocks had come to an end. As I put on my life jacket, I took one last look at the old lighthouse and the treacherous rocks before us. We slowly pulled away, and as we did so, the seagulls and black cormorants flocked back to their home. Perhaps they are the only ones who know the true mystery of Execution Rocks.

GREY HORSE TAVERN

BAYPORT

The historic Grey Horse Tavern sits at the corner of Bayport and Railroad Avenues, just south of the railroad tracks in Bayport. When the railroad was extended to the southeastern part of Long Island, Bayport quickly became a bustling resort town. The wealthy from New York City would come by train and spend their summers. Their first stop: Frieman's Hotel, which is today's Grey Horse Tavern.

It is believed to have been built in 1868, and it was run as a tavern and hotel by Charles and William Frieman until 1910. An old postcard picture reveals that the name had been changed around that time to the Fiat Inn, although it is unclear why or who the owners were. Supposedly it remained as the Fiat Inn through 1920, at which time Gene Amman and his wife, Olga, from Freiburg, Germany, purchased it.

When Gene Amman first came to the United States in 1893, he worked at Ruppert's Brewery in New York City until coming to Bayport in 1920. It was at that time that Amman bought the inn, and the name was changed to the Bayport House. Thanks to Olga's freshly prepared, homemade food, the Bayport House became a well-known destination in Bayport. All kinds of fish, shellfish, meat and wild game were prepared there, and people would come from miles around to partake in delectable meals. Gene and Olga successfully ran the Bayport House for thirty-one years.

In 1948, at the age of seventy, Gene Amman died in the hotel he loved. Olga continued to run it until she retired in 1951. It was then that she sold it to a Mr. and Mrs. Ralph Burnham. By 1953, the Burnhams had sold the

Bayport House to a brother and sister, Hans and Katherine "Katy" Rohde. They kept the German theme, and they continued to serve German food. They even added an accordion player. The name was changed, however, to Hans and Katy's. A few small barns remained on the property. As legend has it, Hans and Katy had a grey horse named Hanko living there, which, on occasion, would be led into the bar, where he was given libations.

By 1969, Ursula Weiss (Katy's niece) had inherited the Bayport House, which she continued to run as a restaurant until 1980. The business was then sold to Diana and Willie Calderale, who changed the name to the Bayport House Ristorante. This new restaurant featured fine dining and Italian cuisine—a big change from what it had been for so many years. It is unclear exactly how long the Calderales ran the business, but by 2002, Leda and Bill Sukow were listed as owners of the Bayport House.

The name was finally changed to Grey Horse Tavern in 2007 when Irene Dougal and Linda Ringhouse became business partners and purchased the old inn. They have been running the restaurant ever since, and it features farm-to-table food that is "seasonally driven, locally sourced, handcrafted cuisine using only the best in fresh, sustainable and humanely raised ingredients," as the website boasts.

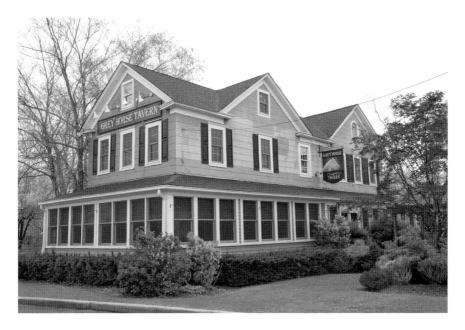

Grey Horse Tavern.

"Bayport is a multi-generational town," began Irene during the interview Joe and I conducted with her at Grey Horse Tavern. "Families stay here forever. My partner, Linda, had a real sense of the community. We were friends for ten years, and we were looking for a location for our business idea. When she found out this place was available, she was just so excited. We were actually looking for something much smaller, but then she called me and said, 'The Bayport House is for sale! The Bayport House is for sale!'" laughed Irene.

Preserving the building's history and bringing it back to its former glory has been of equal importance to creating exceptional food. Before officially opening the restaurant in 2008, Irene and Linda spent ten months restoring the place. They removed the linoleum floors and uncovered old hardwood floors, which they had refinished. The original 1868 front entry doors were found behind a wall that had been hidden by a hutch. The stained glass in the doors was replaced and the wood restored. The interior rooms were painted and scrubbed from top to bottom.

"We spent a lot of time paying close attention to the original historical details," states Irene. "We brought new things in to match the old. We peeled back the layers and let the building tell us what we should do, and it really did. It was really fun—trying, but fun."

Irene continued, "When we realized we were going to be able to take over the space, Linda was very adamant that we bring it back to that community feel. Everybody talks about when it was Hans and Katy's. I always say to folks when they're sharing those stories that we will be so blessed if people talk about the Grey Horse Tavern with the same sort of fondness and memories. This place was where you would go to get a bite to eat. You might stay here as well. I was told by a local historian that there were sixteen rooms upstairs. There was a livery also, so you got your horse and carriage, and it took you to wherever you were going to go from here. Some of the barns remained on the property until the early 1990s; that's when the other part of the property was subdivided."

"Is it true about the horse coming in for a drink at the bar?" I asked.

"I did hear that there were a couple of horses still here in the mid-1960s, and that Hans would occasionally bring a horse in and let him drink at the bar," said Irene. "There is a piece behind the bar that the bartenders use for tips. It's like a silver mug. We found it in the attic when we first opened up, and the bartenders have been using it for their tips ever since. Subsequently, I got a picture that was associated with an old newspaper clipping [about the place], and I'm fairly certain that that's the vessel the horse used to drink out

of. When you look at the photograph, it's quite recognizable, so I believe it's the same vessel."

It's actually because of the story about the horse that Irene and Linda decided to call the restaurant Grey Horse Tavern. Horse-related paraphernalia, including old riding helmets, show ribbons, bridles and halters, is used as decoration throughout the rustic and homey interior, which adds to its charm. The bar area is referred to as the "Tavern Room" and contains a large community table that was made from old barn wood and timbers. Opposite the table is the dark, hand-carved bar. It is believed that the wooden bar hutch was taken from a Vanderbilt estate. Past the bar area is a smaller room for dining. The former wraparound porch has been encased in glass and offers another beautiful, sunlit place to eat. Daily food specials appear on a giant chalkboard on one end. A staircase leads up to a second and third floor that are used for storage and office space.

The conversation quickly turned from history to ghosts. Linda could not be with us on the day of the interview, so I had spoken to her briefly on the phone about her experience. The incident had taken place the day after Linda and Irene closed on the place. With the exception of her dog, which was napping nearby, Linda had been alone working in the tavern during the restoration process. She was lifting up the old carpeting to see if there were hardwood floors underneath. All of a sudden, Linda looked up and saw a bright light coming down the staircase that leads to the second floor. Her dog saw it also, and he immediately jumped up and ran from the room. Since then, many orbs have been photographed in this area.

When we asked Irene if she ever had any experiences, she replied, "Besides Linda, other people on my staff have had some things [happen] that has raised their attention. Me, not so much, although I have had some electronic stuff happen, such as the POS [point of sale] system doing things."

Some employees have claimed that three spirits abound, including that of a maître d' who has been seen holding a towel over his arm. Another ghost has been affectionately named Iris because many people have sensed a female presence in the building. A staff member reported hearing singing in the employee bathroom when no one was there, and doorknobs are known to fall off and break with no explanation at all.

After our interview with Irene, Joe and I decided to roam the building and see what we could uncover. The restaurant was closed, and only a handful of employees were there. We used our recorders, cameras and ghost meters on all three floors and in the basement as well.

Stairs where an unexplained bright light was seen descending.

My ghost meter picked up some kind of energy on the staircase where Linda had seen the strange light. With the exception of that area, the ghost meter remained quiet.

I decided to head back toward the bar where Joe was talking to Kate, the bartender, when all of a sudden my meter began beeping nonstop. The needle was registering very high on the scale, and it led me directly to the second bar stool on the left.

"Joe, I think we may have something," I announced.

Joe, seeing what the meter was doing, said, "Let's set up the ghost box and see if we can communicate with whoever is here."

Through his clairaudience, Joe first asked who was there with us. A few spirits came through, and Joe got the name Harry or Harold from one of them. The man told Joe that he used to sit at that bar stool many years ago. Joe then set up the ghost box to see if we could communicate with him in a more tangible way. Before long, we had communication with him.

Joe: "Hello spirits?"
Spirit: "Spirit."
Joe: "Yeah, answer there."

Spirit: "Hi!"
Joe: "Hey, how you doing?"
Joe: "You like this bar?"
Spirit: "Yes."
Joe: "I heard yes."
Joe: "You know why we're here, right?"
Spirit: "Partly."
Joe: "Partly?"
Kerriann: "We're writing a book."
Joe: "We're writing a book—she's writing a book."
Joe: "Do you miss being on this side?"
Spirit: "Yeah."
Joe: "Yeah."
Joe: "How is Kate as a bartender?"
Spirit: "Hot stuff."
Joe: "Hello?"
Spirit: "Who that?"
Joe: "Hello, hello. How are you?"
Spirit: "Beautiful!"

Communication with the spirits of Grey Horse Tavern had been made. Its history, legends and ghost tales live on.

CHAPTER 8

FIRE ISLAND LIGHTHOUSE

FIRE ISLAND

The Fire Island Lighthouse, which is on the National Register of Historic Places, is located on the South Shore within the Fire Island National Seashore, an area rich in history, wildlife, beach activities and ghosts—at least according to some. All sorts of legends have surrounded this magnificent tower, but lighthouse volunteers deny that there is any truth to them.

The first lighthouse built on Fire Island stood very near the present one. In fact, visitors to the lighthouse can view the ruins of the base of the structure, which was built in 1827. It served as a guide for transatlantic ships, commercial fishermen and recreational boaters, casting its light out to mariners in both the Atlantic Ocean and the Great South Bay.

Just thirty years after it was built, the Fire Island Lighthouse was replaced by a much taller version. Records indicate that the original structure may not have been tall enough for ships to see and that its construction did not stand up well to the wind and salt water. When a Lighthouse Board was created by an act of Congress in 1852, it was decided that improvements would be made to the Montauk Point lighthouse and that a new lighthouse would be constructed at Fire Island.

The new lighthouse was to be seven stories high—168 feet—and it would have a much stronger light that would be visible for at least twenty-one miles out to sea. Construction began in the spring of 1857, and by November 1, 1858, the lighthouse went into operation.

The new structure was built on a stone pier about two hundred feet northeast of the old lighthouse. It was constructed of brick and circular

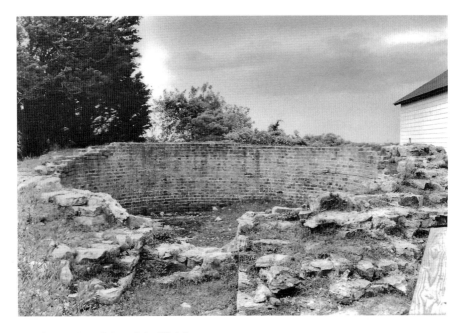

The foundation of the original lighthouse.

in shape, with the walls at the base measuring almost eleven feet thick and tapering to two and a half feet at the parapet. The parapet platform was made of granite with an iron railing, and both the circular staircase and railings were made of iron. Nine platforms and 182 steps were built within the curved tower, and the tower's walls were constructed with air spaces to allow the tower to breathe.

When completed, the tower became the tallest lighthouse in New York State. Today, the lighthouse continues to offer panoramic views of the Atlantic Ocean, the Great South Bay, Fire Island, Long Island, the Manhattan skyline and even the Empire State Building on a clear day.

The original color of the lighthouse was a cream yellow cement wash. In August 1891, the colors were changed to its current black and white stripe in order to be seen more easily.

The lighthouse keeper's dwelling contained accommodations for the keeper, two assistants and their families. The building is now a museum and educational center that explores the history of both the lighthouse and the U.S. Life-Saving Service.

By 1939, the Fire Island Lighthouse was electrified. In 1964, the lighthouse was made more easily accessible when a bridge was built by Robert Moses

over the Fire Island Inlet. For the first 137 years, the lighthouse had only been reachable by boat.

Lightkeeping ended on Fire Island on December 31, 1973, 150 years after it began. Because of the high cost of running the lighthouse, as well as its upkeep, it was decided it would be more economical if the lighthouse were to be replaced by a strobe light installed nearby on the Robert Moses State Park water tower. The strobe light only casts its beams out to the ocean, however, leaving the mariners on Great South Bay in the dark.

Abandoned, the lighthouse fell into disrepair. In 1982, a group of concerned citizens formed the Fire Island Lighthouse Preservation Society in order to save this important part of our maritime history. During the next four years, the society was able to raise over $1 million to repair and save the lighthouse. On May 25, 1986, the Fire Island Lighthouse was relit and its history preserved.

Both lighthouses witnessed several shipwrecks. A famous one occurred in July 1850 during a fierce gale. The five-hundred-ton barque *Elizabeth* was sailing from Rome to the United States when its captain mistook the Fire Island Lighthouse for the Cape May Lighthouse. It crashed along the South Shore, leaving ten people dead. Among them were Margaret Fuller,

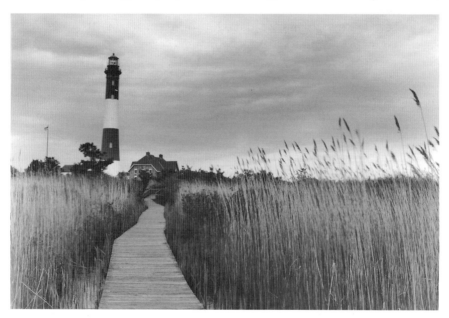

Fire Island Lighthouse.

a well-known writer; her husband, Giovanni Ossoli, an Italian count; and their young son.

In April 1950, a 432-foot freighter called the SS *Hurricane* hit a sandbar while traveling in fog. It landed off Fire Island near the lighthouse. The ship remained stranded for thirteen days, until two oceangoing tugs were able to pull it off the beach.

Sometimes if ships were wrecked in the middle of the night, the lighthouse keeper or the lifesaving crew would find bodies washed up along the shore, along with parts of ships, cargo and fresh fruit.

Tales of pirating also surround the lighthouse. There are stories of pirates who would light large fires on the beach in order to attract ships toward the shore. When a ship would run aground on the shoals, the pirates would take it over and steal the contents. At other times, if pirates heard of a wreck, they would sail across from the mainland to steal anything that might wash up on the shore. Sometimes they would even loot the rescue boats of their cargo.

During Prohibition, illegal rumrunners from Canada, the Caribbean and Europe would make their way through the night, dodging Coast Guard boats, until they landed on Fire Island and its vicinity. In fact, one of the ferries used in recent years, known as the *South Bay Courier*, was once a rumrunner vessel.

The lighthouse itself has weathered its own storms. In 1912, the tower developed a large crack that had to be reinforced. On August 29, 1918, the lighthouse was struck by lightning. The bolt left a one-inch-long hole in the ventilator ball and then traveled down through the watch room. The switchbox connected to the telephone was destroyed.

Then there was the infamous hurricane of 1938. It was September 21 when Long Island's worst recorded hurricane hit. Homes were destroyed and washed away, and coastal areas were flooded far inland. The force of the wind broke through a barrier island and created the Shinnecock Inlet, which remains today. But the lighthouse withstood the storm despite the heavy winds and rains that beat upon it. Throughout all of these events, the keepers of the light were there, keeping their silent vigils on the sea.

The volunteers at the lighthouse laugh when you mention the word "ghost." Although they don't believe the stories, they admit that they have affectionately named one made-up ghost George. Some say the rumor began after a children's book called *Robert's Tall Friend* was published in 1987. Author Vivian Farrell wrote a delightful story based on the life of a boy named Robert Norris who lived with his family in the lighthouse during the late 1970s to the early 1980s. Because Robert lived so far from

his friends, he had to invent his own games and often befriended the wildlife surrounding him. He spent many a day up in the tower of the lighthouse, which also became his friend. Robert came to love the lighthouse, and the lighthouse in turn loved him for taking care of its tower. Soon Robert heard the lighthouse talk to him. Farrell writes in an author's note that not all of the events in the book actually took place and that what is real and what is fantasy is up to the reader. Well, according to lighthouse volunteers, someone took the book to the next level, stating the lighthouse does indeed "talk" because it is haunted by a ghost.

Other stories include the tale of a lighthouse keeper who was so lonely that he hanged himself in the top of the tower. Some people have claimed to hear the sounds of footsteps on the metal stairs, especially during bad weather, while others have claimed to hear music or moaning coming from the tower, and they say that certain doors and windows won't stay shut.

The most popular story has to do with the construction of the new lighthouse and is based on quite a bit of truth, although the name of the keeper during this time does not match up in two different accounts. It is true that Lieutenant J.T. Morton was the project supervisor for the new lighthouse. His orders were to maintain the original tower and keeper's house until the new ones were complete. The new house foundation was being built with rocks, but there were not enough rocks to continue the project. Instead of waiting for a new shipment from the mainland, which would delay completion, Morton decided to use the rocks from the original tower and dwelling. He told the keeper that he and his family needed to move to a wood-frame house on the property so he could dismantle their home.

The lighthouse keeper refused, saying the new house would not be warm enough for his family, especially for his young daughter, who had a lung condition. Morton was determined to finish his project, so he complained to the Lighthouse Board. The keeper and his family were told by the board to vacate the premises immediately. They reluctantly moved into the wooden house, which was quite cold and damp. The keeper's daughter's condition worsened, and she was not responding to medicine. She started running a high fever, and the doctor was called from the mainland. The keeper and his wife cared for the girl for three days and nights, waiting for the doctor to arrive. It is said that the keeper would walk the 182 steps to the top of the light, looking for the doctor. He did not arrive in time, and the young girl died. With nowhere to bury the girl, the keeper and his wife cremated her in the fireplace and put her ashes in an urn. Many have said

that the tower is haunted by the keeper's ghost, who still walks the steps every night in search of the doctor.

The Fire Island Lighthouse Preservation Society and its many volunteers continue to work with the National Park Service, which owns the lighthouse and the surrounding property. The Coast Guard maintains the light, which continues to guide mariners in both the Atlantic Ocean and the Great South Bay. The building is open to the public for tours and events, and visitors can enjoy a beautiful walk across the dunes to the lighthouse via a winding boardwalk.

Is the Fire Island Lighthouse haunted? I'll let you be the judge.

CHAPTER 9

KETCHAM INN

CENTER MORICHES

The first time I met Bertram Seides, president of the Ketcham Inn Foundation in Center Moriches, was at a book signing. He introduced himself and said simply, "I have a great historic property for you to investigate, and it has a ghost." So while working on my second *Ghosts of Long Island* book, I made arrangements for Joe and me to meet him at the property in Center Moriches.

Bert is a walking encyclopedia as far as Ketcham Inn history is concerned, and his energy and motivation toward restoring the place is contagious. He introduced us to Debby Locke, an ambitious volunteer on Ketcham's Board of Trustees. We sat down in the office—a 1950s addition to the old structure that had been beautifully remodeled to serve as a much-needed work space. We were surrounded by black-and-white photographs from bygone days, architectural drawings of the inn and a glass case containing shards of pottery, china and glass that were found on the property during archaeological digs.

As we settled in with our recorders, the remarkable history of Moriches and the Ketcham Inn started to unfold. It began in 1692, when a blacksmith named Samuel Terrill came to Moriches and purchased "one-half of this neck for 23 pounds." What was then called the Paquatuck River became known as Terrill's River.

"Samuel Terrill was probably the first white man to settle here," Bert told us. "We know through archaeological digs that the Indians lived right here. There were thousands of acres, and the Moriches are full of these

little necks; they were very fertile. There were also lots of fish and clams, so the Indians lived off the bay. Right across the street from here is a 260-acre preserve where the Indians had their campsites. It's now the Terrill River County Park."

"Hardly anyone was living here during the years Samuel Terrill owned it," said Debby. "In 1714, he sold the land to Sarah Conkling of Southold. She was from a wealthy family, and she raised cattle here for the seventeenth-century trade between Long Island and the West Indies. She had outlived her husband and was very old, so when she died in 1753, the land, then known as Warracta Neck, was given to her son Thomas. He quickly sold it to John Havens Jr., his nephew."

Benjamin Havens, one of John's brothers, was said to have run a tavern and inn here during the American Revolution, when Long Island was under British occupation. Oddly enough, Benjamin Havens was married to Abigail Strong, the sister of Anna Strong—the heroine in the Setauket Spy Ring chapter of this book. Benjamin had also been very good friends with Caleb Brewster, another one of General George Washington's spies in the famous ring.

In 1772, Benjamin Havens proposed a stagecoach route, which ran from Brooklyn through Moriches to Sag Harbor. This greatly increased business at the inn. A distinguished guest, New York governor George Clinton, stayed there in 1783. He would not be the last of the famous people who spent a night at the inn.

Havens sold the inn to William Terry in 1791, and it became known as Terry's Hotel. That same year, Thomas Jefferson and James Madison stayed there while visiting General William Floyd.

For sixty-one years, the Terry family ran the hotel, tavern and farm. After William, his son Samuel ran it, and then William's grandson Nelson took over. In 1852, the Terrys sold the hotel to a Huntington man named Andrew Ketcham. By 1854, a local court was held there, and the hotel was also used as a voting station during elections. The property remained in the Ketcham family for the next sixty years and was primarily run by Townsend Valentine and his wife, Matilda, both of whom farmed the land and took care of the inn and tavern. It was during the Ketchams' ownership that the inn became an ideal central location for many more public gatherings. During the Civil War, men of the Life-Saving Service were paid here and Civil War volunteers came to practice drilling on its grounds.

"Ketcham has always been a public house," Bert told us. "Any big building two hundred years ago that had two chimney stacks could definitely handle

a guest. People would just come and knock on the door. The location of this building was convenient for that sort of thing…coming from Riverhead and points west. When they established the stagecoach route, they would stop here and then continue on to Sag Harbor."

The building changed hands a number of times after the Ketchams' ownership and eventually became a restaurant, a tea shop and even a women's shelter. It was probably best known during the time of the Ketchams' ownership, hence its name.

What is both remarkable and unique about the construction is that this five-thousand-square-foot structure was actually built in five separate stages, not including the 1950s addition. The early part was built about 1693 and was the original cottage, dating back even before the Moriches Bay area was officially settled. This particular part is quite small and has a large hearth at the north end. It was called the "summer kitchen" from about 1852, during the Ketchams' ownership.

The first addition, which doubled the size of the cottage, was added circa 1700. About 1710, a separate structure was built in front and to the west and was turned into a beautiful two-story house. It contained a second-story parlor, two small bedrooms and an attic. It was enlarged once again about

Back view of the Ketcham Inn, showing the settlement cottage on the right.

1754, when a second two-story structure was added on the building's east side. This addition included a dining room on the first floor and a ballroom and attic upstairs. The last of the 1700s additions was made circa 1790, providing additional sleeping quarters and attic space.

In 1950, a commercial kitchen was built for what was, at that time, the Stage Coach Inn. This is the area now converted to office space for the Ketcham Inn Foundation.

Few people know that the Ketcham Inn, filled with so much history and architecture from many periods, came close to being destroyed. But thanks to the perseverance of one man and perhaps some help from a few spirits, the inn and its history have survived.

"I'm the son of a farmer, here in Center Moriches," Bert told us. "My dad had a mink farm, so we knew all the farmers. Then I moved to East Moriches, to a wonderful old house. I love to see the evolution of buildings." Bert Seides is an architect as well as a historian, and when it came to saving the Ketcham Inn, he was a man on a mission. "By the time I was old enough to know the building was significant, it was really past its heyday. I had always heard stories about it," Bert added.

"Before KIFI," Debby said (referring to the Ketcham Inn Foundation, Incorporated), "it had been a women's shelter. There were women and kids living here, and someone started a fire."

Twenty-three people were inside when the fire broke out at 3:00 a.m. Luckily, everyone survived; apparently a child had been playing with matches and set fire to a couch.

"I was devastated when I drove past and saw that it had burned," said Bert. "There was damage—it was scarred and it was ugly. [The damage] was primarily in the dining room, and then the fire went out through the ballroom floors upstairs and kind of went around," Bert explained.

"Two years prior to the fire, there was a 'for sale' sign, and I had come to see the building," Bert continued. "Everything was neat enough, and there were people in the house. I just perused window frames, trim and fireplace mantels. Everything was pretty much buried behind layers of carpeting, paneling, false ceilings, but I read through all that and I couldn't believe what I was seeing, that this was a home—a shelter."

Bert said, "That first time I was here, I was very taken by the house. And when I went out the front door—that's when I had my first [paranormal] experience. It was very intense." Bert paused, recalling what had happened. "I had energy waves go through me that I've never experienced before, and they didn't stop. I just couldn't believe the emotional waves going through

me. It was really intense, and then it slowly dissipated as I walked away from the house. But for a few minutes I just stood there and had this amazing experience."

"What went through your head when you were experiencing this wave of energy?" I asked. "What did you think it was?"

"I don't know, but I felt a strong connection to the house," Bert answered.

"Did you feel anything else or hear anything?" Joe asked.

"Well, there was heat. I felt very warm. I felt—enveloped." Bert searched for the right words to explain the experience. "I was almost overwhelmed by the nature of it, and I didn't share that with anyone for a long time. But then, two years later when I was driving and I saw the inn had suffered a fire, I became hysterical. It was an inn, it was a tavern, it was a public house, a mail drop, a coach stop—this was really the heart of Moriches, and that is why I was so desperate to save it."

Bert continued, "When the building was rendered uninhabitable, many people in town wanted it gone. I asked for help from other organizations, but they didn't want any financial connection. That didn't stop me, though many people thought I was off my rocker," Bert smiled. "Basically I started knocking on a lot of doors, and I started to network. New York State Parks had grant programs for acquisition of historic properties, but you have to be a not-for-profit. So in 1989 we applied, and the Ketcham Inn Foundation, Incorporated was formed in December of that year. The objective of the foundation was to buy the one-acre property and preserve the building. Then we were told that the building had to be on the State and National Register. We applied for those simultaneously, and as luck would have it, they came through," Bert smiled.

"We did a lot of yard sales. We'd rent tents, and I would tell everybody, 'Bring whatever you have,'" he went on. "We had cars, boats, everything, because we had to match our grant. We also took on a massive undertaking to clean up the house. The outside was completely overgrown. I came in with crews and cleaned the place up. For a long time, I was kind of out there alone—yeah, there were wonderful supporters, but now we have people working here who really connect with the place."

I asked, "Did you ever think, 'What did I get myself into?'"

"I never vacillated in my feelings for the building," Bert replied. "I have wonderful people here and a wonderful board and volunteers. We have people coming every weekend who show interest. We've had people who lived in here for years—previous owners who've come back, who have told stories—people who got married here back when it was a restaurant. In

1997, we stopped doing yard sales because we acquired a barn and had it reassembled on the property. It's known as the Book Barn, and it's open on Saturdays and Sundays from 10:00 to 4:00; we sell used books. This is one of the ways we make money now."

At present, only the "summer kitchen" (the 1693 structure) is open to the public on a limited basis and to school groups. The rest of the inn is under complete restoration and is only available to architects and historians. It is Bert's goal to make the inn a living history museum in conjunction with a cultural center that he hopes to build on land across the street, which he has saved from becoming a strip mall.

Before long, our conversation turned from history to ghosts.

Debby revealed to us her own interesting experience. She has a twin sister, and they both had experiences at the Ketcham Inn, independent of each other. "At one time, in order to put lights on in the Book Barn, you had to run a cord from the house to the barn," she began. "To do so, you'd have to go in the makeshift door into the inn. Now, I think it happened to me two to three times. I'd open the door and hear a snatch of music—just a little tiny bit. It happened to my sister, too, but we didn't mention it to each other for months. Then we found out we were both hearing it. Because there are some trailers over there in the back, I actually came back outside and listened, to find out if anybody had a radio on."

"So you heard it that clearly?" I asked.

"Yes," Debby said without a second thought. "It was old-time music. It wasn't this century, but I'm not familiar enough with music from the 1700s and 1800s to be able to identify it, so I couldn't figure out what it was. After this happened a number of times, I mentioned it to my sister, and she said, 'Oh, that's happened to me, too.' The music was definitely not of this century. That's what's strange about it."

We asked Bert what his opinion was as far as ghosts were concerned, and he said, "I'm open to things. The more open you are, the more experiences you have. As far as Ketcham is concerned, when I'm in it, I'm comfortable. I think if there are any spirits around they know it's okay. The house is being taken care of. I can walk through the building in the dark—I'm never bothered at all."

We walked over to the Book Barn, where Mary Field, author and local historian, told us stories conveyed to her by Gladys Fenner Rogers, the great-granddaughter of Townsend Valentine and Matilda Ketcham.

Bert explained to us that Gladys was a woman who had lived next door. She was very sharp until extreme old age. Bert had asked her several hundred

questions, which he wrote down, pertaining to the inn and her family, and she happily answered every one of them. Mary Field, who has been with Bert and the Ketcham Inn since its early grassroots days, spent many a day with Gladys while she was alive. In between serving customers in the Book Barn, Mary told us what she knew.

"I haven't seen or heard or felt the ghost, but the girls who were doing the archaeological dig years ago said that they felt a presence and saw sort of a 'wisp' go by, and then it got very cold. I wasn't there on the day of the dig, but I did tell them the story about the ghost of the young girl who's supposed to be here," Mary said.

"There were two stories I heard," she went on. "One was about a young girl who was getting married, and she wanted to look at her trousseau. She fell while holding a candle, and she burned to death in the house. The other story was that the father didn't approve of the marriage, and he killed the groom. These stories were from early on, because the Ketchams came here in 1852, and I think it was before that time that the stories originated."

Mary continued, "The one from the Ketcham family said that at one point they were preparing a feast and plucking chickens and ducks. The feathers were on the floor, and a little girl in the family started playing with them. The girl got too close to the fire, and the feathers and her clothes caught fire, and the girl burned to death. That was the story the Ketchams used to tell," Mary added. "We had a psychic here once who told us it [the spirit] was a young girl with long blond hair, and that she [the ghost] was happy to see that we were restoring the inn."

I asked Bert about the medium who came to the Ketcham Inn. "We did have a medium here once," he answered. "We had invited him to do a reading—it was a fundraiser. He conveyed stories about a young blond girl who was pleased to see what was going on here. He also said that there was something buried on the site, but that was all. We've found wonderful shards of pottery, glass and china during our digs, things like that. About ten years ago, under the floorboards of the 1710 addition, I found one single child's shoe, as well as parts of other shoes in bits and pieces. It's unclear whether it was for a boy or a girl, but it had holes for laces. It appears to be nineteenth century but needs to be researched for authentication and period."

Some people might not think twice about finding a shoe under the floorboards, as odd as it is, but Bert decided to do some research on the matter. He found numerous articles written about "concealed shoes," and he gave me copies of them.

One article read:

Little is known about the tradition of hiding shoes, called concealments, in the walls of old houses. It was a custom brought to America by early settlers, mostly from England. Often only a single child's shoe was hidden…Shoes have been discovered in houses dating back to the 1600s…Historians think that people may have hidden shoes for protection and good fortune. Many people of the 1600s and 1700s believed that spirits came into houses. What could stop these spirits? A shoe molded to the shape of its owner's foot. If the shoe was hidden near a place easy for spirits to enter, such as a chimney or window, the spirit might think it found the shoe's owner and leave the rest of the house alone.

Another article, "Concealed Shoes and Garments," revealed the following: "Here we may have a similar principle to the witch-bottle, fooling the witch/spirit that the person is there in the chimney. It was probably hoped the shoe would trap the spirit or act as a decoy of some sort. The location of shoes often either within or near the hearth, does suggest some kind of protective function."

The shoes found at the Ketcham Inn were hidden under the floorboards but were also found very close to the fireplace. The finding does indicate, then, that their purpose was more than likely to ward off spirits coming in or out of the chimney.

From the Book Barn we walked back to the Ketcham Inn office with Bert and Debby. Bert brought out a binder with every piece of information he had ever found having to do with the Ketcham Inn. He showed me snippets of papers having to do with the ghosts.

The first was a write-up in a pamphlet or menu from around 1930. Back then, the inn was called Tea in the Tap Room, run by a woman named Matilda Knox. Five paragraphs had been written about "The Old Tavern." They began by recounting the inn's history to date. The third paragraph read:

The ghost story, that tradition has handed down, making the old Tavern still more interesting, is told of a young girl, one of the Inn Keeper's daughters, who the night before her wedding, took a lighted candle into the spare bedroom to see the feather beds that had been made for her, tripped over a rug and dropped the candle, setting fire to the feather bed and before help could reach her she had been burned to death. Now in the dead of night, they do say, she walks thru [sic] the rooms always carrying the lighted candle.

Bert then found the actual questions that were given to Gladys Fenner Rogers. One of the questions pertained to the ghost. The story is very similar to the one told to me by Mary Field. These, however, are Gladys's own words:

> *It* [the fire] *was in the kitchen* [the 1693 section] *and was caused by a child (girl) playing with feathers around that brick stove that held two huge iron kettles. She set her clothes on fire. The feathers were from chickens being prepared for her sister's wedding. The story was told to me by my grandmother, who said the child's father was driving home from some place, and every time he passed a cemetery he felt strange. When he got home his child was dead.*

Before we toured the inn, Bert gave me the names of two women who had ghost stories of their own to tell. Within a week or two of our visit, I touched base with both of them. The first, Pat, was a longtime volunteer for KIFI who helped run the yard sales. She vividly remembered an experience she had had several years ago.

Over the phone, Pat told me, "I was standing in front of the inn. I felt as if somebody was there. I turned around to look and didn't see anybody, but in my mind I could feel the presence, which allowed me to see an image. It was the image of an Indian. He seemed tall, well built, he was bare-chested—no shirt—and he had Mohawk hair with one feather in it. He looked majestic and regal. It wasn't frightening; it was actually calming, so I felt it must be good. The Indian went to the back. There was a door, and he had to bend down to enter. He went inside, and that was it."

At the time, Pat had no knowledge of the Indian camp that had once existed across the way. She did mention that in the past she has had premonitions of things—feelings, or a sense of things. The Indian's image was so clear to her that she actually drew a sketch of what she had seen shortly after it happened. It was the only time Pat ever had an experience like that.

The other woman, Barrett, told of very different experiences. She had actually lived in the house from 1946 to 1955, from ages four to twelve. During a phone interview, she said, "My father repeated this story time and time again, and I remember overhearing it. He used to say, 'I'm not superstitious at all. I've never believed in ghosts, but once you've been haunted, then all your old belief systems disappear.'"

She then revealed a chilling tale:

On the western end of the house, upstairs, there was a sitting room where my father would read late at night. At times while in there he would be overcome by a depth of sorrow—feelings of despondency, as if you lost your last friend, I remember him saying. After this would happen, he would hear the distinct sound of the late seventeenth- or early eighteenth-century drop latch on one of the side doors—you know, the kind where you press your thumb down and it unlatches. Anyway, many times he actually saw the latch go up, and the door would open. Absolutely no one was there. He was astounded when this happened. Now I have to tell you—my father was a great intellectual. He graduated from Harvard. He was kind, happy, stable and balanced. What he saw was against what he believed. As soon as the door opened, he would get a terrible chill, one that would go right past his neck.

It happened to one of the upstairs doors one night. I remember that I was sleeping, and I woke up to all this commotion. At that point, I heard the door unlatching. I will never forget the sound of that. The mechanism made a loud noise. Even after we moved, my father never got over what he experienced. He never had anything happen again. I've never had anything happen to me, but I am somewhat open to it. All I remember is having wonderful memories of my childhood in that house, but I will never forget the sound of that door latch.

When Joe and I were back at our respective homes, I called Joe to tell him I had captured the image of the little girl who may have died in the fire. Her apparition appeared in an upstairs window. I had also picked up several orbs in the earliest part of the house, the "summer kitchen." Joe then revealed that he, too, had gotten three orbs in the 1754 section of the house. Joe emailed me a fascinating EVP. It had occurred while we were on the second floor in the area that once was a ballroom.

This is what was heard in the recording: We were all talking. Joe said, "Wow, this place is huge." Debby said, "How many square feet is it, Bert?" Meanwhile, I can be heard in the background saying other things about the room. Bert answers Debby, "I think about five thousand square feet." Joe says, "I'm getting a chill now. It's amazing." Right after he said this, a spirit voice of a man could be heard loud and clear. He sounded like an old-fashioned announcer or emcee. In a booming voice, he said, "For Miss Emerald!" It was quite startling to hear.

It seems that the Ketcham Inn is quite active with spirits. All good spirits, we believe, because they picked Bert Seides to not only preserve a history that otherwise may have been lost but also to watch over and protect their precious inn, which had been visited and lived in by so many people.

CHAPTER 10

FIORELLO DOLCE BAKERY

HUNTINGTON

Fiorello Dolce, an upscale bakery located in Huntington Village, is owned by classically trained French pastry chef Gerard Fioravanti. The bakery offers a wide variety of delectable French and Italian pastries, tarts, pies, cookies and cakes. What many people don't know is that Fiorello Dolce is also a hot spot for spirits.

I've known Gerard for several years, and the amount of paranormal activity that has taken place in his bakery is simply astounding. It is consistently active, and Gerard has lots of video footage to prove it.

When Joe and I did an investigation at Fiorello's a few years ago, Joe made contact with some of the spirits who seem to hang around there. One was a black man named Eddie, and he told Joe that he had been murdered nearby in a drug-related fight.

During the 1900s, the area where Fiorello Dolce now sits was a group of ramshackle row houses that apparently housed town workers. The area was said to have been one of the poorest areas in Huntington. Wetlands surrounded the houses. Around 1974, the buildings were demolished, and fill was brought in so that the stores and parking lot could be built. The little strip has seen a variety of restaurants, bakeries and an Italian pork store over the years.

A friend of Gerard's is a longtime resident of Huntington and a bit of a local historian. He had done some research after our investigation, and he found out that a black man had in fact been stabbed there some thirty years

before. It had been drug related, and the man's name just happened to be Eddie. Having no prior knowledge of this, Joe's connection with the man was validated. For reasons unknown, Eddie hangs around the bakery.

Other spirits visiting Fiorello Dolce include some family members and friends of the staff. Pastry chef Meg's grandfather likes to watch her work, while Gerard's partner Steve's mother likes to play with the kitchen timers. One particularly active spirit is believed to be the old landlord who had passed away.

Spirits, unlike ghosts, can communicate with us and can come and go as they please.

These spirits can sometimes make a commotion, especially when they're trying to get your attention. Gerard has actually heard his name being called on several occasions when no one else is there. Pastry carts have rolled on their own, oven doors have mysteriously opened, buckets have fallen off shelves in the kitchen and a wispy figure has been seen flitting by. Most of the activity seems to take place at night when the bakery is closed. Within minutes after Gerard has locked the bakery, the kitchen comes alive with spirits in the form of orbs and light stick laser beams. All of these incredible images have been captured on Gerard's surveillance camera. It's as if the bakery has become a vortex for spirit activity.

I decided to go back to Fiorello Dolce to re-interview Gerard and find out what else had taken place there since Joe and I did our investigation. Gerard had found out some additional information on some of the spirits, and he was eager to share his stories.

"So, you've had a lot of activity going on here lately," I said while taking a sip of my espresso at the counter of Fiorello Dolce.

Gerard smiled, "I had two employees, Meg and Kristy, coming through the front door at 5:30 in the morning. I wasn't there yet. [On the surveillance camera] you could hear them coming in with the chime of the door, and you could hear them talk to each other for a second. The camera also picks up the voice sounds in the kitchen. You hear a big, loud sigh. I don't know where it came from. Maybe the spirits were annoyed they were coming in so early," Gerard laughed.

"They're here," he continued. "That same day, a couple of hours later, someone whistled at Kristy in the refrigerator, and she got so scared she came running out, saying, 'Oh my God! Someone just whistled at me in the refrigerator!' Kristy went back in and she said, 'Don't whistle at me,' and she heard a grunting noise. So somebody was hanging out with them that morning."

Fiorello Dolce bakery surrounded by orbs.

Gerard paused and then said, "At the end of the night, the kids help us clean up the store, and for some reason they left a roll of paper towel on the table [in the kitchen]. I came in the next morning, and I noticed that the roll was completely unraveled about two times, and it was standing up. It was in the center of the work station. I checked the surveillance camera, and it looked like someone was actually pulling on it, pulling a sheet off."

Gerard showed me the video footage, and sure enough, you see the paper towel slowly start to unwrap. The air conditioning unit was ruled out. No air

blows on that area, and the motion was precise. The sheets went all the way back and then came all the way forward, as if someone was gently pulling it.

Gerard went on to explain how he had met another medium who gave him some additional information. Like Joe, she picked up on Eddie and several of the staff's departed family members, including some of Gerard's relatives.

"My aunt came through, Aunt Angie, who passed away years ago. She's always here at the bakery with my grandmother, taking care of the front of the store and keeping customers out of the kitchen," Gerard laughed. "Steve's mom, grandmother and father came through, and Meg's grandfather is like her guardian angel. It's pretty crazy. So we have family members that are here."

The medium picked up another spirit, Gerard's previous landlord named Charlie. Charlie's daughter is the new landlord, and she takes care of the property. The medium said Charlie was relentless, wanting to get through to Gerard.

"He was ninety-two when he died," said Gerard. "He was my landlord from the beginning. He was very happy that we were here. He loved French pastries."

"So he hangs out here?" I asked.

"Yeah, he hangs out here," Gerard laughed. "He loved this property. I don't know why, but he always loved this property. Even when he was in an assisted living place, he'd have someone drive him here. He'd come into Fiorello's and just talk to me, and he'd ask me how I made everything. It was kind of nice, but he was always on top of you. He'd say, 'Oh, let me tell you how to make it.'"

"Was he Italian?" I asked.

"Yeah, he was Italian. He'd come back in the kitchen and say, 'I show you, I show you. You make it like this.' He always wanted to make things his way," said Gerard.

"Charlie is back now," I said.

"That photo you took, I think that face [in the orb] is Charlie. It kinda looks likes him. I think Charlie is that laser stick orb [that appears on the surveillance camera]. It looks like a glow stick. It's about six to seven inches long, and it zips around. I think Charlie is responsible for all the little things that are happening in the bakery kitchen—when a knife falls and slides across the table, when the spatula would rattle, when the rolling rack would move, when the parchment paper would come flying out of its compartment, when the spoons fall. There are a ton of little activities that go on here. I think

Charlie is responsible for most of that. As for Eddie, I think he chills in the back of the store. We have a mixed bunch here," said Gerard. "I did see Charlie's daughter one day, and I told her we think Charlie is here. She said, 'I wouldn't be surprised. My dad loved this place.' I told her, 'Please tell your dad he's welcome here but not to help us out. Please tell him to go home with you.'" Gerard laughed.

"It's nice because spirits can come and go," I said. "If heaven is a perfect place, they can come and visit us. It's not the old belief, 'Oh my God, they didn't make it to heaven, get the priest.' It's not like that. They're in heaven, but they like to come and visit and help out, and this was a place that made Charlie happy."

"It made him very happy," replied Gerard. "It was a little frightful at times because things were happening, and we were like, 'How did that happen?' or 'Who's doing this?' It took a while to understand and to figure out all these spirits who are here."

There still remain a lot of spirits whom they don't know. There are times when hundreds of orbs can be seen on the surveillance camera.

"There are some mornings, and you can ask my chefs, we're looking at it and there are a TON of orbs," states Gerard. "I mean hundreds, like

A magnification of an orb with a face inside the bakery.

an orb-pede," he laughs. "They're all coming across. I'm thinking it's more like the lost souls of the world, and they're all following one another, and they don't know where to go. You see some bright light orbs appearing on the floor, in the center of the store and in the kitchen. They're sort of just passing through."

"There is such good energy here though," I commented.

"When you and Joe came, he felt a lot of good energy here, and so did the other medium who came. We do feel protected," said Gerard.

"I do think the spirits like it here. Maybe they're coming for an almond croissant or your flourless chocolate cake," I said.

"You even said it yourself," said Gerard. "Hey, if you died, would you want to live here with all the wonderful smells and cakes?"

Whatever the case may be, the spirits of Fiorello Dolce seem happy, and they are there to stay.

CHAPTER 11
WINFIELD HALL

GLEN COVE

No ghost book would be complete without mentioning Winfield, because it has long been public knowledge that the house is supposedly haunted. I knew that getting into Winfield would be a challenge. The building has been abandoned for several years and is on private property, and I was unsure who owned it. I decided to take my chances one afternoon and drove over to Winfield in Glen Cove.

I pulled my car under the large stone archway and saw the infamous no trespassing signs on the tree-lined drive ahead of me. I sat for a moment wondering what to do. I decided to take my chances. Something told me to proceed. I drove along the winding road and could see the mansion in the distance. As I drove toward it, I saw a car parked under the carport. I got out of my car and approached the house hesitantly. An older gentleman got out of the car under the carport and looked at me quizzically. I told him who I was and about my interest in Winfield. I handed him a business card and waited for him to respond.

He talked to me for a few minutes about Winfield without introducing himself. He seemed like a kind man, and he was dressed as if he had just put in a full day of manual labor. Finally he told me that he owned the place and that his name was Martin Carey and that his brother had been a governor once. I was shocked.

"Governor Hugh Carey?" I asked. "Are you his brother?"

He nodded and smiled. "Would you like to take a look at the place? I can give you the ten-cent tour."

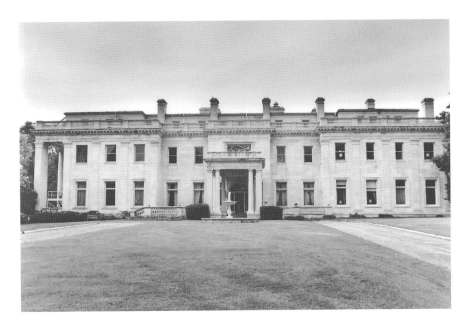

The Winfield mansion.

I was elated. My timing couldn't have been better. Mr. Carey has been spending much of his time painstakingly restoring the building with the help of only five men. He had been getting ready to go home after a long day of work when I arrived.

Mr. Carey opened the large set of doors, and as we entered, my breath was taken away by the beauty of the solid marble staircase, constructed almost a century ago. Every aspect and detail of it was exquisite.

Winfield Hall was built in 1916 for five-and-dime store mogul Frank W. Woolworth. Woolworth was not from a wealthy family. It is said that his mother believed he would be a very rich man one day, but Woolworth began as a clerk who earned only $3.50 a week. Through extremely hard work, vision and perseverance, he eventually became a multimillionaire.

It was Woolworth's dream to own a magnificent Gold Coast estate on Long Island. Around the turn of the twentieth century, he purchased a large piece of property in Glen Cove and moved into a Mediterranean-style stucco mansion. In 1916, a fire destroyed most of the house, and he was forced to rebuild. Rumor has it that his wife, Jessie Creighton Woolworth, set fire to the drapes in the house during a fit of rage, but there has been no evidence to support this.

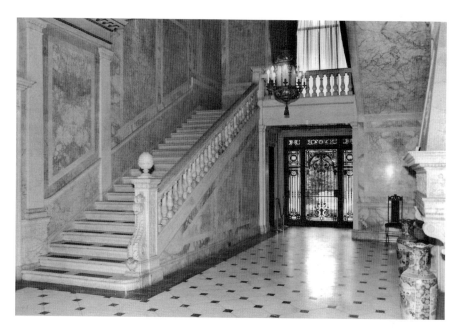

Winfield's marble staircase.

Woolworth decided to erect a unique marble palace on the site of the original home and hired C.P.H. Gilbert to design it. He spent approximately $9 million on the house, with $2 million going into the entrance foyer's marble staircase alone. It was one of the most costly staircases ever constructed and one of the most expensive houses ever built.

The house contained fifty-six rooms on three floors. A brass light fixture in the entranceway hung from an ornamental plaster coffered ceiling that was trimmed in blue and fourteen-karat gold leaf. To the right was a Georgian dining room with elegantly carved paneled walls. Also in the room were two magnificent sterling silver chandeliers, French wicker furniture and an all-glass solarium with a marble fountain.

To the left of the foyer was the grand ballroom, which contained a seven-foot-wide crystal and gold chandelier that hung from a fourteen-karat-gold vaulted ceiling with intricate detailing. Along the back wall in the center of the room was a sixteen-foot Italian marble fireplace, ornately decorated with angels and mythological beasts. Opposite this wall was an enormous hidden pipe organ, which Woolworth had for entertaining his guests.

The rooms upstairs were absolutely unique. Each one was named for a famous person in European history. Woolworth's room was called

the Empire Room or the Napoleon Room and was an exact replica of Napoleon's bedroom in his palace in France. The Empire-style gilt-carved circular canopy bed was said to have belonged to Napoleon. It has often been asserted that Woolworth was obsessed with the famous French general and actually had a Napoleon complex. Most of his furnishings had the letter N carved in the center. Other stories mention that he really believed he would return after death as a reincarnation of the French ruler and that he may have dabbled in experimenting with time travel.

Among the fifty-six rooms, various others were called the Empress Josephine Room, the Elizabethan Room, the Louis XVI Room, the Gothic Room and, one of the most famous and haunted rooms in the house, the Marie Antoinette Room. Woolworth also had a billiard room, a Ming Dynasty room and a gilded music room.

Elsewhere on the property were a sixteen-car garage, a King Neptune statue that stood in a decorative pool, marble Roman statuary throughout the property, fountains, two limestone gazebos, a greenhouse and formal gardens similar to those found in Rome.

No expense had been spared in creating Woolworth's dream mansion. Unfortunately, only two years after it was completed, Woolworth died in his Napoleon bed in the Empire Room. The cause of death was reported to be septic poisoning due to an infected tooth. Woolworth was said to have had an enormous phobia about dentists and had absolutely refused to have the tooth taken care of.

Frank W. Woolworth was buried in a $100,000 Egyptian mausoleum in Woodlawn Cemetery in the Bronx. However, the structure was not completed until a year after Woolworth's death, and where his body was temporarily stored is not known. There are mysterious stories surrounding his death. Woolworth was very interested in Egyptian history, and it is said that at some point he may have brought back an Egyptian sarcophagus, although it has never been found. Winfield contained many secret tunnels and rooms throughout the house and basement. Some say that Woolworth is actually buried in the sarcophagus in some secret room in the house that was sealed up upon his death in 1919. Rumor has it that a sarcophagus brought back from Egypt is cursed and brings bad luck. Did the sarcophagus actually exist and was Woolworth secretly buried with it and sealed away, never to be found? The answer to this remains a mystery.

Mrs. Woolworth was also on the strange side. Unlike her husband, she was not enamored of the limelight. She was very reserved and quite matronly in her looks and behavior. Some say she was not of sound mind,

while others have stated that Woolworth mentally abused her. Supposedly she was not allowed to leave her room often. Unlike the other ornately decorated bedrooms, Mrs. Woolworth's was quite plain and ordinary, and it was the only room in the house without a name or connection to history. Mrs. Woolworth died in 1924, five years after her husband, but whether she died in the house is not clear.

A family crest, designed by Mr. Woolworth when the house was built, hangs in the Main Hall above the fireplace. It shows Woolworth in regal form on top, wearing a plumed warrior's helmet. Mrs. Woolworth is directly beneath him, oddly wearing a steel helmet that covers her entire face. Below them are the Woolworths' three daughters, Helena, Edna and Jessie. A very large crack runs through the face of daughter Edna. Apparently, on one occasion while Mr. Woolworth was entertaining some guests in the music room, a storm suddenly broke out and a bolt of lightning mysteriously struck the mantel in the Main Hall, causing the crack in the crest. Most bizarre, however, is that Edna took her own life that same night. There are conflicting stories as to where she actually died. One states she died at Winfield and wasn't found until the next morning. Another claims she died in a Park Avenue apartment in the city. The exact place of her death is unknown, but many people believe it may have occurred at Winfield. Supposedly, Edna is one of the ghosts who haunts the place.

After the deaths of the Woolworths, the house was closed up for many years. In 1929, it was purchased by Richard J. Reynolds and his wife. Mr. Reynolds converted Woolworth's garage into a laboratory, where he created the first aluminum foil. Mrs. Reynolds remained in the house long after her husband died. She had kept everything the way it had been when the Woolworths owned it. However, she kept the Marie Antoinette Room permanently locked, claiming it was always cold in there even in the summertime. It is said that Mrs. Reynolds believed the house was haunted by the ghost of Edna Woolworth. The apparition of a girl appeared to her many times, walking through the formal gardens on summer evenings.

By the early 1960s, Mrs. Reynolds could no longer keep up with the needs of a mansion of this size, and she moved out, selling it to the Grace Downs School for Girls. Winfield soon became known as the Glamour Manor. All sorts of strange happenings were reported during this time. A cook from the school claimed to have seen an apparition of a young girl appearing regularly in the gardens. Many of the girls attending the Downs School also claimed to have seen a girl wearing a faded blue dress.

Even during the girls' school years, the Marie Antoinette Room remained locked and off limits. Sometimes girls would sneak in there through a secret door and passageway that connected to the room. On one occasion, a girl smuggled her boyfriend into the house and went through the secret doorway. During the night, she awoke to see the vision of a woman wearing a blue dress. The woman stood before her crying. The ghost then told the girl that soon she would be joining her. Two months later, the girl was killed in an accident near the house a few days before graduation.

A secretary who worked in the school, and who had stayed in that room a year later, said she was attacked by bees and was given some sort of upsetting message. Two weeks later, the woman died of heart failure.

In 1975, the girls' school closed down, and the house was put up for public auction, along with all of its contents. The bidding on the house, which originally cost $9 million to build, was to begin at $400,000. Many people attended the auction, but no one bid on the house. The taxes were $62,000, and not many people could afford it.

Several months later, Andre Von Brunner and Martin Carey became partners, pooling their money and purchasing the sixteen-acre estate. Von Brunner lived there for a while, although he traveled for long periods of time, and Carey stayed on as a silent partner.

During the time Von Brunner was there, so was author Monica Randall, who lived with him. According to her book on Winfield, sounds of voices were often heard at night, along with a woman's sobbing, murmurs and whispers. The chandelier in the Main Hall occasionally would swing, the organ would sometimes play a note or two and sometimes footsteps could be heard walking up the stairs. More hidden passageways, along with wall safes, were discovered by them, and a coldness was felt in the house, similar to a feeling of being unwelcome.

A friend of Ms. Randall's who was a psychic, numerologist and astrologer in New York City visited the house on several occasions. She claimed the house was also haunted by Mr. Woolworth himself. She stated that his presence was very strong and that he did not want to let go of his possessions. During her stay, she had used a recorder and recorded the rhythmic sound of a human heartbeat.

After Von Brunner sold his share of Winfield and moved back to Europe, Carey kept the house and leased it for many years to the Pall Corporation. Millions of dollars were spent restoring the estate. The Pall Corporation left the premises around 1995. A learning center for seeing-eye dogs occupied the space for two or three years until Winfield was abandoned again.

Carey continues his restoration project, and much work still needs to be done to bring it back to its complete former glory. The house is listed on the National Register of Historic Places.

Carey's "ten-cent tour" turned out to be very exciting. I had taken a step back into history, into the lives and mysteries of people from the Gilded Age. It had been the chance of a lifetime.

Note: This story was originally written for *Ghosts of Long Island: Stories of the Paranormal* in 2006. In January 2015, Winfield caught fire. At least 30 percent of the building was severely damaged, but it was limited to one side of the mansion. It is estimated that it will cost millions of dollars to repair and that some items lost are irreplaceable.

CHAPTER 12

SETALCOTT CHIEF GAIL REVIS

STRONG'S NECK

The Setalcott Indians once called the area north of Setauket *Minasseroke*, which means "Island of the Wild Huckleberries." It was in this place, now called Strong's Neck, where we took a spiritual journey with Setalcott chief Gail Joyce Revis, whose Native American name means Joy and Happiness of Running Water.

It was a beautiful July morning when Joe and I were to meet with Margo Arceri, vice-president and trustee of the Three Village Historical Society and president of the Strong's Neck Civic Association, in the St. George's Manor Cemetery. It is the burial place of the Strong family and has a rich Revolutionary War heritage. Chief Revis's ancestors once roamed the area in search of game; what better place to gather and speak of spirits and the afterlife?

As I came through the cemetery's wrought-iron gate, I saw in the distance a most spectacular sight: an Indian in traditional garb. On this day we were to have the privilege of spending time with the newly appointed acting chief of the Setalcott tribe.

Making my way among the tombstones, I saw that Joe and Margo had already arrived. Chief Revis was holding a small smoldering pot, and Joe was turning slowly in a clockwise circle. She was saying something to him as she waved a steady stream of hazy smoke in his direction. In a clearing on the ground behind them was a very large hand-painted canvas; on it lay a turtle shell, a large piece of hollowed-out log and a hawk feather. Sensing my approach, Chief Revis turned slowly. With a slight nod and a faint smile, she said, "Welcome."

Her outfit was made of split elkhide, and it was elaborately decorated with sea pearl, also called glass trade beads. Chief Revis had hand-sewed the beads to the elkhide with horsehair. Strawberries symbolize the pathway to heaven in the Algonquin language, and the color red signifies the blood of life. The yellow "Y" outlined in red and black means, according to Revis, "You don't ask why; you understand and obey." The color black signifies entering into death. Her beaded headdress was flanked with the feathers of a red-tailed hawk. Chief Revis was born under the Indian sign of the red-tailed hawk, which, as Algonquin legend claims, is the thunderbird.

She turned toward me with the billowing pot and said that before we began the interview, I was to go through a smudge ceremony. I recognized the scent as sage, and she explained that it is different from cooking sage. This type of herb is from the Midwest. It was to cleanse me of any negative spirits and to protect me on life's journey. I was told to slowly turn clockwise while Gail gently wafted the smoke around me. She then asked me, Joe and Margo to join her on the canvas. As we settled in, she said, "There are tribes that will enter and go counterclockwise, and that is because they are not afraid of Death. In the Hopi tribe, he is the clown, and in the Midwest he is the coyote—so it is the trickery of life and death."

Gail paused and then said, "The artwork on the canvas you're sitting on is called the medicine wheel." It had been carefully painted by her. "I use it as a teaching tool. Everything has a plant; we take medicine from the plant…it has the moon that would be represented in the Aztec calendar." She pointed as she went along. "The medicine wheel has pictures of the four seasons, the four elements, the four directions—north, south, east, west—and then it goes to the twelve months.

"The animals represent the elements. For example, the butterfly represents air. The medicine wheel is like a maze. You're walking into the maze and within it. It [life] will go back and forth, back and forth."

She continued, "When you're a newborn, there's always a chance of dying. When you're a youth, there are possible accidents—you climb a tree, you break a leg, accidents that make humans closer to death. When you mature, childbearing brings you in and out, hunting brings you in and out. In old age, you're mentally in and out until you go. Then out of death comes life. The medicine wheel represents this journey.

"So at that point," Gail continued, "you call it birthright that you pass your entity on to the next person. It is the same for us. A spirit passes to the next person. But there are places and times that no one is there to collect

Setalcott chief Gail Revis.

those entities. Who are they? Where are they? Will anybody ever collect them?" She paused to let us think this over.

"Sometimes," she went on, "that's what you call 'hauntings.' They're looking for someone to attach themselves to or to send them in the direction they need to go.

"When you go to a hospital," Gail pointed out, "whatever your belongings are, they look for a family member to pass them on to. So I don't call them 'ghosts'; I call them entities—that, or birthrights that are looking for the person who they're supposed to introduce themselves to and pass on their knowledge.

"The knowledge of good and evil is not put out there on a level that makes sense to children," Gail continued. "To them, it is nonsense. We talk of spirit; we talk of ghosts. Children today laugh at the spirit world."

Joe responded, "But when they're first born they're closer to the spirit world."

"But they cannot speak it," Gail said. "That is part of the protection of 'the veil.' If everybody could see through the veil, there would be no death."

We sat again in silence until Gail continued. "I don't have a concept of death. I can wash a body, knowing it's going to die and prepare it for its 'death,'

95

as you call it. I call it a journey of the soul. Is it dead? Nothing is dead. No matter what you do, that tree will have atomic energy, pulsation," she said, pointing. "There is a negative and a positive constantly beating. If you make a table out of it you'll still have movement in that piece of 'dead' wood, so is it really dead? No. There is always a structure of atoms combating, negative and positive. How much? How fast? That is another story."

Gail's great-great-uncle had been a medicine man. "He decided I would be taught the secrets," she told us. "I've been trained as a medicine woman since I was five. That's due to a vision that I had at that age. It was my first one." Collecting her thoughts, she said, "I grew up in Nassau County, and an Irish woman, Mrs. Hahn, lived next door. She would let us [Gail and her siblings] play with her kittens. She would bring us homemade cookies and donuts. She made a little table for us behind the barns. We fell in love with her. She was so kind to us," Gail smiled, remembering.

"One day I was at the window of my mother's bedroom, and I said, 'Look at the parade.' My mother said, 'There is no parade, Gail.' I said, 'Yes, there is. I can even see the bagpipes; they're going down the road.'" Gail paused. "Well, Mrs. Hahn had died—and that was my first vision. So my parents took me to my great-great-uncle, the medicine man. I described my vision, and he brought out the smudge pipe. I said to him, 'What is that?' He said, 'This is to protect you.' I said, 'Protect me from what?' He said, 'From all kinds of things.'"

Gail continued:

> As a medicine woman, I've buried my brother, my father, my mother, my uncle, Ted Green, the last chief. This is our responsibility when someone passes on but is very close to a clan. You honor them in the proper manner of Native Americans. My first service as a full medicine person was my brother. I stood before my father and said, "If this is what I was being raised for, I think I would have turned away." My brother was in his forties when he died. He was very sick. I watched him dwindle, and we spoke many times before he passed. During one of his last visions, he said to me, "I know this is not a reality, but I am looking at a bear." He was at Nassau County Medical Center, somewhere up on the fortieth floor. He said to me, "I know there is no bear that tall, but I can see it outside my window." And I asked, "Is he growling? Is he eating?" and he said, "No." I said to him, "Then the bear is not for you." My brother had been an acolyte as a boy. An acolyte is like an altar boy. We were raised Lutheran, so they were called acolytes. I told my brother, "Remember the spiritual life

of an acolyte, and your journey will be safe." It is the light—they are the keepers of the pure light. They're the ones that walk in with the smudge pots at high service. In other words, I told him to go back to the pure times, when his spirit was pure.

My job is to cleanse them and to prepare them for death. When my uncle was dying of cancer, his question was whether he should go for his third blood transfusion. I told him that the transfusion would only prolong the dying. I asked him, "Do you want to die at home like the old ways? If you get this transfusion and your body is not strong enough, you will die in the hospital and they will service you there. You must decide. God is going to come for you, and when He comes it does not matter where, but you have the choice now to go home and wait for Him to come for you there." On the day of his transfusion, he called me at home and said, "Gail, I'm not having the transfusion," and I said, "Oh…then you will be prepared."

We waited intently to hear the rest of the story.

I put the red ribbon to the window, which represents the blood of life. I put feathers at the window to gather the spirit, and the day that he passed on, I was called within three minutes. I was there to wash his face before the undertaker came. Washing the face is a purification of cleansing and re-baptizing. We call it the re-baptizing of the elements—you are the earth, now you need the water. When you brush a person you are bringing air, and as you see, we need fire to open the smudge. So all four elements are present. Those are the four pillars of Heaven. If you take any of those elements away—if you take the earth away you have no place to stand. If you take air away you cannot breathe. If you take away water, which we are 90 percent of, you will not exist. If you take away the Father and the Son, it becomes a dead planet. Those are the four pillars of Heaven.

We sat quietly, taking it all in. Then Gail turned to me.

"I'd like to tell you about my second vision," she said. "If you write about it, it will be the first time my vision has been written down." Gail thought the timing was right, since she recently became chief of the Setalcott tribe. It was time for people to know of her vision.

"My visions have to do with the past, present and future," she began. "When I turned sixteen, I had the longest vision of my life. At the time, I didn't know how to control what I had seen. I was a Lutheran then. I was in high school, in the eleventh grade. I was in the classroom, but I was no

longer seeing the teacher. I was seeing the death of my first husband. That was my first vision."

Gail had not even known who this person was; she did not know until the vision came true years later.

She continued:

> I couldn't stop seeing what I was seeing. I could hear the teacher at the blackboard, but I couldn't see her. I kept seeing this vision of a man's death, and I didn't know who he was. The vision becomes my reality. We call them "vision quests." We wait for young people to "see." Sometimes it is their second naming of who they will be. They're sent into the wilderness to the point that, out of hunger, you go into subconsciousness and then you "see."
>
> The purpose of the visions is to see who you really are, inwardly, without the outward material world of food and water. There is a spirit there. And in the spiritual world they say you need no food, no sleep. But I did not have to go out into the wilderness to "see." It just came to me.
>
> So, at five, I see my first vision. By sixteen, I had the strongest vision. I told the teacher I didn't feel well and asked to go to the nurse. I never went to the nurse's office. I was like a blind person. I went to a phone and tried to call my mother. I couldn't reach her, so I called a taxi. I heard the horn beep. I knew where the front of the school was, and I got in the taxi. But don't ask me how I got across the street, because he parked on the other side, yet no car hit me.
>
> He drove me home, and I walked to the back door. I heard my mother preparing lunch. I said, "Mom, I know you're at the refrigerator, but I can't see you. I'm going to sit in the kitchen chair, because I know where it is." I was temporarily on the other side of the veil. It has made me a stronger person. So I sat at the kitchen table, and I described it to my mother. Now, in the 1960s, they were doing testing for sixth sense and other things, and my mother said, "If we take you to a psychologist, they'll test you and put you away." I didn't think I was that badly off, but I knew this wasn't right and I didn't know how to stop it. So she said, "Do you want to go to a doctor or to the priest?" I said, "I think this has more to do with the priest."
>
> We had been in his church from the early 1950s. I sat and talked with the pastor, and I was telling him of my vision and how it was going. He told me that it was not something to be afraid of because even Joseph had visions. That calmed me down.

Margo asked Gail, "Did that vision come to pass?"

"Oh yes," Gail replied. "It was filled about seven or eight years later."

We all wondered how and when this vision finally ended.

Gail said:

> *Even after meeting with the priest, the vision was still going on. I thanked him for his time. Then I got back in the car with my mother, and I told her that the vision was not stopping. I said to her, "If it does not stop, I am going to die."*
>
> *We went to a Dr. Young, who was a Haitian doctor. I told him exactly what I told my mother. I said, "Dr. Young, I can hear you but I cannot see you."*
>
> *He said, "What do you see?"*
>
> *I said, "Things like a 35mm camera flashing through my mind. It is just clicking like a camera."*
>
> *He asked, "Do you want it to stop?"*
>
> *I said, "Yes."*
>
> *He said, "Get on a train. Can you get on a train? Do you see the train?"*
>
> *I said, "Yes."*
>
> *"Look out the train window," he told me.*
>
> *It was the same thing as when you sit on a [moving] train. Everything was flashing by. He said, "Stop the train." I stopped the train and got off. It worked. You have to be the one to stop it. You have to decide if you want to be in this dimension or the other. I did have visions after that, though, where the concept of the train did not work. At that point, it got to be mind over matter.*

"Gail," Joe interjected. "Do you consider yourself a master teacher—an old soul—a spirit that's here for more than the sake of living here?"

She answered:

> *I would put it to you this way. So many of my native family and elders and people before them have given up hope of being native. Because of that, there are ancestors who are looking for people to absorb their essence, people who will speak to them and who will recognize them. My brother would say to me, "You are an old, wise Indian." I would say, "No. I am your grandmother, I am your great-grandmother, I am your great-great-grandmother and many more before her. That is who you speak to—the essence. You do not speak to the young woman, you speak to the elder."*

So yes, I believe that many a person has died, and that birthright was not passed on, hand to hand, or element to element. They look for someone to speak their name and take the essence.

Gail stopped and looked at us, hoping we were taking in the knowledge she was sharing.

When you think of birthright, you're not passing on your riches. You are passing on the knowledge of God. People today think when their mother or father dies, "I'm going to get the house, or the car." They're thinking of the material, not the spirit of birthright. They think they control the material wealth of the birthright, but in the biblical sense of birthright, it is the spirit. You don't miss the spirit; you, as a human of small mind, miss the flesh. It says in the Bible, "Don't chase after the flesh," but that's why we cry. We say, "I miss her, I can't touch her, I can't see her, but oh, I smell her. I know that scent." You'll see someone grab an old article of the parent, and they'll smell it and say, "Don't take that. I'm smelling Mom."

Gail paused. "What are they trying to do?" she asked us.
"They are trying to get the essence of the person," Joe answered.
"Yes," Gail replied.

It's because of our simple minds that we don't see the whole picture. I enjoy creating my own pictures, with all of the knowledge. Those are my visions now. If I want to know something, I can just sit there for a while, and it comes to me without opening a book. As I've gotten older, I questioned, if there were only so many people in the original time [the beginning of time], then those are the original birthrights. Let's say there were only ten thousand people, if even that, and now there are billions of people. Are there enough birthrights to go around? I see people with a dullness in their spirit, a dullness in their eyes, and I think, "Ahhhh, they've never received." Some hold the ancient ones, but there are only so many of them. There are only so many original spirits. But yet we have new ones. As the Catholic Church says, "You are worthy of becoming."

"Young souls," Joe said. "Young souls that live in the flesh."
"Yes," Gail responded. "Children see all of them [the spirits]. But because they do not have the language, they do not speak of it."

"But that's not a limitation of the soul," Joe added, "that's a limitation of the body."

"That's because we're not supposed to know everything," Gail explained.

"Why are people afraid of death?" Joe asked.

"The unknown," Gail answered. "Or some people don't have the spirit of elders, of wisdom. If people are introduced to death properly, they have no fear of dying. Everyone that I have attended to who is ready to die, you let them know that this is okay—you're not going to be alone. Some people talk of 'out-of-body experiences'—they saw so-and-so who was dead, or you hear those getting ready to die say, 'I see so-and-so standing over my bed…I talked to so-and-so the other day, but I know she is dead.'" Gail paused. "You hear all these things. Why? How can you be alone then? You can't be alone if they've already come. They've already started to come."

CHAPTER 13
KATIE'S BAR

SMITHTOWN

Besides the Amityville Horror, Katie's Bar in Smithtown is probably the most talked about and publicized haunted location on Long Island. Ghosts and spirits abound at this small and popular nightspot. Paranormal activity occurs on a regular basis and is seen by dozens of eyewitnesses. Katie's Bar has attracted the attention of ghost investigators everywhere, including those from popular television shows like Travel Channel's *Ghost Adventures* and A&E's *Paranormal State*.

Joe and I set out early one morning to interview Katie's Bar owner Brian Karppinen and bar manager Meagan Flaherty. The bar was closed, and no other people besides the four of us were there—or so we thought.

We pulled up some bar stools, sat with glasses of seltzer and prepared our recorders for the interview. We were quickly amazed at just how much activity has taken place there over the years.

Brian Karppinen felt he was called to own Katie's Bar. He took the business over from a friend who was struggling to make it work back in 1999. Brian helped run it for a while until his friend asked him to become partner. That soon led Brian to obtaining full ownership of the place. He changed the name from Wolfgang's Pub (a German bar) to Katie's Bar, which was named after Brian's great-grandmother Katherine "Katie" Donegan. Brian's family had owned two Irish pubs in Harlem and several others in Ireland, so Brian wanted to keep and honor that tradition.

Brian put his heart, soul and money into the business and made some major renovations, including moving the bar, which was actually located in

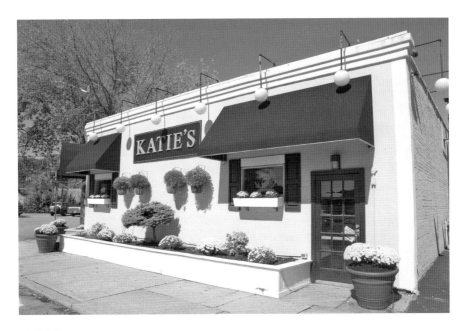

Katie's Bar.

the middle of the room. Before long, Katie's Bar was up and running, and Brian's dream of owning his own Irish pub became a reality.

We asked Brian, who is also a musician, how he would describe Katie's Bar.

"We have the best live music around and the best sound. Our strongest point is our music. That's what's been keeping us alive," says Brian.

Brian hopes that he will eventually be able to sell food, but for now, drinks and music are in order, and they're open every night of the week, with live music at least three to four times a week.

Our conversation quickly turned to the history of the place and, of course, ghosts.

"This used to be the location of the Trainor Hotel," began Brian. "It burned down on December 5, 1909, at midnight. It was located here, and the train station was next door. We don't know if people died. We feel that maybe some of the darker energy that's in the basement may have something to do with that fire. This place is built on that foundation. I did not know that when I took over this place. I was doing some construction, and that's how I found out."

Brian continued, "No one knows how it burned down, and we're not sure how long it was there prior. It's rumored there was a makeshift hospital on

the grounds before that, maybe mid-1800s. A lot of times when things are getting spooky and creepy, you'll smell smoke."

"Charred smell?" Joe asked.

"Yes," replied Brian. "It [the present building] was a convenience store, a soda place with rumors of bootlegging and a cigar place. A lot of people also claim to smell cigar smoke here. Then it became a bar named Bishops. It also was a real estate agency, a welding supply, a telephone company, a hairdresser, and that's just some of the places. The really cool thing that I found was an old storefront from one hundred years ago, hidden by an old stockade fence which was up against the building and covered in poison ivy. It was the old entry to the building," Brian said.

He continued, "Early on I had three bartenders, three girls who all went to school together. Sorority sisters. They would always see a guy walk right through the men's room door, like it wasn't even there. And I'd say, 'Why is that guy haunting the men's room?' It turns out he was just leaving."

"Because that's where the old entrance was," I added.

"That's not a spirit," said Joe. "That's a traditional apparition of a ghost. There is a distinction between spirits and ghosts. A ghost is a remnant, like a video playing over and over. It's residual. The door doesn't exist anymore, but the entrance used to be there. A spirit is a person who passed who can actually communicate with you on cue."

Brian said, "My old partner who had the building before me was always told the place was cursed. That it had a dark cloud over it. I wasn't going to put up with that. You can't beat up a spirit, but I'm not backing down. I used to be a bouncer," he laughed.

Several weeks later, I was at home transcribing the interview by hand. As soon as Brian had made his remark about not backing down, a man's voice could be clearly heard saying, 'You win!' I was in complete shock. It was that audible—a class-A EVP. There was absolutely no other person in the bar with us who could have said that. The comment could not have been more fitting at that moment. It was truly incredible.

Getting back to our interview, I asked Brian if he believed in ghosts.

"Yeah," he replied. "Ghost stories are bedtime stories in the Irish culture. I'll tell you about Charlie the ghost. In the early days, I used to have psychic fairs downstairs. Three women asked if they could rent downstairs. They had a good business going, and they wanted to do the fairs. They had been taking a break in between customers and were having lunch. All of a sudden, all three of them said, 'Do you feel that? I'm getting Charlie.' So they asked me who Charlie was. I said I didn't know. They said, 'Well, you got a guy

named Charlie here,' and then word got out. We're famous for glasses flying, so people will yell, 'Charlie' when it happens. Stuff like that."

Brian continued, "So around 2007 [the people from] *Paranormal State* come in. They went to the library and met with the town elders and the town historian. They were looking through all these historical documents. One of them asks, 'Does anyone know anything about a guy named Charlie?' and the town historian says, 'Yeah, Charlie Klein. He lived across the street from Katie's in a white house he bought in the 1940s. He killed himself. He was a bartender.'"

"A bartender here?" Joe asked.

"No, this wasn't a bar at that point. We don't know, but he did own the place next door, and that's where he apparently killed himself, although some documents claim he did it at the Smithtown Hotel," said Brian. "A lot of people feel that we have some kind of connection to Charlie Klein."

Charlie Klein's death certificate and an old newspaper story confirm that he committed suicide in 1933. Apparently Charlie was afraid of going to jail because he sold a drink to a man in the federal government during Prohibition.

All kinds of phenomena have occurred at Katie's Bar. On several occasions, the police have come by because motion detectors have been set off in an old stairwell. When the area is checked, nothing at all is there. Voices can also be heard, something Brian calls mimicking.

"I had a manager named Dustin, and every time he walked in that door he'd say, 'Hey man.' I'm hanging around here one day, and I hear, 'Hey man.' I'm thinking Dustin is here. I look out the window, and it turns out he's getting out of his car. He wasn't here," said Brian.

Chairs have moved, and wine glasses have gone flying. Wine glasses have flown right off the rack on the wall, and it's been captured on numerous videos, which can be viewed on Katie's Bar's website.

"When I first came [here] I saw the video and I heard people talk about it for years," says manager Meagan Flaherty. "This past year I actually watched the glass physically fly three separate times. I'm like, 'Are you kidding me?'"

Meagan and Brian demonstrated for us how and where the glasses flew off. The glass comes to the edge and stops and then smashes into the sink.

"The patrons have seen this as well?" I asked.

"You see people actually jump off the bar when it happens," says Brian. "It happens now with bottles as well."

"What's interesting about the bottles," states Meagan, "is that it was here, behind other bottles," she demonstrates. "And somehow it would come up

and over. Both times it happened while I was on shift, and I would turn back around, and a bottle I knew was up there," she points, "would now be on the floor and would need to be cleaned up."

"A lot of bartenders actually feel like somebody walks up to them and touches them," adds Brian. "It's as if they're trying to get past them, and they're like, 'What the hell was that?'"

"It's happened to me," said Meagan. "You go to move out of the way behind the bar, and nobody is there. It feels like someone is there, and then I see something out of my peripheral vision."

Brian told us a story about a bouncer he had hired who was very sensitive to these things. On several occasions, he almost quit. He was constantly hearing voices downstairs when no one was there. Another time he left Katie's Bar, and when he put his truck in reverse to pull away, in his rearview mirror he saw a little boy with a Dutch boy haircut sitting in his back seat and then disappear. This happened twice in the same night.

"He was very upset," said Brian. "He believed the boy came from here. The thing is, I've seen this boy before. I've seen the boy with the Dutch boy haircut. People have gone downstairs and take pictures, and then they come up to me and say, 'Who's this little kid?' There he was in the photos."

Another figure has been seen crossing the street almost every night. It turns out it may be the ghost of a man who got hit by a car under the bridge several years before. He apparently came through to patrons who were using a Ouija board at Katie's one Halloween night.

"Another guy who used to do my website was doing work here at three in the afternoon. He goes out to his car, a sunny day like this, and he puts down his computer, puts his car in reverse, and he locks eyes with a guy sitting in the back seat," said Brian. "He wore a tall black hat and a suit. He turned around, and he was gone. He called me from the parking spot, frightened out of his mind—three on a sunny day."

"I do get scared," said Meagan. "I don't like going in the basement, and I won't go down and get ice by myself."

"Another thing, you'll hear the drums," said Brian. "Somebody will tap the drums, but there is nobody there."

"Have you experienced anything on your surveillance cameras?" I asked.

"Oh, yeah. We get tons of orbs," said Brian. "The ghosts seem to come in cycles. Certain ones seem to come and go. We've done clearings. It works for a little while."

Brian continued, "People come [here] from all over the world, and people find a lot of activity here. We're not here to debate anything. Still, to this

Katie's Bar basement with orbs.

day, there are some people who don't know about the place. Then you'll get knuckleheads that say, 'Come on! Come on!' They want to see something happen. Then they'll say I made it up for publicity. I'm not that creative, and it's too much work. Places like *Paranormal State* get thousands of submissions, and they're going to pick me?"

After our interview, Joe and I spent time roaming around the building, both upstairs and downstairs. My electromagnetic field indicator was registering very high energy levels no matter where we went. I captured a few orbs around the stage area, but I received many more and much larger orbs when I photographed in the basement. As our time at Katie's came to an end, we told Brian and Meagan about our own discoveries and thanked them for sharing their stories with us. It is clear that for reasons unknown, Katie's Bar in Smithtown still remains a hot spot for ghostly activity.

CHAPTER 14

GOURMET WHALER

COLD SPRING HARBOR

Main Street in Cold Spring Harbor may be one of the most haunted streets on Long Island. The old buildings and shops have seen the likes of whalers and travelers during a time when the harbor was a bustling port. There were so many people passing through that the main thoroughfare became known as Bedlam Street.

Through the years, many of the shop owners have reported inexplicable happenings that have occurred in their stores. Although dealing with the unknown can be a bit spooky at times, most of the merchants have learned to live and work harmoniously with their ghosts.

One such place is the Gourmet Whaler. At the time I did this interview, it was called Gourmet Goddess, and the story appeared in my book *Ghosts of Long Island: Stories of the Paranormal*. Its owner, several employees and even a past owner were more than willing to speak to me about the ghost they call Lillian.

Lillian Feldman was a student at the famous Cordon Bleu culinary school in France sometime during the late 1940s or early 1950s. Rumor has it that she did not graduate because she refused to kill and cook a rabbit. She left France, headed back to America and settled in Cold Spring Harbor, where she opened up a gourmet store in 1953.

Everything she sold was homemade, and she became successful. Everyone knew Lillian's store, and she was very fond of the old stove she used for baking. By the 1960s, she sold the business for unknown reasons, leaving the stove and other items behind. In 1970, a man named Richard Simmons

bought it and brought in a partner named Bob in 1972. (It was actually Bob's father who had purchased it originally from Lillian.) For thirty-one years, Gourmet Delights was a well-known business in Cold Spring Harbor. By 2001, its owners were ready to pass on the business once again, this time to Barbara Esato, who changed the name to Gourmet Goddess.

Throughout all these changes in ownership, some of Lillian's things remained. These items were her old stove (now used as a decoration in the store), some old scales, several apothecary jars, an old chewing gum machine and an old cash register. The owner and her staff were convinced the store was haunted by the ghost of Lillian Feldman.

One employee named Pat said, "She's here a lot, and things fall a lot."

Another employee, Gloria, told us that just that day, while she was downstairs, the basement door to the outside swung open. They always keep it locked, so she thought someone had gone outside to take out the trash, but nobody had. "No one was there," she said. "Now when these things happen we think nothing of it."

Thomas, who has worked for Barbara and the last owner, said, "I'd be working late over the holidays, and I'd be downstairs with Bob. You'd hear people walking around upstairs. We'd come running up thinking someone was in the store, and there would be nobody here."

Thomas also recalled several incidents where items would mysteriously fall off the shelves.

Barbara and Gloria mentioned that the footsteps are the most common occurrence. "I'm always in the basement," said Gloria. "Most people don't want to stay down there alone," she chuckled.

"Occasionally I've heard the oven door slamming," Thomas added. "You attribute it [the noises] to 'Oh, it's an old building.' One time I turned around quickly, and from a distance it looked like someone, like a shadow, was crouching down and opening up the stove. It occurred in the early morning when only one person besides me was in the store. It's that—the footsteps—and the items falling off the shelves."

Barbara is a very friendly and vivacious person. On two separate occasions, frequent customers were passing the shop after closing time. Both claimed to see Barbara in the store, and when they waved, she didn't wave back. They thought this was odd, since Barbara had always been so friendly to them.

When questioned about the incident, Barbara replied, "It wasn't me. I wasn't in the store at the time, and I told them that."

Before purchasing the business, Barbara told us that Bob mentioned to her that the building came with a ghost. Having been both a science major

Lillian's stove, where her apparition may have appeared.

and a science teacher, Barbara is a practical person, and she simply blew off the possibility. If a ghost did exist, it was the ghost of a previous owner, and a female, she heard. It wasn't until Barbara started experiencing events herself that she started to think twice about the ghost.

"I would be downstairs, and I would hear footsteps upstairs. It was after hours, and I thought maybe I locked someone in the store. I'd go running up, and no one would be there. Another time I was working with Patty before the store was open. By the women's hat room we heard a woman's voice very clearly. We couldn't talk because we were so frightened. It seemed loud, but we couldn't hear what she was saying. Our hearts were pounding, our mouths were dry; we couldn't speak."

Probably the most unusual event occurred in her first or second year in business. "I'll never forget. It was a Friday morning. I had a bunch of French music CDs set up in the player. It was Parisian bistro music, and I had two or three CDs on that day. The CDs ended, and before I could go over and turn them back on, the cash register started ringing up on its own. Once I put the music back on, it stopped ringing."

Barbara told us that that incident only happened once. The footsteps and things falling off the shelves, however, are a regular occurrence. "I'll come in

in the morning and find broken jelly jars or tomato jars. This happens a lot downstairs. She's definitely more active when everyone goes home."

Because of the events that have occurred in her store, Barbara has become more of a believer, and so have her employees. "I have a lot of practical people who work here," she said. "We all have witnessed the same things."

It is believed that Lillian was a heavy drinker, and according to Thomas, he had heard that she passed out and died in the basement of the shop. However, in a telephone interview with past owner Richard Simmons, he said that Lillian did, in fact, sell her store in the 1960s and moved to Florida, where she eventually died of natural causes. "She didn't die in the basement," he stated.

Richard said that during his years in the gourmet shop, not much went on. He never saw anything, but supposedly two of his employees claimed to see apparitions. The only things Richard remembered were hearing footsteps upstairs when the store was closed.

"I was there alone a lot, especially during the Christmas season. I never saw anything, but I did hear the footsteps," he said. "Another peculiar thing was that every once in a while, things would fall off the shelf upstairs.

Gourmet Whaler.

I don't really know if it [the building] is haunted, but some of these things can't be explained."

"It's become a joke for us," said Barbara. "Anything that happens, we say, 'Oh, Lillian's here.' I always hear my employees saying that. They just take it in stride—if it is her."

Barbara concluded, "I think she's happy, and I think she approves."

Today, the store is owned by Chef Shawn Leonard and has been renamed the Gourmet Whaler. Shawn and his partner, Constance Olson, claim things have been quiet at the Gourmet Whaler as of late, although Constance can't explain the time when someone tapped her on the back. When she turned around, no one was there.

DEEPWELLS FARM

ST. JAMES

Deepwells Farm, a magnificent Greek Revival home in St. James, went through its share of hard times. At one point, it was known as the scariest house in all of St. James. Entering the graceful home today, which is owned by Suffolk County and run by the Deepwells Farm Historical Society, one would never know the hardships the house has been through.

It was built circa 1845 for Joel L.G. Smith, a descendant of Richard "Bull" Smith, the founder of Smithtown. Joel Smith purchased the property on which the house stands from Gamaliel Taylor, another member of the Smith family. The original plot was about fifty acres and was a working farm, complete with outbuildings. The only outbuildings still in existence today are a nineteenth-century well house and laundry house and the Caretakers House, located at the corner of Moriches Road and North Country Road. The Caretakers House is owned by the Village of Head of the Harbor.

Joel Smith did not live in the house very long; records indicate that a man named George Pullis owned the property by 1858. Less than fifteen years later, Milton H. Smith owned the property, and upon his death, Clinton Smith, secretary of the New York City Parks Department, inherited it. He rented it to William J. Gaynor, mayor of New York City. Mayor Gaynor, who loved raising pigs, was so enamored of the property that he purchased it for a summer residence and winter retreat. It is believed he named the estate "Deepwells" because of the two 125-foot brick wells on the property.

Mayor Gaynor, known as the city's "Most Independent Mayor," served from 1910 until 1913. He was considered a very strong candidate for

Portrait of Mayor Gaynor at Deepwells.

both governor of New York and president of the United States, but an assassination attempt early in his first term ended all hope of achieving these positions.

It was August 9, 1910, when Gaynor and his son Rufus boarded the SS *Kaiser Wilhelm der Grosse* out of Hoboken, New Jersey. Gaynor was planning to vacation in Europe but still had with him three city commissioners, his corporation counsel, his male secretary and a few friends. A photographer from the *New York World* also happened to be on board. As he went to take a photo of Gaynor and the group, an unidentified man jumped in next to the mayor, pressed a gun to the back of his neck and pulled the trigger. The photo of Gaynor getting shot became one of the most famous yet rarely seen photographs in photojournalism history.

The gunman was James J. Gallagher, a disgruntled New Yorker. He had been fired from his job on the New York City docks and blamed Gaynor. Gallagher was subdued by a former Princeton football player until the police arrived. Meanwhile, Mayor Gaynor was rushed to St. Mary's Hospital, where he remained for three weeks. Surgeons who worked on him were unable to remove the bullet from his throat. It remained there for three years, and although Gaynor stayed in office, he suffered greatly. He died of complications from the shooting in 1913 aboard the steamship *Baltic*, six days into what he thought would be a restful vacation.

About 1920, an attorney, Winthrop Taylor, began renting Deepwells; he purchased it from the Gaynor estate in 1924. The property remained a working farm, although Taylor's interest was cows, not pigs. He turned it into a dairy, which became quite well known. Before World War II, however, Taylor sold his cows. In 1956, the barn and milk house burned down, but Taylor lived in the house until his death in 1975.

Taylor's son Jeremy, who had no interest in the estate, inherited it. He had plans to develop the property, which had been originally zoned for commercial use, but after Winthrop Taylor's death, the village decided to rezone the land. Jeremy sued the village to allow commercial building.

After ten years of legal wrangling, the zoning was upheld. Disgusted, Jeremy abandoned the house and property. All maintenance stopped, and the house began to fall apart. Deepwells' fate became uncertain.

Joe and I met with Scott Posner, president of the Deepwells Farm Historical Society (and a skeptic as far as ghosts are concerned), and he gave us a tour of the old mansion. He was proud to show us what the house is today—a well-known cultural showplace in St. James that has become an asset to the community. We began our interview in the large parlor.

"Mayor Gaynor did a lot of entertaining out here," Scott told us. "This whole area [St. James] was really a hot spot for entertainers from New York City, mainly vaudeville acts. While most houses from this period were saltbox style," Scott continued, "this one was quite grand, with its soaring ceilings. All the moldings and cornices are original, as well as the large mahogany staircase. It didn't always look this great, however. It went through some difficult times. When Winthrop Taylor died and his son Jeremy wanted to develop it, the town wouldn't let him, so he walked away from it."

"What happened then?" Joe asked.

"Well, people started coming here, and soon it was taken over," Scott replied.

"Squatters?" Joe asked.

"Lots of them," replied Scott. "It was very unkempt. You can see the pictures on the second floor of what it looked like. There was a motorcycle gang here at one point, and they would go up and down the stairs with their motorcycles. It was a complete wreck inside and out. You wouldn't believe it. I remember driving by here for years, when you couldn't even see the house—it was completely overgrown. We were all wondering, 'When is a fire going to happen to get rid of that place?'"

"It was the scariest-looking building I've ever seen," Scott said emphatically. "It was one of those places not even teenage kids would go into. During the last five or ten years before the county took it over in 1989, even the squatters gradually left. It had become completely uninhabitable. Fortunately, through state grants and the aid of the county, they were able to restore it to what it is today. The county took it over in 1989. The amount of work that had to be done here was beyond massive. It took two and a half years to clean it up. It was like building a house all over again. Almost everything had to

be repaired or replaced. The weird thing is—these are plaster moldings," Scott said, pointing toward the ceiling. "If you look, even the cornices where the lights are—I don't understand how they survived. They all did, and the staircase also. They needed some repairs, but they're all original. I don't know how that was possible. And these are the original wood floors. It's just amazing how well the house stood up from where it was."

Joe commented, "Sometimes when there's so much love in a house prior to that, the energy of the people who were there is enough to help the house survive."

"I don't really subscribe to these things," Scott replied, "but I do believe that there's something going on here now that's very powerful, and there's some amazing vibes, for lack of a better word. Every week we do a podcast from here of live acoustic recordings, and it's put on the Internet," he explained. "We have ten thousand listeners a week, and at least one hundred people come out for this. We have created a new community of entertainers and artists here. There's an incredible sense of community now. So you're getting a whole room full of artists every week, and they create a lot of energy."

"This is a very busy house," Joe observed. "I can feel the energy." On the white noise created by the air conditioning unit, Joe, through his clairaudience, heard the footsteps of people. "Lots of people," he said. "Like the house was just filled with people. I also hear the voices of people milling around."

"Well, like I said, I am skeptical," Scott replied. "There have always been rumors about it [the house] being haunted. Someone who once worked for the county used to say that she wasn't alone in the house. She'd say, 'The ghost is there,' referring to the third floor being haunted."

"Skeptical people are the most credible, because they don't 'believe.' It's good to be skeptical and not subscribe to everything that's out there," Joe commented. "But what you see and what you feel is intuitive."

"The only thing I do know," said Scott, "is that I hate being here at night alone. That's all I can tell you. It's a spooky place at night. It's quiet. It feels lonely. It feels like there should be forty or fifty people here."

Lightening the moment, Scott laughed and said, "It's definitely haunted at Halloween. We decorate the place like you wouldn't believe. We have a Halloween parade in town, and it ends here. We make a graveyard; there are people dressed up as characters. The kids love it." Scott added, "The Deepwells Historical Society has two missions: to share the house by getting people here and fundraising. The chamber of commerce helps run a number

of the special events here, like the Fall Festival on Columbus Day weekend. We get a couple of thousand people for that. In the summer we do movie nights. We put up a big screen and set up a sound system out front. The community loves it. Parents come with their children and blankets. It's a lot of fun. We get about five hundred to six hundred people for that, and we do an Easter egg hunt as well."

"Spirits usually go where people go," Joe observed. "If you believe that spirits are the essence of people who have passed on, well, the sense I get of this house is that because so many people come through here, if I were a spirit, I would hang out here. It seems like a fun place, and I think people tune into that when they come here."

Agreeing with Joe, I remarked, "When you're looking to buy a house, you get a certain feeling from it. Some say, 'I don't know, this is just not sitting well with me.' There's something about it. Then other houses you go into and there's just such a positive energy. Houses such as this one, with all its history and all the people who have passed through, affect us."

When we had concluded our interview with Scott and had toured the house, we came away with a sense that there were perhaps many spirits dwelling there from days gone by. A few weeks later when Joe was checking his EVP findings, he made an interesting discovery. To

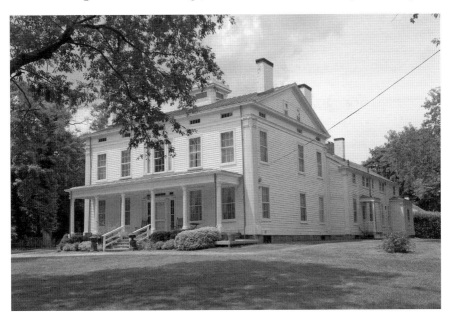

Deepwells Farm.

our astonishment, smack in the middle of our interview with Scott, the plucking or pulling of a cello or guitar string could be heard as clear as day. This was impossible, since we were the only three people in the house at the time. The sound also appeared close to the recorder, not in the distance, so it was unmistakably an EVP.

I happened to get the name of a man who ran a cleaning service and who used to take care of Deepwells years ago. Apparently he had an incredible experience take place there that could not be explained. His story just may make your hair stand on end.

His name was John, and he was retired. Ten years prior to our investigation, he had, in fact, had a contract with Deepwells. Friends of Long Island Heritage had been running theatrical "teas" there at the time. Each production lasted several weeks. John would come in three days a week to do cleaning and wax the floors. In between productions, he would be there seven days a week, getting the place ready for the next production.

On one occasion, John was there alone, cleaning the carpets in the main room. In his words, this is what happened next:

I got to the end [of the carpet] *and ran out of cleaning fluid. My truck was parked out back. I started to walk out of the room to go and get more cleaning solution. As I was walking through the doorway, I saw someone standing in another doorway. A guy was standing in another doorway. I thought to myself, this is baloney. I can't be seeing this. I knew he wasn't a real person because of the way he was dressed. He was wearing period clothing…he had on black pants, a white shirt with some fancy thing like an ascot and he had on a black smoking jacket, like a leisure jacket.*

He was an older gentleman with salt and pepper hair. When you're in a building by yourself, that's not what you want to see. My attitude was, if you don't bother me, I won't bother you. Let me just clean and get out of here. This is what I was thinking to myself. I wasn't about to talk to him. I walked out of the room and I could still see him. He walked into the next room, and then he moved toward the front door. Luckily I was going out the back.

I went outside and got the solution, and then I waited. I waited for him to leave. This isn't a lot of baloney, I'm telling you. I saw it. It wasn't a cloud, it wasn't a shadow. It was as clear as if someone was standing there, and believe me I don't have a vivid imagination. I remember a woman who used to come to the "teas," she was a psychic and said she used to feel ghosts there [at Deepwells]. *Then there was a volunteer for Friends who claimed*

he used to see someone. I never believed any of it. Anyway, so when I came back inside, I didn't see anyone. I finished the job fast. I didn't want to be there. I was ready to leave and had put the alarm on.

I headed toward the back door again, and I started to open it. Something made me turn around. When I did, I saw him standing at the front door. We just looked at each other for about two minutes. I couldn't understand what I was seeing. Then I had to get out of there. I locked the door and went outside. I started putting stuff in my truck, and I happened to look up at the cupola on the roof. There he was. I saw the same guy in the cupola! Now, I'd walked the whole building hundreds of times, in the day and night. I never had any incident ever. I never even believed in ghosts or considered it. Even after my experience, I still didn't believe. All I can say is that I saw a person as clear as I would see myself. As clear as I would see my wife. It was just unbelievable.

COE HALL

OYSTER BAY

As a historian, it has been my great pleasure to explore the magnificent homes and mansions of Long Island's Gold Coast era. Through my research and books, I have helped to keep their history and splendor alive.

One such place is the majestic Coe Hall in Oyster Bay, which sits on 409 acres of public parkland known today as Planting Fields Arboretum State Historic Park.

William Robertson Coe was born in England and came to the United States in 1883 at the age of fourteen. He was a believer in the American dream, and he worked his way up in the marine insurance firm Johnson and Higgins. By age forty-seven, William Coe became chairman of the board, a post he retained from 1916 until 1943. His other business endeavors included funding American studies programs at several colleges and donating rare manuscripts to Yale University. He was also the director of the Virginian Railway, where he eventually met his second wife, Mai Huttleston Rogers. Mai's father was industrialist Henry Huttleston Rogers, who was the builder of the Virginian Railway as well as the vice-president of Standard Oil. Mai and William met on a transatlantic trip in 1899, and they were married a year later.

Mr. Coe's first wife died unexpectedly on a cruise to England. Little is known about her or her relationship with William. As for William and Mai, they had four children, three boys and one girl—William Rogers Coe, Robert Douglas Coe, Henry Huttleston Rogers Coe and Natalie Mai Coe. Together, William and Mai set out to build a beautiful Classic Revival

Gold Coast estate where they could spend their summers and raise their children. Their main residence was in New York City, but they also had property in Florida, South Carolina and Wyoming. A previous house existed on the property before Coe Hall was built. In 1918, the house burned down, and the Coes decided to hire New York architects Walker & Gillette, who designed several other estates on Long Island. The Coes wanted their new home to be in the style of an English sixteenth-century Elizabethan country house. Using only the best materials, including Indiana limestone, the sixty-five-room house took four years to construct and was finished in 1921. Beautiful floor-to-ceiling windows can be seen throughout the house, as well as meticulously carved stone and woodwork. The home's interior and exterior were built to evoke the time of Renaissance England during the reign of Queen Elizabeth. About one-third of the furnishings are original, and many family members have graciously donated back several other pieces over the years. The furniture is generally Elizabethan Tudor, Jacobean and Louis XVI in style.

It is interesting to note that the stained glass featured in the dining room is from Hever Castle in Kent, England, the ancestral home of Ann Boleyn, queen of England from 1533 to 1536. The Coe family had a great

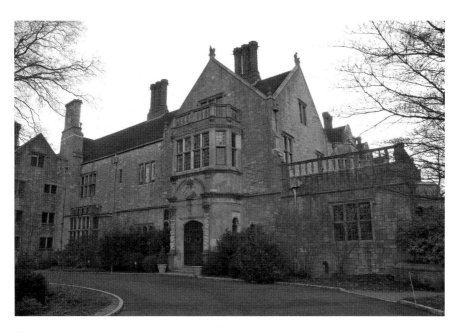

Coe Hall.

appreciation for art, and Mrs. Coe decorated her home with European art and décor from well-known artists of the time, including Robert Chanler, Everett Shinn, Samuel Yellin and Charles Duveen of London. A beautiful mural is located in the "buffalo" room of the house, which remains one of Robert Chanler's few surviving works. Since the house was built during Prohibition, a hidden bar is located in the den, along with several bookcases that were hidden behind paneling and once contained Mr. Coe's rare books and manuscripts.

The Coe family enjoyed horseback riding, and they could often be seen riding together on the grounds of the estate. Mrs. Coe spoke fluent French and played the piano, while Mr. Coe loved astronomy, hunting, the American West, horse racing, horticulture and landscape design. Mrs. Coe shared her husband's enthusiasm for plants and trees. Greenhouses were built so Mr. Coe could develop his plant collections, and fresh flowers were delivered to Mrs. Coe in Manhattan during times when they were not residing at Coe Hall. Rare specimen trees and shrubs were also planted on the property. The Coes hired the famous landscape architects the Olmsted brothers to design their gardens, which can still be viewed and enjoyed today. They named their land Planting Fields after the Matinecock Indians who cultivated the rich soil that surrounds the Long Island Sound.

Mai Coe's time at Planting Fields and Coe Hall was unfortunately short-lived. She died in 1924 at the age of forty-nine. In 1926, William Coe married his third wife, Caroline Graham Slaughter, two years after she had divorced her husband. It is said that the *New York Times* had reported the event as "a surprise wedding." Caroline and William were marred almost thirty years, until William's death in 1955. The manor house at Planting Fields was built for her use shortly after Mr. Coe's death, and Caroline was the last to own the house and live on the estate.

Mr. Coe had deeded the Planting Fields Estate to the State of New York in 1949 to "preserve the house and land so that people could visit and learn." Planting Fields is currently one of the last estates to survive with its acreage intact. It has retained its historic integrity because the house and grounds have not been altered from their original state. Its magnificence is enjoyed by thousands of people, and it remains a rich cultural resource in Oyster Bay.

William Coe's grandson Michael D. Coe (son of the Coes' eldest child, William Rogers Coe) is actively involved in his grandfather's estate. He is the chairman of Planting Fields Foundation, where he continues to ensure that Coe Hall is preserved and visited by the public for years to come.

The gallery in Coe Hall, with an orb in the fireplace. A photograph of Henry Huttleson Rogers Coe (circa 1920) sits on the table.

While working on a video project on Long Island's Gold Coast mansions back in 2012, Joe and I had the opportunity to tour Coe Hall and see if any spirits have remained. Although Coe Hall is not known to be haunted, I've received requests from readers over the years to investigate the historic home. After all, what old mansion doesn't have a ghost or two?

First, I would like to distinguish the difference between ghosts and spirits because oftentimes the two are confused. A typical "ghost" is a spirit who, for reasons unknown, is "place centered." They either cannot or choose not to cross over to the other side. A ghost usually cannot communicate. Instead they appear to those who happen to be at the right time and in the right place. Sometimes it is simply residual energy that has been left behind and is resurfacing and creating a phenomenon. In the case of spirits, it's very different. Spirits can communicate with us, and they are usually family members or friends who have passed on. They are in heaven, or whatever you choose to believe, but they are able to come and go on the earth plane to help us along our own journey. They often make themselves known by

Second-floor hallway in the children's wing of the house. Note the orbs.

manifesting into orbs, which are translucent balls of light that appear on photographs, or through EVPs, music or scents.

As Joe and I toured Coe Hall, we felt nothing but good family energy around us. Within a half hour of being there, orbs were consistently appearing in my photographs. It was almost as if members of the Coe family were following us throughout the house, eager for me to tell their wonderful history.

Joe went around with his EVP recorder, and although no voices came through, Joe felt cold and warm spots and the presence of spirits around us. Before we knew the full history of the place, Joe had picked up the feeling of a wedding reception. We later found out that Caroline Coe had helped her stepdaughter Natalie plan her wedding there in 1934. We also smelled flowers in various parts of the house, and Joe picked up on a hidden door, which led us to the old bar from Prohibition days.

The staff members we had spoken with did not report any type of paranormal experiences at Coe Hall. The energy there has always been positive, they told us. Joe and I surmised that the spirits of the Coe family members live on, protecting not only their family home but also their rich and important history and their contribution to society.

COUNTRY HOUSE RESTAURANT

STONY BROOK

There is perhaps no ghost story more captivating than that of the Country House Restaurant in Stony Brook, known to be haunted by the beautiful Annette Williamson for over one hundred years. This ghost may be one of the most active spirits we've ever encountered. Her legend and presence is nothing new at the restaurant, and quite possibly her spirit adds to the charm of the place.

The two-and-a-half-story home was built circa 1710 by Obediah Davis and is located on the northeast corner of Route 25A and Main Street in the Historic District of Stony Brook. The eastern part of the present house was built first, and the larger two-and-a-half-story section was built a few years later. It was used as a farmhouse by Obediah Davis and his family, who came to Stony Brook from Mount Sinai during the early 1700s. Old photographs reveal that the house had a long front porch, and the upstairs windows were without their current dormers. Just when the porch was removed and the dormers added is not known.

During the 1800s, the home was used as a stagecoach stop, and after serving four generations of Davises, the house was sold to Englishman Thomas Hadaway, who was a famous actor and comedian of the time. While he owned the house, the first Episcopal Sunday school in Stony Brook was established there. The house and property, then known as Hadaway House, was operated as a farm until about 1900. After that, it was a private residence until it became a restaurant sometime between 1960 and 1970. Eventually the name was changed again, and the Country House Restaurant was born.

According to historical records, the only insight into the Williamson family living there appears on the gravestones of two of its members, John Williamson and Annette Williamson. The family cemetery is on the property of the Country House, back in the woods, and contains about fifty graves, many of which have been covered by leaves and debris. Four Revolutionary War Patriots are said to rest there: Joseph Wells, Caleb Davis, Obediah Davis and John Williamson. Little is known about how long the Williamsons lived there. The historical documentation I found was often incomplete and unclear.

Joe and I sat down one evening with Country House owner Bob Willemstyn, amidst a beautiful array of delicious appetizers, and discussed its resident ghost, Annette Williamson.

Bob has owned the Country House since November 2005 but worked in the restaurant for twenty-seven years before he purchased it. He began as a busboy and worked his way up to waiter, and his dreams finally came true when the keys to the place became his.

"I grew up in Stony Brook, and everyone had heard about the Country House being haunted," he told us. "When I first came to work here, on one of my very first nights, I experienced a change in the air. It was cold, and the air felt different, heavier. Then I heard someone say, 'Bob,' and I turned around, but no one was there. I went running down the stairs and said, 'Is somebody playing tricks on me or something?'" Bob laughed, remembering the event. "Then I was told that you'll hear that all the time, and you do!"

We listened intently while Bob told us the entire story of the night a psychic made contact with Annette.

A man from England came around some years ago. Somehow he'd heard about us, and he asked if he could come in one night. So he arrived with all his equipment, all his electronic stuff, and he first made contact with what we believe was the ghost across the street, at the old Smith Hawkins house where William Sydney Mount once lived. The psychic wanted to come back the next night and bring a Ouija board. He gave us all these warnings, "Don't ever play with Ouija boards"…well, as it turns out, he made contact with the spirit who originally lived here.

The house was built in 1710, and the people who lived here were very wealthy. Historically we know this by the house itself. This house has five fireplaces; it's a colonial, not a saltbox; these are original ceilings and beams; the ceilings are very high; we have a lot of windows; two root cellars and four stories if you include the basement and the attic. We were told that

the house was used as a farmhouse and as a stagecoach stop. At the time, the people who owned this house also owned property in New Jersey. They were Dutch settlers, and at a certain point, they went to New Jersey and left the eldest daughter in charge of the house and the slaves, as well as the homestead and the brothers and sisters.

Bob went on:

During this unsettled time—the American Revolution had begun—you were either a Loyalist or a Patriot, either pro-British or against the British. If you did not defend against the British with your life, you were considered to be a Loyalist. While Annette's family was away in New Jersey, the British came and occupied the house. Because she did not defend against the British with her life, the local townspeople decided that she and her family must be Loyalists. When the British soldiers eventually left, the local townspeople murdered her in the Old Field room [now one of the small private dining rooms at the Country House] *in front of the fireplace.*

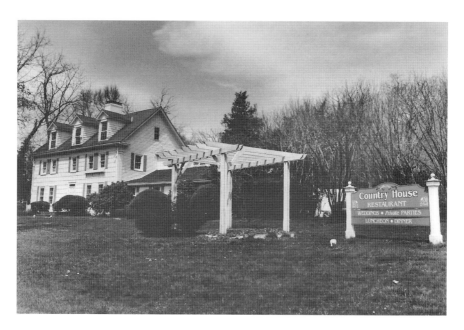

Country House.

The English psychic claimed this story was told to him by the girl herself.

During my own research, I had come across information that the girl was hanged by the British in an upstairs bedroom. But historical records, especially when they involve a local legend, can often be inaccurate. So it is unclear exactly who killed her and where, but she was definitely murdered in the house.

Bob continued:

> Because she was wrongfully accused, and it was such a violent murder, and she wasn't pro-British, and she felt responsible and in charge of the house, it is possible that her spirit may have been hiding all these years. But the English guy told us something even more amazing; something the town never knew about because this was all pre–historical society files. We didn't have any historian taking notes back then on who this family was and who this girl was—nobody knew their names. So he [the psychic] tells us, "By the way, she told me her name: Annette Williamson." He then went on to tell us they were Dutch settlers and that there was a family plot on the grounds here. So we went up into the woods with rakes and shovels, and we just start poking around, then we start finding all these tombstones. We found at least thirty tombstones on the crest of the hill with all these cryptic, morbid sayings on them. Some we propped up, others were footstones, but not only did we find all these tombstones, but we found her stone under about two feet of mulch. The names and the dates matched—Annette Williamson, and she died during the American Revolution. Now, nobody could have known about that.
>
> It's said that while the British were here, Annette would sit at that window [in the Old Field room] for hours looking out, waiting to see her parents return from New Jersey. The way the legend goes is that after they murdered her, they also murdered the family in New Jersey for being Loyalists as well. They slaughtered the whole family. People have driven by over the years, and pictures have been taken, and people see what appears to be a young girl looking out the window—a pretty, blond-haired, blue-eyed girl in a white gown. I've seen her several times.
>
> She has a face, features, everything. The first time I saw her, it was an August night, there was heat lightning going on out front, and we went outside. All of a sudden, the lights go out, and we hear a noise. We look around and see that the window in the Old Field room is all lit up. The inside lights were off, but the outside lights stayed on, illuminating the window—which was impossible, because they're all connected on the same

circuit. When the inside lights go off, the outside lights always go out, too. So for some reason, the outside lights stayed on. They were bright, and shining in, when all of a sudden we see the silhouette of a woman walk by. Then the lights came right back on, instantly, and there's nobody there. This was around 1980. So I said to the staff, "Did you see that?" and they're like, "Yeah."

So the first time I saw her, it was just a silhouette, but you knew it was a woman. Then one night I was here with my friend, and we were bussing tables. I said to him, "You won't believe what happened here last night. The candles were re-lighting themselves." This happened all the time. We stopped using candles for a while because of it. We'd be hanging out outside, and then all of a sudden there would be a candle lighting inside. A few times we actually had to call the owner at the time to come back and unlock the doors so we could blow out all the candles.

The second time I saw her, my friend was going on and on about how he didn't believe in anything and that I was so full of it. Well, she literally threw a chair at him. We both saw it. Then at that same second, we both caught out of the corner of our eyes the tail end of a white shirt turning the corner. I said to him, "Did you see that?" and he said, "Yeah, I saw that." We never saw the whole thing, we just sort of got a glimpse of her.

Recalling another story, Bob added:

Once, one of our waiters was at the top of the stairs and saw a woman go into the storeroom. Every once in a while someone will wander around wanting to see the place, so he said, "Excuse me, ma'am, no one's allowed up there." He walked into the storeroom, and nobody was there.

A lot of times you can feel the spirit. There is an overwhelming sadness and your eyes will well up. I've seen people just start crying. The time I saw her best was at Christmastime, many years ago. We were doing a lot of parties. The house was packed. We do a lot of decorating for the holidays, and we had floor-to-ceiling tinsel on the doorways, so when you passed through, you had to move the tinsel out of the way. So one night after a party, I walked into one of the rooms and looked around, and it was a total mess. There were chairs and Christmas paper all over the place. The party had left an hour before, and the guy working that room hadn't touched anything yet. So I'm thinking, "Where is he? This room is a mess."

As I went through the room, I see part of his head come out from behind one of the doorways. We're all in white tuxedos for the holidays, and I see

the white tuxedo as he moves the tinsel out of the way. It happened really fast, and he didn't come out all the way. What struck me as odd was that I saw his skin was pale. But he was from Brazil, and his skin was dark, and he's tall and skinny, and I said, "Wait a minute," and all of a sudden when the tinsel moved away again, there was a woman looking at me—a woman with blonde hair, blue eyes, very pretty. She had a pretty white dress on, and I said, "Excuse me." Then she jumped back, so I pulled the tinsel away, but there was nobody there.

I thought it was a guest behind the tinsel, but everyone was gone. I told the singer, who's been with us for years, "You'll never believe this. I think I just looked right at the ghost," and I said, "Come on, let's see if we can find her." Now the singer is a little clairvoyant and has some psychic sensitivity, so we went upstairs, and she started calling out to her. We heard footsteps—we hear footsteps all the time, by the way, and running. She loves to run around and play. Anyway, we hear her coming towards us, coming down the hallway and getting closer. And all of a sudden it got chillier and the air was thick and the footsteps were behind us. She literally passed right by us. We went running down the stairs. The singer said, "We hear you, we're your friends, you can come out." We never did see her again, but we actually felt her. It was unbelievable.

Bob and Country House employees are not the only ones who have encountered Annette. According to Bob, people see her all the time:

Customers see her, children see her, and they call her by name. One day we had this young girl going into the men's room all the time. So I kept saying, "Excuse me, excuse me, you can't go in there." She wasn't listening, so finally I had to go up to the mother and tell her that her daughter keeps trying to go into the men's room. So she called to her daughter and said, "You can't go into the men's room, that's for boys, and the ladies' room is for girls." Then her daughter said, "But I want to go in there and play." So the mother said, "But girls don't play in the men's room," and the daughter answered, "But Annette keeps going in and asking me to play." There is no way she could have known the name of the ghost at that time.

Another time we had a bunch of guys putting in the sprinkler system who actually wouldn't finish the job because they said they saw a woman dancing in the mist, and they said they knew she was not of the earth. A local artist who comes to the restaurant also claimed to see a woman dancing in the mist. She actually painted a picture for us, showing Annette

flying above the house and looking down at it. She based her picture on what she saw. She [Annette] also likes music. Sometimes she cranks the music way up. Our bartender never believed. He was here a few more months than me. He had never experienced anything until three or four years ago when one night one of the tables started rattling, and he heard a plate drop. Then he heard the music go way up. There is no remote. You have to manually turn it down. She was literally turning the knob in his hands! He tried to turn it off, but it didn't go off, so he finally had to unplug it. She likes music.

Now when the other ghost comes around, the one from across the street, we know it. It's not a nice spirit. We'll be standing by the piano, and a glass will smash in front of us, or another time, a purse fell off the bar like a Slinky and walked across the floor. Plates, knives, glassware and bottles are thrown when the bad ghost is here. One time I was down in the wine cellar with one of the waiters, and all of a sudden bottles were flying as if a juggler was throwing them.

Events involving Annette continue today, and on a regular basis, including flashes of light. A change in the air, either in temperature or in quality, also occurs, and strong scents of vanilla, smoke, perfume or even chocolate appear out of nowhere.

"The flashes of light occur a lot around the bar," Bob told us. "Everyone has seen it. It's like a bright flash of light, like someone is taking a flash photo, but faster. It can be a band of light or a trickle of light. Sometimes it happens several times a day."

Several stories also seem to focus around Bob. He'll hear his name being called, and he claims that Annette often steals his tie clip. "If I wear a tie clip, she always steals it. I'll find it hours later in the Old Field room by the fireplace where she was supposedly murdered. Another time I was painting upstairs. I had my hands full, and I was trying to open the window at the same time. We have old windows, and they're hard to open. All of a sudden, the window opened on its own about four inches," Bob recalled.

It is obvious that the spirit of Annette is happy at the Country House and that she has taken a special liking to Bob. It's also intriguing that their last names are practically the same: Williamson and Willemstyn. "My family was also Dutch settlers," Bob explained. "It's pretty weird." Bob told us that the spelling of his last name changed several times through the generations. At one time, it could have been spelled the same as Annette's.

Joe asked Bob, "Do you ever think that maybe, by some work of fate, that you're here, and that you were actually a member of the family?"

Bob replied, "A Catholic nun I used to know well from here, she'd come in all the time, she'd tell me all about these things. She would tell me that I was here before, and that I'll be back again. It's just amazing, because there is absolutely no reason why I should own this business, except that it was meant to be. There were so many obstacles in my way. It's an astonishing story in itself. I have met the most amazing people in my life, and they're all from here. I can't even fathom it sometimes."

Joe said, "Something tells me you were here before, and that you're here to keep an eye on the place, because you're here, in the physical realm. They can't do much from the other side."

Almost every single person who has worked at the Country House has witnessed something. While we were there interviewing Bob, Joe saw the light flash. We also toured the restaurant, including the second floor and the attic, which Bob told us is always very spooky. I walked around taking photographs while Joe kept his recorder running. The next day, Joe called me and said that he had picked up two EVPs, and they were class As, which means they could be easily heard. He sent them to me by computer, and I listened to them. We had been hesitant to go into the attic at first because the stairs were wooden, steep and very narrow, and the attic was not well lit. Bob said he hated going up there, and I wasn't thrilled with the idea because I was lugging two cameras and flash equipment around. Joe headed up, and reluctantly, Bob and I followed. It was when we were entering the attic that the EVPs were heard. None of us were talking, and all of a sudden you heard a male voice say, "Come." A minute after that, another male voice said the same thing, but more slowly and louder, "C-O-M-E." Obviously some other spirits there really wanted us to see the attic.

The most amazing thing for Joe and me took place after the interview. We had said our goodbyes to Bob, and before we got into our cars, Joe suggested we take more photos outside. It was a very clear night. We were both shooting with different digital cameras. We stood next to each other for most of the shots. Practically every photograph we took had orbs in it. Some photos had several, and depending on who snapped the picture first, the orbs would appear slightly below or above when Joe and I compared images. In one of my photos, a semicircle of orbs appeared over one of the dormered windows. The orbs were all translucent—another sign of their being genuine—and some were incredibly bright or even colored.

The spirit of Annette continues to haunt the beautiful Country House Restaurant, and apparently several other spirits have enjoyed it enough to come back, too.

CHAPTER 18
SAGTIKOS MANOR

BAY SHORE

The Sagtikos Manor in Bay Shore has a remarkable history, a legend and perhaps a ghost or two. It was even visited by George Washington. This Suffolk County–owned property offers tours, fall festivals and a number of other family events. Joe and I were given a private tour of this beautiful place.

The land on which the house sits once comprised 1,200 acres, stretching from the Great South Bay to Brentwood, where the house is today. The original inhabitants were a group (not a tribe) of Native Americans called the Secatogue Indians. They were a branch of the Algonquins, who occupied much of Long Island.

There are two stories about the name Sagtikos. One states that the shape of the acreage resembled a "snake's head," which the Indians referred to as "Sagtikos." The other says that the term means "snakes were hissing." There used to be a creek winding through the land that resembled a slithering snake. It made a hissing sound as it babbled over the rocks. It's possible that this is what the Indians were referring to.

Since they shared the land, the Indians had no concept of landownership, nor could they comprehend it. When the white men came, they often agreed to their proposals. In the Sagtikos Manor's archives is a deed written by white men in a language the Indians couldn't understand. They sealed the deed by making a thumbprint in blood. Next to it they would make their mark, a signature of sorts. Trades were made, some wampum given and the land no longer belonged to the Indians.

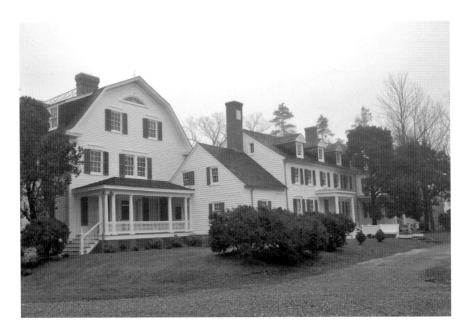

Sagtikos Manor.

Joe and I were greeted by Nancy and Larry Donohue. Nancy has been the president of the Sagtikos Manor Historical Society for over twenty years, and her husband, Larry, was president three years before that. Nancy is an expert on Sagtikos history, and I was looking forward to interviewing her. The house had been closed up, with all of the shades drawn, so the rooms were quite dark. We followed Nancy and Larry through a chain of hallways and rooms. Nancy opened up the shades as we went around, and each furnished room seemed to come to life before our eyes.

"I promise we'll come back to all of these," Nancy remarked as we swiftly followed her to another wing of the massive house. She wanted to tell us the history before we took our in-depth tour so we would have a better understanding of how the house had been put together; the manor was actually built in three sections at very different time periods. It is one of the features that makes the house so unique.

"Here we are," Nancy said finally, turning the lights on in a large, high-ceilinged room. An enormous red area rug covered most of the dark wood floor. The room was furnished with antiques from both the Chippendale and Empire periods. A round wood table was in the center, and above it hung a lavish red fabric chandelier.

Nancy told us that the table was once at Green's Tavern in Valley Forge, General George Washington's headquarters, and supposedly he sat many times at that very table.

When the table was moved aside and the chandelier raised up, the room could be converted into a ballroom. Stately portraits hung throughout the room, as well as several coats of arms. The room, where we conducted our interview, was regal in every aspect.

Nancy explained:

> A man by the name of Stephanus Van Cortlandt purchased 145 acres from the Secatogue Indians in 1692. Five years later, he received a grant from the governor and built a small house on the property. Van Cortlandt was the first American-born mayor of New York City. Why did he come here? Questionable. Maybe he wanted to hunt, fish, get away from the city. It was a small house when he built it, probably just three or four rooms. This is the oldest part of the manor, built in 1697. He died in the early 1700s, and in 1706, his widow and son sold the property to Timothy Carll, who was from another prominent family. The Carlls added several more parcels of land to the estate, and they lived here for fifty-two years.
>
> In 1758, the real history of the house begins. Jonathon Thompson of Setauket came down here on horseback with two saddlebags full of money. He paid 1,200 British pounds sterling for 1,206 acres. He was a landowner; you can visit his home in Setauket. Thompson sent his younger son Isaac, who was only about fourteen, to learn land management from the Indians. He was to develop a farm here.
>
> In 1772, when he was about twenty-eight, Isaac married Mary Gardiner, who came from a prominent family in East Hampton. She was the daughter of Colonel Abraham Gardiner. She came from the very developed east end of the island to the rural farming community that existed here. It wasn't until after World War II that this area started developing. Jonathon Thompson had given Isaac and Mary the deed as a wedding gift. It was a seven-room house then. But she was a descendant of Lion Gardiner, so she had a second seven-room house built alongside the first one—so it was up to fourteen rooms.
>
> From 1758 until 1985, the property was privately owned by either a Gardiner or a Thompson. In 1985, it was put into the Robert David Lion Gardiner Foundation. It is a very long period for any house to remain in one family. They were prominent people. Isaac's son Jonathon was collector of customs for the Port of New York.

135

"How many generations of Gardiners lived here during that stretch?" Joe asked.

"At least eight or nine," Nancy replied. "And you know what's incredible? There have been different branches of the family but very few children. Robert was the last of the Gardiner name when he died. He owned and used this house as well."

We also learned that for a brief time, the estate served as headquarters for British forces on the island during the Revolutionary War. "Legend has it," Nancy said, "that one night during the Revolutionary War, Isaac Thompson, who was a squire, was signaling to someone from the house. Outside, some Hessian soldiers had been killed. The rest of the Hessians saw Isaac and fired at him. The musket ball came right through the house. There's a hole in the stairway from when it came in."

"And when did George Washington come here?" I asked.

"Washington made a tour of Long Island in 1790," Nancy said. "He spent one night here on April 21, 1790, and it's documented in his diary. He did pay, but it said that he was here to thank Squire Thompson for signing the Letters of Confederation for the independence of the country. That's why Washington toured the island; he wanted to thank the people for their loyalty and help during the time of the British occupation. He also wanted to see how Long Island fared. Many of the battles of the Revolution were fought on the island. It's hard to believe that during the time of the Revolution there were only about eighty families living here in Islip Town."

As we contemplated this, Nancy said, "So upstairs we have the room where George Washington slept, although it's not the bed he slept in. I'll take you up the original staircase he walked on. It's always amazing to me to climb that staircase."

Isaac Thompson died in January 1816. He had accomplished a lot: Thompson had been a judge of the Court of Common Pleas, he had been a magistrate for more than forty years and, in 1795, he was a representative of the County of Suffolk in the Assembly. He had been very active during the Revolutionary War; he organized the militia and was chairman of the Islip committee.

During my research, I came across another story regarding Isaac Thompson. It is said that one evening in 1777, more than three hundred British soldiers set up camp for the night on the grounds at Sagtikos. The commanding officer in charge was British general Sir Henry Clinton, who had been making tours of the island. The house came under attack during the night by British sailors who arrived on a warship. The legend says that

Isaac Thompson was dragged by a rope around his neck across the highway, where he was threatened with death. He was spared because someone shouted that he was a magistrate under the king. I also came across the story Nancy told us about the musket ball. Apparently, Thompson was fired at while going up the stairs. The musket ball was supposedly in the hands of his great-grandson Samuel Ludlow Thompson, Esq., who was an Islip resident. Where it is now, no one knows.

After his death, Thompson's descendants used the manor primarily as a summer home for the next seventy-eight years. It remained a working farm during this time, with outside workers hired to run it. In 1894, another great-grandson of Isaac Thompson and Mary Gardiner became the sole owner of the estate, having bought out all the heirs.

"Over the years, the property would have been subdivided," Nancy told us. "Somebody maybe needed twenty acres—we don't know the parcels that were given out. At the turn of the twentieth century, this gentleman whose portrait is in the corner," Nancy said, pointing to one of the paintings, "Frederick Diodati Thompson, bought out everyone else who laid claim to the property and had the last addition put onto the house. He hired the prominent architect of the period Isaac Green. This is the entire east wing he put on. So the entire west wing was the first portion of the house. The house went from fourteen rooms to forty-two rooms."

"It was his 'summer cottage,'" she smiled. "He called it Apple Tree Wicke. At that time, it was very fashionable for the wealthy of New York to summer in this area of the South Shore. The additions were made, and the property went from a country farm to an elegant estate. He lived here only twelve years before dying in 1906. Since he never married, the property went to his nephew David Gardiner. He brought the estate back to its agricultural roots, but he didn't live long either. At his death in 1927, the property went to his sister Sarah Diodati Gardiner, who also never married."

Sarah was an avid gardener and created most of the gardens on the estate, many of which need restoration. It was Sarah who had given a large tract of land at the northern end of the estate to the State of New York. On this land the Sagtikos Parkway was built. Because she did not marry, she deeded the property to her nephew, Robert David Lion Gardiner, in 1935.

Nancy explained, "Bob held the deed for fifty years before he created the Robert David Lion Gardiner Foundation, which sold it [the manor] to the county in 2002. He died two years later at ninety-three, the last to bear the Gardiner name. Bob told us about his ancestors, his travels in Europe and Gardiner's Island."

"He called himself the sixteenth lord of the manor," said Larry, referring to Bob's ownership of Gardiner's Island. Gardiner was a descendant of Lion Gardiner, New York State's first permanent English settler, who bought the 3,700-acre island off the coast of East Hampton from the Montaukett Indians. When Robert's aunt Sarah Diodati died in 1953, Gardiner's Island was given to Robert and his sister Alexandra Gardiner Creel. Today, Robert's niece Alexandra Gardiner Creel Goelet is the sole owner of Gardiner's Island, after many tumultuous legal battles she had with her uncle before he died.

Getting back to Sagtikos Manor, Robert David Lion Gardiner married a woman named Eunice in 1962. A year later, they decided to move their summer residence to East Hampton and didn't have much use for the manor. Eventually, Mr. Gardiner began selling off the estate, except for the ten and a half acres that now surround the house. A carriage house and garden sheds (not open to the public) are also there and a family cemetery with approximately fourteen graves, including that of Isaac Thompson.

The last parcel, about 230 acres south of Merrick Road, was sold to Suffolk County, which turned it into Gardiner County Park in 1971. A man named George Weeks convinced Mr. Gardiner to open the manor to the public, turning it into a museum with tours. Shortly thereafter, the Sagtikos Manor Historical Society, Inc., was created and was granted an absolute charter by the Board of Regents of the University of the State of New York, which incorporated the group. Its goal was to preserve historic buildings in Suffolk County, including the Sagtikos Manor, and "to perform historic research and promote public knowledge of local and national history."

The Sagtikos Manor Historical Society works closely with the Suffolk County Parks Department Division of Historic Services, which is the official owner of the estate. Together, they promote and raise funds for the constant restoration of the beautiful Sagtikos Manor for future generations to enjoy. Incidentally, the manor was placed on the National Register of Historic Places in 1976.

I thought perhaps ghosts might abound at Sagtikos Manor, since many of my readers have mentioned this. With an understanding of the history of this interesting place, Joe and I set out to find if there was any truth to the rumors.

"They say there's an Indian maiden who used to come across to the property with men in canoes," Nancy said. "People say they return at the end of October every year. Someone else said once that ghosts were

coming out of the graves in the cemetery, because on Halloween the stones would be shifted. I don't know if they were vandals or what, but we hired a security guard."

"There's a little marker on a section of fence on the property that says it's the [burial] site of an unnamed Indian girl," Larry added. "It must have been done because there was something to the story, and that was intended to commemorate it."

Nancy added, "People used to say there was an Indian ghost up in the loft area of this house, too. The loft is in the oldest part of the house. I don't know…"

"A few years back we had a woman who knew the whole story of the Indian girl," said Larry. "We had a fall festival and a haunted house, and she told the story of the Indian girl who came every year."

"The only time I've ever experienced anything, and I'm not sure if it is anything," Nancy said, "but right after Bob Gardiner died, the chandelier here was stolen. Luckily, we got it back, but we needed an electrician. I was here after hours on a Thursday afternoon; the electrician was repairing it, and I was working on the crystals. I had them on the dining room table, getting them ready for him to hang. He left to do something, and I was alone. Suddenly, I heard the doorknob turn. I thought, 'That's odd.' I hadn't heard any steps on the porch, but I was going to tell whoever was there that we were closed for the day. When I opened the door, no one was there. And then I realized that we had the screen door latched, so the knob on the inside door couldn't have turned. It was very odd because it was almost two weeks to the day after Bob had died."

Joe asked her, "He was paying you a visit?"

"Yes," said Nancy, laughing. "Before that if anything was strange, like this door would open, I used to joke and say it must be my Indian ghost. There's a young man who's now working for the county…he's here sometimes on his own, and he really feels there's something here." Nancy paused. "I'm on the fence about ghosts. There was one guy who came here about three years ago—he got some orb photos."

"I don't know if I believe there are ghosts here," Larry remarked. "I haven't gotten that strong sense that something's going on. I've heard people talk about them in other places, and you can give some credence to it, but not here. Bob Gardiner was ninety years old and never talked about experiencing ghosts in this house. He was always more concerned with family ancestry than spirits, so we never really heard much about it, except for the story of the Indian girl."

Nancy commented, "But Larry's experience is different also, because he's very rarely in the house with one or two people. He's normally here when the house is active, full of people. I'm not afraid of ghosts, but sometimes I do get a strange feeling, but then I wonder if it was concocted in my own mind. I do recall one other time when I was closing up the house, and I saw a shadowy figure of a man in a farmer's hat standing on the front porch. But there was absolutely no one on that porch."

We finished our interview and took the tour of the house. Joe and I had the opportunity to walk up the very steep and narrow, winding staircase that George Washington had climbed. Nancy was right—there was something about walking on the same stairs as our great president did. We also spent a few moments in the room where George Washington once slept. At one point, Nancy stopped and smiled at us. She put her left hand on one wall and her right on the opposite. Then she moved her foot slightly back and said, "I love to come and step here. I am in all three eras of the house at the same time: 1697, 1772 and 1902. It's simply amazing."

We said goodbye to Nancy and Larry and thanked them for being so generous with their time.

"Feel free to take a look at the cemetery and the rest of the grounds," Nancy said. We toured the small cemetery, which was enclosed in wrought-iron fencing. We saw the remains of what once was a beautiful garden. In the distance was the carriage house. Up against a tree was a section of old white fencing. We walked toward it. Screwed into the wood was a bronze plaque reading, "Grave of Indian Girl, Name Unknown."

About a week later, Joe and I discussed the findings from our day at Sagtikos Manor. Joe sent over four EVPs. One of them was quite audible. He had entitled it, "Saying hello." When we had entered the elaborate room where we had conducted our interview with Nancy and Larry, you can hear Nancy saying, "Sit down, sit down," as she ushered us to our seats. I am then heard saying "Thank you." Right after that a soft voice says, "Hi." I couldn't help smiling when I heard it because whatever spirits were there were welcoming us.

I then told Joe that further Internet searches happened to turn up the story of an Indian princess at Sagtikos Manor. Apparently the legend has been passed along since the early 1700s. It told of an Indian princess named Sagitowana who lived with her tribe on the grounds of the present Gardiner estate in Bay Shore. One day there was a ship off the Fire Island coast, filled with settlers who couldn't make it to the harbor because of a fierce storm. Braving the storm, Sagitowana made several trips back and forth in her

The wooded area where the Indian maiden was seen.

canoe, rescuing settlers with the help of her braves. But before they could save the last group of settlers, the storm began to worsen. Sagitowana was determined to rescue them and set out with her braves one last time. The Indian princess did not return; she was lost at sea. It has been said that on a stormy night, Sagitowana and her braves can be seen walking across Montauk Highway from Gardiner Park to the old grounds on which she lived—the grounds of the Sagtikos Manor.

CHAPTER 19

CULPER SPY RING

SETAUKET

The Setauket Spy Ring (also known as the Culper Spy Ring) is a fascinating part of our history on Long Island. Much of the events that took place with the spies occurred in a small, quiet residential area known as Strong's Neck, which is next-door to Setauket. I have spent a lot of time researching and doing investigations in Strong's Neck over the years, and the story of the Culper Spy Ring is perhaps my favorite. This remarkable group of people ultimately was one of the forces that helped the American Patriots win the Revolutionary War.

At the time of the Declaration of Independence in 1776, the British (known as redcoats) had had a sizeable occupying army in America for many years, including garrisons in New York. When the Revolution broke out, British troops commandeered everything in their path—people's homes and businesses, cemeteries and village greens. The same held true for Long Island, where they set up occupancy almost everywhere. The quiet little town of Setauket was turned upside down upon the redcoats' arrival. The Presbyterian church on the Village Green was turned into a British fort. The pews in the church were knocked down to make temporary stalls for the soldiers' horses, while the tombstones in the churchyard were used for barricades. For those living in the area during these times, life was unbearably difficult. Settlers who were against the British occupation were called Patriots. They were the men and, yes, women who fought early on for our country and our freedom.

Eventually, a group of Patriot soldiers came over from Connecticut by boat to wage war against the British. It was August 22, 1777, when the Battle

of Setauket took place. Unfortunately, the Patriots were outnumbered, and their attempt to overtake the British fort failed. They didn't give up, however. They were determined to fight to the end.

With careful planning and much effort, the Setauket Spy Ring was put into place a year later. It began in 1778 and lasted six years without the British ever knowing they were being spied on. In fact, it was so secret that no one had ever heard of it until a historian named Morton Pennypacker stumbled across it and broke the code of silence in his book, *George Washington's Spies on Long Island and in New York*, in 1939. For over 150 years, the story of the Culper Spy Ring had remained a secret—possibly one that could have been lost forever.

Much of what I'm about to relate happened in Strong's Neck. There's an energy there that I cannot explain to this day. It is just different, unlike any other area Joe and I have investigated. You can almost feel what went on in that land.

The Culper Spy Ring, and the use of Nancy's "clothesline" in particular, can make history come alive. It begins with Robert Townsend, a twenty-five-year-old merchant and Patriot from Oyster Bay. (See Raynham Hall story in this book.) His family owned that house in Oyster Bay, which was also occupied by the British during the Revolution. It actually became the British headquarters because the Townsends were Quakers and they were willing to bury both American and British soldiers.

Robert Townsend secretly served his country during the Revolution by becoming one of General George Washington's chief spies. He worked under the code name "Culper Jr.," and the Townsends ultimately betrayed the British.

At one point, Townsend disguised himself as a redcoat and made his way to New York City, where he talked with British generals over tea. Afterward, with his newfound knowledge, he wrote to Washington (using invisible ink) and told him of their plans.

This all began when General George Washington asked his trusted aide, Colonel Benjamin Tallmadge of the Second Regiment of Continental Light Dragoons, based in Connecticut, to form a network of spies on Long Island. Tallmadge, a Setauket native, crossed Long Island Sound in his whaleboat and called on some trusted friends.

One was Austin Roe, a twenty-nine-year-old tavern keeper in Setauket. It would be his job to carry messages from the city to the newly formed spy ring in Setauket. Disguising himself as a country merchant, he rode fifty-five miles on horseback several days a week from Setauket to the

city, never getting caught. During the time he ran his tavern, British officers and soldiers would come in from the local garrison. Roe treated them politely and went about his work, all along gaining additional information that he could report back to the Continental army. The messages would be given to Tallmadge, who would then deliver them to General Washington.

The spy in charge was an unlikely fellow named Abraham Woodhull. He was a direct descendant of Richard Woodhull, one of the first settlers in Setauket. He was a short and somewhat introverted twenty-seven-year-old who ran a farm between Conscience Bay and Little Bay. The farm became his base of operations, and oddly enough, the majority of letters in the Spy Ring were written by Abraham Woodhull, who traveled back and forth to New York City carrying messages. His role in the Spy Ring became so important that he went under the alias "Samuel Culper Sr." Eventually, when Robert Townsend was introduced to the group, he became known as "Samuel Culper Jr." Townsend also took over the role of sending messages to and from New York City during a time when Woodhull feared he was about to be discovered.

During his travels, Woodhull was able to discover British troop movements, the size of their forces and who was doing what and where, from Jamaica to the eastern tip of Long Island—about one hundred miles. Like everyone else in the area, his house was occupied by British troops, which made it difficult to receive messages. In order to solve the problem, Woodhull arranged for Austin Roe to bring his cows to his pastures. With the cows on Woodhull's land and Roe coming by to attend to them, Roe was able to hide the messages from New York City in the hollow of a tree. From there, Woodhull would pass the messages to an ex-whaler named Caleb Brewster, a descendant of the Reverend Nathaniel Brewster, the first minister in Setauket.

Caleb Brewster was a big, young, energetic man who thrived on the war effort. He knew how to successfully navigate Long Island's waters, and because of his skills, he became a huge asset to the Spy Ring, as well as a lieutenant in Washington's army.

Brewster and a small group of men would row across Long Island Sound to Fairfield, Connecticut, where the messages would get to Tallmadge. Oftentimes, during his trip back, Brewster would capture British supply vessels and attack any British ships he came across along the way. With his small group of armed men, he would perform raids, burning anything he could that belonged to the British—except for their supplies, which the Patriots greatly needed.

Brewster had participated in the Battle of Setauket and in the capture of Fort St. George. Because of the openly active role he played in the war, to the British he was an unlikely spy.

Out of all of this comes the heroine of our story, Anna Smith Strong, of Strong's Neck. According to the information Morton Pennypacker came across back in the 1930s, she was known as "Nancy" within the Spy Ring, and there was reference made to her clothesline.

Nancy was married to Judge Selah Strong. Under normal circumstances, she would have been living in a manor house; however, for the duration of the war, she, her husband and their eight children lived in a cottage across Setauket's Little Bay—which happened to be across from Abraham Woodhull's house and farm.

To make Austin Roe's trips to New York City more believable if he were to get caught, Nancy would give him orders to bring back yards of fabrics and other dry goods. It made sense that a merchant like himself would have to go back and forth to the city to fulfill orders. It was a perfect plan.

Once information was obtained, it went to Woodhull and then on to Caleb Brewster. It was soon determined that it was not safe for Brewster to keep landing in the same spot with his boat. They feared he would get caught. The Spy Ring then created six landing spots for Brewster. However, how would Woodhull know when Brewster was in town, and at what location he would be? As Woodhull pondered this from the window of his house, he looked across the water and spotted Nancy's clothesline. It gave him an idea.

Woodhull and Nancy devised a secret code based on what she hung on her clothesline. It is not known exactly how Nancy knew of Brewster's whereabouts, but there is the possibility that one of her young sons on his daily jaunts would search for Brewster along the way and then report back to his mother.

So as the legend goes, if a black petticoat was hanging on the line it meant that Caleb Brewster was in town. Most women wore red petticoats at the time. The number of handkerchiefs hanging on the line would indicate which location Brewster's boat was at; each of the six landing places corresponded with a number. Through his spyglass, Woodhull would count the number of handkerchiefs hanging amid the rest of the laundry, and he would know exactly where Brewster could be found.

Nancy's husband, Selah, although not named on the list, must have had something to do with the spying because he was accused of "communicating with the enemy" and was thrown onto one of the worst British prison ships imaginable, the *Jersey*.

The area where Nancy's clothesline may have hung, facing Abraham Woodhull's farm across the water.

The *Jersey* housed about one thousand prisoners at one time, most of them being captured seamen. Diseases such as smallpox and yellow fever swept through the boats, where many men were left to die. Nancy was determined to save her husband. Risking her own life, she went to see some of her Smith relatives who were still loyal subjects of King George. She begged them for permission to board the ship and visit her husband. They granted her wish, and with a boatload of food, Nancy left her children behind and rowed alone across the waters to the prison ship. It is said that because she brought food with her, they released her husband. It was unsafe for him to go home, so he fled to Connecticut, where it is believed he stayed until the war's end.

On our trip out to Strong's Neck, Joe and I met with Margo Arceri, vice-president and trustee of the Three Village Historical Society and president of the Strong's Neck Civic Association. Our first stop was the old St. George's Manor Cemetery, which is the private family burial site of the Smith/Strong families. Anna Smith "Nancy" Strong and her husband, Selah Strong, are buried here. It is also the place where Nancy would have hung her clothesline.

We walked among the tombstones and looked out at the water that peeked through the many large trees that have grown there. According to Margo,

as we stood facing the water, the site of the famous clothesline would have been to the left, about halfway from where the old Strong's Neck Bridge used to be, as one exited Little Bay. The cottage where Selah and Nancy stayed during the war would have also been located in this area, and Abraham Woodhull's farm would have existed across Little Bay.

I could picture in my head what it must have looked like—and how frightening it all was.

During a previous investigation on Strong's Neck for my book *Ghosts of Long Island: Stories of the Paranormal*, Margo, Joe and I visited nearby Spy Coast Farm, which was so appropriately named. A ghostly man had appeared at the stable and was seen by two stable workers. Could the figure have been the spirit of Caleb Brewster? Abraham Woodhull? Austin Roe?

On several other occasions, we walked in the woods by a home named the Cedars, built in 1879 by Selah Brewster Strong. It was in these woods that British and Revolutionary War soldiers once roamed. On one particularly beautiful day, Margo took us through the woods by the Cedars until we came to a clearing. It opened onto a small beach, where beach grass swayed delicately across the sand. A long pile of large rocks formed a sort of path that led to a big boulder where the Strong children might have once played. Margo said, "This was probably one of Caleb Brewster's landing spots. Logistically, it makes sense." We tried to picture him landing quietly and then making his way up through the woods.

On yet another trip to Strong's Neck in November 2007, it was cold and rainy. Once Joe and I had met up with Margo, the weather turned into the tail end of a nor'easter. This was the day we had set out to visit what was called the Upper Barn, which was located on the same property as the Cedars. At one point, the rain let up slightly, and we decided to venture out back into the woods.

The woods just beyond the barn were the same woods that connected with the trails we had walked through while visiting the Cedars. There were some things on this side of the woods that Margo wanted to show us. Through the wind we walked the spooky, dark trail. The woods narrowed, and we came to a small clearing where the remains of a small, square rock formation peeked through the overgrown brush. It looked like the remains of a foundation from some sort of a structure, perhaps a cabin.

"A lot went on in these woods," Margo remarked. "This could have been a small house or shelter." The image of redcoats and Patriots running through the woods, guns in hand, came to mind. I took some photos. Later, three orbs appeared in one photo taken at that spot.

Left: Caleb Brewster may have landed here.

Below: The stone foundation in the woods where we heard the sounds of cannon fire.

We continued over rough terrain until we got back to the path. Like the path at the Cedars, this, too, led us down to a clearing at the beach. We stayed for only a moment because the storm was worsening. Silently, we walked single file back up the path. I was in front, and Margo was close behind. Joe lingered maybe twelve feet away from us. Suddenly, I stopped dead in my tracks. The sound was unmistakable, yet I thought I might be losing my mind. It was the distinct sound of cannon or musket fire. I quickly looked at Margo, who had turned white. Her eyes opened wide as she scanned the area. I said nothing, waiting for her to speak.

Just then Joe shouted, "Did you hear it? It sounded like a—"

Before he could continue, Margo looked at me and said, "A cannon."

"I had my recorder going. Hopefully we got it," Joe announced as he made his way back to us. "Did you hear it?" he repeated. "I think we got cannon fire."

We all heard it, so we weren't imagining it. It was definitely not thunder. There had been no thunder at all that day. We heard it once more, and we all stood frozen. Because we were in the tail end of a nor'easter, there was absolutely no boat activity on the water. We had just been down there and seen that for ourselves. It was also not a day for hunting, fireworks or anything else that could possibly make that sound. It was a slow, low sound off in the distance. We all agreed that it sounded like a cannon being fired. How could it be possible?

Later that night, Joe revealed that he did capture the cannon fire on his recorder. It was fainter than we had actually heard it, but it was there.

In his analysis to me, Joe wrote, "I rule out other possible explanations. I believe it is an imprint or a sound effect created by the resident spirits. I think with the rain and wind this was an imprint trapped in the environment and the right combination of wind, temperature and humidity had these sounds carved out by the way the woods and beach created the right echo chamber. This may have been a rare event never to be heard again."

Joe sent the clip of the cannon fire to Margo as well.

Her remark to us on the phone was, "I have walked these woods my whole life, as a child and now as an adult, and in all kinds of weather. I know the sounds of this place. I know every inch of it. I have never heard a sound like that out here ever."

The ghostly image of a man seen just down the road, the sound of cannon fire heard in the woods and orbs mysteriously appearing in a photo. The energy and spirits are there—events trapped in time and space—secrets of the Setauket Spy Ring revealed. They are the ghosts of our country's Revolutionary War past and our reminder never to forget.

CHAPTER 20
OHEKA CASTLE

COLD SPRING HILLS

I have always had a fascination with and love of OHEKA Castle in Cold Spring Hills. During my teenage years, I remember driving up to the old abandoned mansion, wondering who had owned it and why it had fallen into such neglect. As an adult, I had joined in the campaign to save it. As luck would have it, Gary Melius, a reincarnated Otto Kahn of sorts, purchased it in 1984 and painstakingly restored it for over two decades. I have had the privilege to spend a lot of time at OHEKA, and I am always in awe of its beauty and magnitude.

I took the photo of OHEKA Castle in the snow back in 1997 when it graced the cover of my book *Huntington's Past Revisited*. I had written about its wonderful history, forever preserving its fascinating past. Today, I will share with you not only some of that history but also the tales of the spirits who have remained.

Otto Hermann Kahn was born into a wealthy banking family in Mannheim, Germany, in 1867. As a young boy, Otto had a deep appreciation for culture and the arts. At age sixteen, Otto's father, Bernhard, introduced him to the field of banking and set him up as an apprentice at a banking firm where he worked and went to school until serving in the military. After that, Otto Kahn decided to travel and spent several years in London. He fell in love with England and eventually renounced his German citizenship and became a naturalized British subject.

Otto worked as a banker at the London branch of Deutsche Bank until an American firm, Speyer and Company of New York, offered him a position.

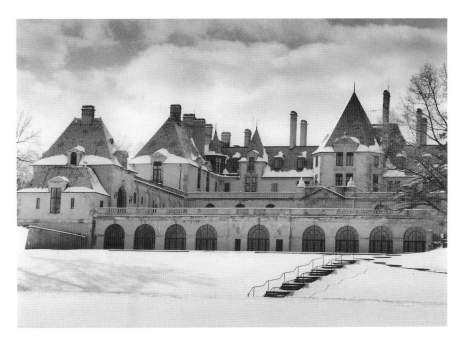

OHEKA Castle in the snow, taken in 1997.

Otto was intrigued by the idea of living in the States, so in the summer of 1893, at the age of twenty-six, Otto sailed to America.

Within three years, Otto Kahn became quite successful, making a name for himself on Wall Street. He married Addie Wolff, the daughter of Abraham Wolff, a partner in the banking firm Kuhn, Loeb and Company. Wolff, impressed with young Otto's skills as an investment banker, made him a junior partner in his firm.

The Kahns purchased a mansion in Morristown, New Jersey, and traveled extensively in Europe, purchasing fine artwork and furniture. In 1905, a fire broke out and destroyed over $750,000 of personal property. After that, Otto Kahn had an excessive fear of fire. Although the home was rebuilt, Otto did not quite fit in with Morristown's wealthy. Despite being well educated and wealthy himself, Kahn was refused membership into the prestigious Morristown Club strictly because he was Jewish.

Kahn began spending less and less time at his Morristown estate, and instead, he rented and purchased several other homes in the United States and in Europe. He eventually came back to New York during the time of the Gilded Age. He had amassed a considerable amount of wealth over the

years and even supported and became good friends with President Theodore Roosevelt. Otto loved America and eventually took the Oath of Allegiance and became an American citizen.

In 1914, Otto Kahn purchased 443 acres of land on Long Island, in Cold Spring Hills, where he wanted to build an extraordinary French chateau. He hired the prestigious New York City architectural firm Dalano and Aldrich to design the estate. It took two years to cart in enough dirt to build his "castle on the hill." He had originally wanted his home to be built on the highest point on Long Island, but unfortunately, the property was not available.

The 126-room mansion with 109,000 square feet of living space was completed by 1919. Otto called his estate OHEKA after his own initials: **O**tto **He**rmann **Ka**hn. OHEKA became the second largest private residence in the United States, with Biltmore in North Carolina being the largest.

Kahn's estate included prestigious gardens designed by the famous landscape architects the Olmsted brothers, as well as reflecting pools, a greenhouse complex, an eighteen-hole golf course, swimming pools, tennis courts, a stable complex and even a private air strip.

French chateaus were known for having secret rooms and passageways. OHEKA was no exception. What is the ladies' room today, located off the main floor, was once a private office for Kahn's secretary. The only way to get to this office was through the library and a secret revolving bookcase. It is said that Kahn also had secret tunnels running from the main house to the harbor and another one to the Cold Spring Harbor train station. There is no proof that these tunnels existed, but according to the Eastern Military Academy, which occupied the building from 1948 to 1978, they did exist but were cemented shut and used for target practice.

Another strange rumor is that Otto Kahn kept wild lions and tigers in cages in the basement of OHEKA in order to keep out intruders. The structures or "cages" that existed were actually built as wind tunnels. It was Kahn's sophisticated way of cooling off the castle.

Otto Kahn died of a heart attack in the private dining room of Kuhn, Loeb and Company in 1934. He was sixty-seven years old and left behind four children. OHEKA was left vacant until 1939, when the New York Department of Sanitation used it for weekend retreats. By 1948, the castle and approximately 23 acres of the 443-acre estate was sold to the Eastern Military Academy. The rest of the property was divided up and sold.

Thanks to Gary Melius, the castle is back to its former glory and is used as a hotel and catering facility. Despite the hustle and bustle of activity at OHEKA today, spirits from the past have made themselves known.

The wind tunnels, once thought to have been lions' cages.

I contacted past employee Scott Bellando, who took me around OHEKA back in 1997 when only the first floor of OHEKA was restored. Scott was a caretaker in charge of both grounds and security, and he also lived in the building for ten years. Although he admits it was a spooky place back then, he only had one major paranormal experience there.

"One night, I was laying down in my duplex, which was off the first floor," Scott began. "I heard this beautiful music being played on the piano on the main floor. It was being played by someone who obviously knew how to play the piano. I kept listening and couldn't believe that someone was in the building. I walked down the steps, and it got louder. As soon as I opened the door to the first floor, it stopped. When I walked over to the piano, no one was there. There was not a soul in the building."

Scott's brother Rick Bellando, who has worked in sales at OHEKA for thirty-one years, shared his stories with me.

"When I first started here, I was working security. It was an abandoned building, full of vandalism. I was looking out the window when I saw an older woman walking in, by the main staircase. It took me no longer than a minute to get over there. When I got there, there was nobody around. She just disappeared," said Rick.

"Then there was a time we had a kerosene heater, and I was doing security on the night shift. This was probably 1985–86. The building was still being renovated, so we had a temporary office set up inside OHEKA. We had only these kerosene heaters to keep us warm. I remember I was dozing. The next thing I knew, I was sitting in the hallway. It felt like somebody carried me out. I don't remember getting up, how I got out or anything, but I do remember feeling like someone carried me there," Rick continued. "When I went back in, there were fumes from the kerosene heater and carbon monoxide. That was an incident that I can't figure [out] to this day."

There are times when Rick is working on the weekends in his office and not many people are around. He'll swear he sees a shadow walk past his door, and when he gets up to look, no one is there.

Shadow people are very common, and several people have reported seeing them at OHEKA, including Kelly Melius, Gary's daughter, who is director of sales. Kelly works in the corporate offices with Rick.

"The first time I saw it, I was working late by myself. I saw the shadow people walk back and forth past my door. I kept saying, 'Hello? Hello?' I looked, and no one was there. I called my husband and said if I'm not home soon, come look for me," Kelly laughed. "The dogs will see things as well. All of a sudden, they'll just sit up and just stare."

An orb in the window of a fourth-floor bedroom.

Like Scott, back in the early days, Kelly heard the piano play once on its own. She also stated that several guests have claimed to feel the presence of ghosts in some of the rooms on the fourth floor. Nothing bad has happened—it was just a feeling, and they brought it to the staff's attention.

"Some people have said they have seen a woman in the library," said Nancy Melius, Kelly's sister. "The library seems to be very popular," she smiled.

Nancy gave me the name and number of retired employee Maryellen Kobrin, who she said is

very intuitive. She worked as an administrative assistant for the corporate office for two years.

"I'd hear doors creaking, and then I would look and see a fleeting figure," began Maryellen. "Another time I was getting ready to go on vacation. Gary was joking with me, saying they couldn't live without me. Right after that, I was heading down the back employee staircase when it felt as if someone pushed my arm straight out. All the contents of my bag was dumped out. I actually felt the force of the bag getting pushed forward. I was thinking maybe Otto Kahn didn't want me to leave either," Maryellen laughed.

On another occasion, Maryellen was walking from the bar to the restaurant on the other side of the building when she felt a dog rub up against her leg. When she looked down, she saw a small, black ghostly dog run behind the bar. When she went to find it, it simply disappeared.

Lastly, I interviewed Lisa Farmiglietti, who worked as a waitress, bartender and maître d' assistant at OHEKA for three years and who firmly believes OHEKA Castle has several spirits.

"When I first started working there, I would start closing up [the bar and restaurant] around 11:00 p.m.," said Lisa. "Sometimes I'd forget something, and I'd go back. I would always have this overwhelming feeling that someone was behind me. It would happen right around the Charlie Chaplin room. One time I ran into some people from the Eastern Military Academy, who used to live here. They told me about a young man who died of an asthma attack in that hallway. What's weird is that I was studying to be an EMT. The people from the Eastern Military Academy said maybe the spirit was coming back to me looking for medical help. So after that, I'd start saying, 'I know you're here. It's okay.' After that, it was less intense."

Lisa experienced a few things in the Charlie Chaplin room as well. The Charlie Chaplin room is filled with images of the entertainer. He was one of Otto Kahn's favorites. It's a small, elegant dining room with an old-fashioned bar.

"There is a photo of Otto Kahn, Douglas Fairbanks and Charlie Chaplin on the bar in a stand in a regular picture frame," said Lisa. "I have watched it fall forward when nobody was in the room. The way that photo is situated, it would fall backwards, not forwards. Another time, in that same room, there was a silver tray on the bar. You'd hear it slide and then fall to the floor. I'd say to myself, how the hell did that happen? That bar is wide. There is no way it could slide and then fall on its own, and there was nobody around."

Lisa and another employee saw the shadow of a woman sitting in what once was Addie Kahn's room, and oftentimes she'd see shadows or orbs in the library. Lisa said she always sensed really good energy in the library.

"As for all the other experiences, none of it really bothered me. It was weird but not discomforting," she said.

Like its hidden rooms, no French chateau would be complete without a ghost or two. Whether it's spirits from the Eastern Military Academy or Otto and Addie themselves, OHEKA Castle is surely being guarded by the ghosts from long ago.

CHAPTER 21
LLOYD ANTIQUES

EASTPORT

One rainy afternoon, I set out for Eastport, where I was meeting Joe at Lloyd Antiques on Main Street. We had plans to interview Lloyd Gerard, who was going to tell us the story of his great-great-great-great-uncle Levi, who's been haunting the place for years.

When I arrived, I saw Joe and someone whom I assumed must be Lloyd sitting in the window of the shop. I walked in and introduced myself to Lloyd, who looked comfortable in an old red wingback chair surrounded by lots of antique knickknacks. I took a step up into the window, and Joe pulled over a stool for me. Lloyd soon began telling us about old Uncle Levi.

"He's a local legend," Lloyd told us. "Every Halloween, I get calls from people who want to see Levi. I tell them he doesn't just come out on command." He laughed. "One time, four young kids came in and went upstairs. I said, 'Is there something I can do for you, gentlemen?' They said, 'No, we're just looking for Levi.'"

Andrew Simon Levi came from Russia to Long Island in 1860. He was a teenager determined to avoid serving in the Russian army—a draft dodger. He became a traveling salesman, a peddler, selling needles and pins door to door. It is said he walked two months from Brooklyn to Montauk to Greenport to Orient and then back to New York for supplies. He traveled alone and never married. Levi died in 1926. For reasons unknown, his spirit has returned to haunt his great-great-great-great-nephew's store.

"I've always been a skeptic," Lloyd said. "But what I see, what I hear and actually what I smell—I have to believe, skeptic or not. Levi used to smoke

cigars, and we have smelled cigar smoke, and I don't let anyone smoke in here. The girl who works here said to me one day, 'Who's smoking a cigar around here?' I said, 'Nobody.' A few minutes later, she said, 'But I smell cigar smoke.' I said, 'It's Uncle Levi. He's here.'"

Uncle Levi always enjoyed playing practical jokes, and Lloyd says he still does. "He tips over tables, knocks things off shelves. He told one of my customers that a table upstairs was $65. It was a $400 table, and he tells this guy it was $65."

The apparition of Uncle Levi has appeared to many people, although Lloyd himself has never seen him.

"This guy across the street is a cook. He's seen him. He asked me one morning who lived upstairs in my store. I said, 'Nobody.' He was outside one night taking a break, and he looked across the street at the upstairs window, and lo and behold, didn't he see a short man smoking a cigar and waving at him? I couldn't believe it."

Lloyd's family has always been involved in selling things. Levi worked by himself as a peddler, and Lloyd's grandfather, Harry Goldstein, who came to America in 1880, had a store near the one now located across from Lloyd's Antiques. Unlike Levi, Harry sold goods from a horse and buggy until he got married and settled into his store.

"In 1923," Lloyd recalled, "my father and my uncle told my grandfather that they wanted to be partners in his business, and my grandfather said no. So instead, they built this building across the street from my grandfather, and they opened up their own store over here since my grandfather wouldn't let them be partners. It eventually put my grandfather out of business. Then they asked him if he would be partners with them. He did that a few years later."

Lloyd continued, "I bought this building from my father and uncle in 1978. I'm selling used what they sold new." He chuckled.

I asked him why he thought Levi came to this building if he never worked here. "I have a theory," Lloyd replied. "For many years, I would ask my father and my grandfather and my uncles where Levi was buried, and nobody knew. And I said to myself, that's a lot of baloney. There would be some record, something. But nobody would tell me. Then one day I happened to be at a funeral in Patchogue, and after the service, everyone is sort of wandering around the cemetery, and lo and behold, didn't I see a headstone that said Simon Levi? I just happened to see it. I said, 'That's my great-great-great-great-uncle. What's he doing buried here?' They had to know, but nobody would tell me."

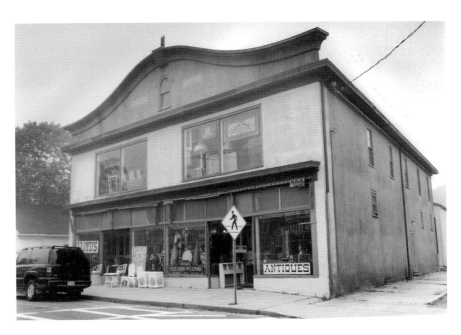

Lloyd's Antiques, where Uncle Levi's ghost appeared in an upstairs window.

Lloyd continued, "I went to the man who manages the cemetery, and I said to him, 'How come there is a gravestone over there with Simon Levi?' It was way over in the corner with a bunch of other small headstones. I said, 'What's over there?' He says, 'That's the potter's field. That's the area where we bury indigent people.' I said to myself, *He wasn't indigent. His relatives had money.* I went to see my father, and I said, 'You guys have been kidding me for many years. I was at the cemetery today, and what did I find? Uncle Levi. Why is he buried in a potter's field?' 'Well,' he said, 'we didn't want to pay for his funeral.'"

"My theory is that Levi is still here because he's annoyed," Lloyd said. "Nobody would pay for his funeral. He was their uncle. I don't think Levi had any money to speak of. He was a peddler. He just walked around. I asked for a copy of his death certificate, and his official cause of death was that *he just wore out.* Can you imagine? That's what it said. Is that a medical reason to die? He wore out?" Lloyd laughed.

Joe interjected, "But his spirit hasn't worn out, though."

"I think he's staying here to get even," Lloyd said. "Now everybody who knew him is gone: my father, his brothers, my aunt and anybody else who knew Levi is gone. He stays here. He's a friendly spirit. I mean,

he plays practical jokes, he tips over things, he tells people a table is $65 when it's $400," Lloyd smiled.

"And you sold it for $65," Joe said, laughing.

"I thought I better sell it for $65, or else. I didn't want to incur his wrath. He's been seen. He's been heard. I hear him. He walks around upstairs. It could go for months with no indication that he's here, then all of a sudden he'll knock something off a shelf, something will fall over in front of you when you're walking down the aisle.

"I think he's moved to my house," Lloyd continued. "I think he moves back and forth now. I have a grandfather clock that works intermittently. It keeps time, but it chimes when it damn well pleases. I spoke to a clock guy and asked, 'Why would a clock work sometimes and not other times?' He said, 'It doesn't happen. Either they work, or they don't work,' and I said, 'Oh yeah, well I have a grandfather clock that sometimes it chimes, sometimes it doesn't.' It will chime in the middle of the night, it will chime during the day, and then it will stop. I tell my wife, 'I think Uncle Levi has moved his venue.' Now he goes back and forth. I mean, is he mad at me? What did I do to him? I have been thinking that maybe what I should do is move his grave. I was told by the rabbi that it's not a good idea to do that. It's just not done. So I thought that maybe I should have some sort of a memorial, but I don't really want him to leave."

"So how do you explain that you were a skeptic and now all of a sudden…" I trailed off.

"I *am* a skeptic," Lloyd replied. "I always said that's a lot of baloney, but I know what I see, and hear, and what people tell me."

Joe commented, "Spirits can come and go, anytime, even if they don't need to make a statement anymore."

"They come back to say hello?" Lloyd asked.

"Yes. The wall between here and the other side is very thin," Joe replied. "It's good to be skeptical, though. It makes it more credible, because you're not a believer."

"Well, if it happened one time, like the cigar smoke smell, I would say maybe someone was driving past and it came in on a breeze or whatever, but it's been several times. And I don't know anybody around here who smokes cigars. So what's the conclusion?" Lloyd asks. "Logical or not, people come to see me and say, 'Where's Levi?' and I say, 'It beats the hell out of me,' but usually he's upstairs. He's a friendly sort," he continued. "People accuse me of using him for publicity, but I didn't start it. I didn't go looking for publicity. *Newsday* came to me, and a number of other

people, and the high school kids would hear about it. Everybody would come to see Levi.

"The legend has been going on since I've had the place," said Lloyd. "Before that, I don't know if anyone cared if something fell off the shelf. Something just fell off the shelf. I think I'm right—that nobody would pay for his funeral and he's annoyed."

"You know, the memorial is a nice idea because you don't have to move the grave," Joe observed. "If you had a nice stone, a proper one, then I think he would be satisfied. The question is whether he would stay or not. I don't know the answer to that. What do you think would happen?" Joe asked Lloyd.

"I think he would leave. I think he would say, 'Okay, that's all I wanted. I'm gone. I got what I wanted, and I'm out of here.' I don't want to get rid of him, but I want to do something for him."

"Maybe he'll like being in the book," I joked.

"All I can say," Lloyd concluded, "is Levi lives."

After we finished our interview, we stepped out of the window and said goodbye to Lloyd. He said we were welcome to look around and take some photographs, adding that maybe Uncle Levi would knock something over for us. Joe and I laughed and headed to the infamous upstairs. All was quiet. Joe walked around with his recorder while I took photos. On assignments, I shoot with two cameras. I had just taken some photos with one and set it down in the middle of a table behind me. I picked up the other camera and turned slightly to take a photo, when suddenly the camera on the table crashed to the floor. I was completely stunned. I had a bag over one arm and a battery pack over the other. Possibly I might have knocked it over, but it was not as if the camera had been at the edge of the table. I've had my equipment for over twenty years and have never dropped it, damaged it or even scratched it—ever. I found this "accident" hard to believe.

Joe looked at me and said, "Uncle Levi."

Luckily, for the most part, the camera and flash attachment were okay. I was still in disbelief, trying to figure out how this could have happened.

Several days later, I received an e-mail from Joe. He had picked up some EVPs on his recorder. He wrote, "I honed right into the camera episode which I thought would be a good starting point, since I also asked Levi to talk to us afterwards. The best EVP is when your camera crashed and I said something like, 'Oh, Levi? Was that you?' Right after, you hear a guy go, 'Psssst!' Like someone is saying, 'Come over here.'"

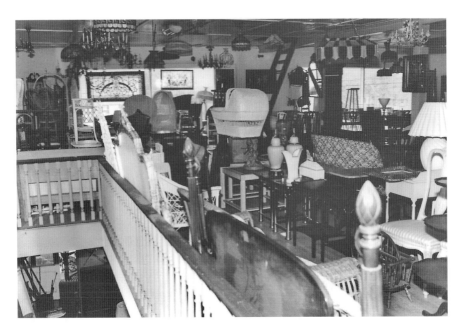

This photo was taken upstairs in the store just before the camera fell off the table.

I listened to what Joe sent over, and sure enough, I heard the voice saying, "Pssst!" In another EVP maybe five minutes later, the sound of glass breaking could clearly be heard. There was definitely no glass breaking in the store at that time. We would have heard it. Was Levi making fun? Perhaps this time, the joke was on us.

ROGERS MANSION

SOUTHAMPTON

Tucked away in the quiet town of Southampton is a grand Greek Revival home that is currently the headquarters for the Southampton Historical Museum. Back when it was built in 1843, it was known as the Rogers Mansion, home of whaling Captain Albert Rogers, who lived there with his family until his death in 1854.

Joe and I set out to meet with Laurie Collins, program and education coordinator for the museum. Laurie is an expert when it comes to many of Southampton's historic structures. Laurie began by telling us the early history of the mansion:

> *The land the house is built on was in the Rogers family since 1644, around the time when Southampton was founded. That is why Albert Rogers decided to build his house here, even though as a whaling captain, he sailed out of Sag Harbor. The house was originally located right on Main Street and was not as big as it is today.*
>
> *Captain Rogers was married to Mary Halsey, but she died young, before they had children. He then married her sister Cordelia, and they had three children, Mary, Jetur and Edwin. This was before the house was built, but all three children grew up in the house. After Rogers's death, the family lived here until 1889 when it was sold to Dr. John Nugent, who added the carriage house in the back corner of the yard. Dr. Nugent lived here from 1889 to 1899, when Samuel Parrish bought the house. He was the third and last private owner. He was a lawyer from New York City and bought*

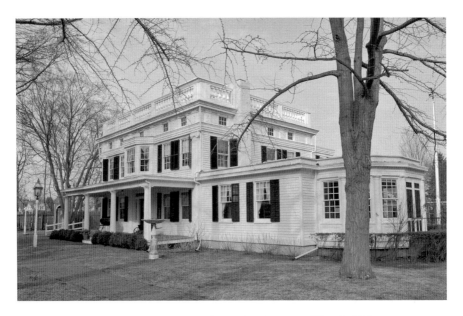

Rogers Mansion, currently headquarters for the Southampton Historical Museum.

the house as a retirement home; in this community he was a well-known philanthropist.

Samuel Parrish put a lot of money into the Southampton Hospital, he founded the Parrish Art Museum on Job's Lane and was involved with the Shinnecock Golf Course. He brought a lot of money into the community. He was very generous. He was a bachelor and didn't marry until age seventy-nine, to a widow who was a friend of his, so he never had children.

He did a lot of entertaining in this house. When he bought it, the house was still on Main Street. He began making additions in 1911 and doubled its size by 1914. He added the big room on the south side that we call the music room now, and this part of the house, which is the servants' quarters. In 1926, Mr. Parrish moved the entire house back one hundred feet from Main Street.

"Why did he do that?" I asked.

"He built the stores in front here, as a financial investment," Laurie told us. "But that was just before the Depression, the Crash, so it didn't turn out well for him."

We learned that a few years later, Mr. Parrish died from complications of being struck by an automobile in New York City. His wife remained in the house from 1932 to 1943.

"Mrs. Parrish wasn't happy here alone," Laurie continued, "so she sold the house to the Village of Southampton and moved back to the city. Before she did that, Mrs. Parrish saved the Parrish Art Museum financially. She really rallied for his causes here and kept them going."

The house itself was then used as a headquarters for the Red Cross and later the YMCA. Several alterations were made during these times to accommodate their offices.

By 1952, the Southampton Colonial Society had leased the house and grounds and began restoring it. Several historical buildings, including a blacksmith shop, a one-room schoolhouse and a paint store, were moved to the grounds and still exist today. During that time, collections and furnishings donated by members of the community started filling the house, and it became a museum. In recent years, the name was changed to the Southampton Historical Museum. The museum has changing exhibits three to four times a year and also has a research library available to the public.

As for the ghosts, there was no rumor that the Rogers Mansion was haunted at all, until several employees experienced phenomena that they weren't able to explain. Laurie herself is a skeptic. She does admit to experiencing some strange activity in the house, however.

"It was Sharen Dykeman, the previous director's assistant, who first started hearing things here," Laurie told us. "She was frequently alone in the building and had experiences for many years until she left in October of 2006. I thought, well…" Laurie laughed. "I was kind of skeptical. Sharen felt for some reason that the ghost was Cordelia Rogers, the second wife. I didn't really pay attention to the stories being told. Then one day I was here—I used to stay here alone on Sundays. Sometimes I was scared. I'd always go upstairs and shut things down while it was still daylight, so I wouldn't have to go up when it was dark out. One Sunday I was in the gift shop alone, the house was empty and I heard—it sounded like somebody moving furniture upstairs. It lasted for a couple of seconds. I just stood there for a minute, and then I heard it a second time."

Laurie continued, "I went to the stairs and started up a little bit, trying to find out if I could hear where the noise was coming from. It had sounded like it was right above my head. But as soon as I went onto the stairs, I never heard it again. I have no explanation of what that was.

"Then one day Sharen and I were upstairs in the library. She was sitting across from me, facing the door to the hall. I had my back toward the hall, and I heard footsteps. I turned around because I thought somebody was coming to the office, and she [Sharen] kind of laughed and said, 'Nobody's

there.' I didn't believe her, so I got up and opened the door and actually walked to see who was going down the hall. There was no one there. Sharen said, 'It's Cordelia!'"

Laurie burst out laughing, remembering the incident. "That was it. I started thinking, 'Oh, my God.' I said to Sharen once, 'If I wanted to haunt this place, I would be Mary. I'd be mad that I died and my sister married my husband and had three kids.' There is definitely something," she continued. "There are a lot of unexplained sounds here that I never paid attention to until those two times."

"Why does Sharen think it's Cordelia?" I asked.

"I'm not sure," said Laurie. "But she thinks it's a woman because the footsteps are light, not heavy like a man's. Things went on when changes were being made here. Sharen feels the spirits were unsettled then. Maybe Cordelia was watching over it, and if she didn't like it, she'd make noises, or maybe she was happy with the renovations."

After our interview, Laurie took us on a tour of the house. Before we left the kitchen, Joe asked into his recorder if there was anyone there, and he instantly experienced a cold spot. We made our way throughout the house. All the while, I had my electromagnetic field indicator on.

The ghost meter had remained quiet throughout our tour through the house until we entered the butler's pantry. The meter then went to its highest reading and was buzzing nonstop. Joe had his recorder going at the same time, and he said, "Wow. That's great. It's really keying," referring to the ghost meter. Joe then said, "The recorder is vibrating in my hand and is pointing to the sink."

The vibration Joe was getting is common when in the presence of spirits. When he analyzed his recordings several weeks later, he discovered an EVP right after he said the words, "pointing to the sink." The voice in the EVP said, "I will help you, Joe." Immediately following that, Joe, not having any knowledge of the presence of this EVP, said, "Somebody's connecting to it."

We made our way up to the second floor, where we all felt a cold spot. We toured the research library and the area where Laurie and Sharen had their experience and then we climbed the narrow, dark and winding staircase up to the widow's peak in the attic, an area not usually open to the public.

We toured every inch of the Rogers Mansion, including the basement, seeing if any connections could be made with the spirit world. Laurie revealed to us that many visitors to the museum ask if it is haunted, and the staff is always unsure how to answer. Laurie also told us another interesting detail. For unknown reasons, items in the building constantly go missing.

"Many times before we have museum programs, the lights also become a problem," Laurie confided. "The circuits get overloaded, but we have attributed the situation to the building being so old." Laurie said she laughs when it happens and says, "Maybe Cordelia doesn't want us to have a program today."

As we toured the museum, the rooms of the old building came alive with artifacts, antiques and exhibits that have been painstakingly assembled. We enjoyed these delightful rooms as much as we loved searching for the ghosts who may roam them.

Not long after our day at the museum, I made phone calls to Sharen Dykeman and Richard Barons, the director Sharen had worked with for six years. During my conversation with Sharen, I asked her, "Why Cordelia?" She answered, "It was just a feeling. There's no doubt in my mind that if there's a spirit there, it's a woman."

She went on to explain that she always opened the museum in the mornings. During that time, she would often hear the murmuring of female voices, along with scurrying footsteps. "I used to think there were raccoons upstairs," she said. "When I heard the voices, I could never distinguish what was being said. Another time, during a Civil War enactment we were doing, I heard footsteps upstairs. The play had taken place in the music room, and we had forty or fifty people. During the play, I kept hearing footsteps upstairs and thought maybe someone had gone up there. When I looked, though, no one was there and all the lights were off. It was never anything scary. I knew the presence was benign. I always assumed it was Cordelia."

I called Richard Barons sometime later. Richard had been the director of the Southampton Historical Museum from September 1999 until 2005–06. He is currently the executive director of the East Hampton Historical Society. During a phone conversation with him in which I asked him about the ghosts, he answered, "There was no question you heard sounds, especially on the second floor and in the attic and widow's peak. It's an old building—it could have just been the building. I must say though, I certainly did hear things, mainly in the morning. I assumed it was squirrels in the attic. But upon searching the attic, no squirrels were ever found. I side with Laurie. I think it may be Mary rather than Cordelia haunting the place. She would have more of a motive for coming back," he reasoned.

"But Cordelia did live many years in the house," I countered.

"Does anyone know how Mary died?" he asked.

"Not that I know of," I replied. "We did not know her cause of death, or where she died, for that matter. Was it possible that she died in the old house?"

Richard Barons explained, in his own words, that it "was an odd place to leave" because of how the electricity was set up. "It was always very dark, especially at night," he told me. "Because of the way the electricity was wired, you'd have to turn off a light switch and then walk down a darkened hall. It was easy for your mind to get the best of you. The upstairs hallway was strange," he added. "There was always a claustrophobic feeling there."

Can these feelings and phenomena simply be traced to the fact that it is an old house? Do our imaginations just run away with us, or could there be some ghostly truth behind the happenings experienced by many at the Rogers Mansion?

CUTCHOGUE VILLAGE GREEN

CUTCHOGUE

Long before the arrival of the white man, the Corchaug Indians hunted, fished and lived on the land now known as Cutchogue, which means "the principal place." Cutchogue is located on Long Island's North Fork. The first settlers in the area came ashore in 1659 and lived peacefully with the Corchaug tribe. By 1661, the town fathers began to formally divide the land and lay out lots, but official settlement did not take place until 1667. Many have said that Cutchogue was the town of Southold's first colony.

Much of Cutchogue's early history has been preserved, and many historic buildings remain. Joe and I met with architectural historian and director of the Cutchogue–New Suffolk Historical Council, Zachary Studenroth. Joining us were president of the council Michael Malkush and his wife, Carol, who is a trustee. Together we would explore three historical buildings located on Cutchogue's Village Green.

We began with the Old Schoolhouse, which was built in 1840 and served as Cutchogue's First District School until 1903. The one-room schoolhouse had stood directly across the street on Route 25 (known then as "the Kings Highway") until the number of students outgrew the building. It was moved to a local field, where it was used as a residence to house farmworkers. A new, larger school was built on the old site. The schoolhouse was used as a residence for at least fifty years. In 1961, it was donated to the Cutchogue–New Suffolk Historical Council, which moved it to its present location and restored it to its original condition.

The Old Schoolhouse.

"The Historical Council was founded in 1960," began Zach Studenroth, "by a group of historically minded people who were concerned about some of these older buildings being endangered and vacant. The Old House across the street had been there since 1660, but this [the Old Schoolhouse] was the first building brought to this site after the Historical Council was begun."

"Prior to the settlement here, this area was considered a meeting place for the Native Americans," added Mike Malkush. "A lot of arrowheads have been found in the area, and we have them displayed here."

The Old Schoolhouse, which once held about twenty-five students ranging in age from six to sixteen, remains as a museum today. It is open to the public and to school groups during certain times of the year.

"You can still see where the partitions were to make it into a little residence," said Zach. "We have one original desk, and the rest are reproductions from around 1840 until 1903."

After hearing about the Old Schoolhouse's history, we decided to give the ghost box a shot and see if we could communicate with any spirits who may be around. Joe started channeling who he believed was Mr. Travis, a favorite teacher who once taught at the school. Joe turned on the ghost box, and Zach began with a question.

Zach: "Mr. Travis, how many students did you have the last year you taught here?"
Spirit: "Five."
Joe: "Where did you go when you left Cutchogue, Mr. Travis?"
Spirit: "The stairs."
Joe: "He's coming over now."
Spirit: "Good."
Spirit: "…answer."
Joe: "Did you enjoy being a teacher?"
Spirit: "Yes."
Kerriann: "Are you happy that we're including the schoolhouse in the new book?"
Spirit: "Yes, I am."
Spirit: "I wrote…a book."

Satisfied with the connection we made, we left the Old Schoolhouse and headed over to the Old House, the oldest house still standing in New York State. It was built near Southold circa 1649 by John Budd, who was one of the earlier settlers of Southold. Budd was a successful merchant who was married to Katherine Browne, whose ancestors were kings and queens. Their wealth allowed them to build one of the biggest and finest houses in Southold.

By 1658, John Budd wanted to build a larger home for himself, so he decided to give the Old House to his daughter Anna and her new husband, Benjamin Horton, as a wedding gift. Benjamin had a large estate in Cutchogue. He hired his brother Joshua, who was a carpenter, to dismantle the house and move it six miles down the road. The land had to be cleared, and the house was rebuilt by 1660. The house was surrounded by forest and Indian trails, much different from the open space that surrounds it today.

Anna and Benjamin did not have any children, so after they died, the house was passed along to Benjamin's brother Joseph. When Joseph left Southold and moved to Rye, New York, he gave the house to his son John, who had no use for it. John sold the property to Joseph Wickham, circa 1699, and three generations of Wickhams lived there until around 1779. Parker Wickham, a well-known government leader, was the last of the Wickhams to live in the house. He, along with fifty-eight others, was accused of being an English sympathizer and was banished from New York. Parker died in exile in New London, Connecticut, in 1785. His house and land was confiscated and sold.

The Old House.

The Landon family and then the Case family came to own the Old House after that. Nancy Wickham Case, wife of William Harrison Case, was a direct descendant of Parker Wickham. Their family was the last of the families to occupy the house. In 1936, Frank Case died, and three years later, his wife and five sons transferred the house to the Independent Congregational Society of Cutchogue. The house was restored by the society in 1940, just in time for the Tercentenary Celebration of Southhold Town.

It remained unoccupied for many years and was used primarily for storing farm equipment. Today, the house serves as a museum and is furnished with antiques and period furnishings, which have been donated by several descendants of original settlers.

Zach describes the house as "a vernacular, first period house, medieval English in style, with a full two stories." The house has undergone a few changes and some restoration over the years. While touring the house, Zach showed me a display case of some old objects including small dolls, scissors and a comb. He explained how these objects were hidden behind a wall they needed to replace. I asked how the objects got there, and he told me that rats would enter the dwelling at night, pick up family objects and bring them back to their nests in the walls.

We made our way to the attic, where I took a photo as Zach walked toward the back of the room. It wasn't until weeks later that I found a dozen orbs in the photograph. Although paranormal activity hadn't been reported there, many spirits from the past were with us that day.

The next house we visited was the Wickham Farmhouse. This house is often confused with the other Wickham Farmhouse in Cutchogue where a brutal axe murder took place in 1854. It was a very famous story, and I wrote a chapter about it in my book *Ghosts of Long Island: Stories of the Paranormal.* Many people believe that the Village Green house is where the murder took place, but it did not.

The Wickham Farmhouse was built by Caleb Horton in 1704. Its original location was on Route 25, just west of the present-day village of Cutchogue. Caleb's grandson David eventually sold the farmhouse to John Wickham, and several generations of Wickhams lived in the house and worked the farm until the early 1900s. The house was moved back to its original location, and then in 1913 it was moved again to Route 48, Sound Avenue, where it was used as a home for tenant farmers. In 1964, Route 48 was going to be widened, and the house was set to be demolished. Its last owner, William Wickham, decided

Zach Studenroth surrounded by orbs in the attic of the Old House.

to donate the home to the Cutchogue–New Suffolk Historical Council, and it was moved yet again to the present Village Green in 1965. Restoration on the double Cape Cod farmhouse began, and it was completed by 1973. The interior of the house, which has a first floor and a full attic, has been reconstructed. A chimney runs through the center of the house, and there is some indication that there was a fire upstairs. It is also believed that there were partitions or small rooms in the attic at one time. The house now serves as a museum and is furnished as it would have been in early Victorian times, around 1830. The collections span several centuries.

A few years ago on separate occasions, two former migrant workers who had lived in the house came for a tour. One woman told the docent about what life was like growing up there. The other woman said she did not have a good experience in the house and was reluctant to talk about it.

"Those two women really validated that migrant workers lived there," said Mike.

There has been speculation that the Old Wickham Farmhouse has a spirit or two. Whether they are from the days the migrant workers lived there or if it is a former owner is unclear.

Paul Silansky has a technical, behavioral and management background and is the vice-president of the Cutchogue–New Suffolk Historical Council. He also is in charge of buildings and grounds at the Village Green. He has had some experiences in the house that could not be explained, and he was willing to share his stories with me during a phone conversation.

Paul always had a sense that there was good energy within the house—the pioneering spirit of the people who lived there. One day Paul experienced some unusual events in the Wickham house, and he began to understand that someone was trying to get his attention. The first occurrence took place on a very quiet, windless night around dusk.

"I went into the Wickham house at dusk to check on a few things, leaving the front door open to let some late afternoon remnants of light into the house. I made my way through the parlor to the back kitchen where the staircase to the attic is. I had some trouble with the door latch leading to the attic staircase. All of a sudden, the front door slammed. I went outside, and nobody was there. I thought to myself, *That's odd.* There was no wind at all—nothing—and no one was there. I went back inside the house, and this time I turned the lights on. I left the front door open, and right when I got to the back stairs, it happened again. The front door slammed shut. I said, 'Who's here?' but there was no one. I didn't think too much of it at the time, just that it was odd," stated Paul.

Wickham house.

"I experienced another occurrence with an attic shutter in the back of the house, on the south end. Every time I would close the shutter, it would open, even though I always latched it. It's latched with metal hooks. I'd lock it, and then the next time I'd go to the house it would be open again. It made no sense. It was ridiculous. It happened so many times that I started believing there was a spirit in the house," said Paul.

Paul wasn't the only one to witness the front door slamming. On another occasion, he came back with his significant other, Sheri, who had waited in the car when Paul went in to check on the house. Again, when Paul went to the back staircase, the front door slammed shut. There was absolutely no wind. Sheri saw it happen, and she couldn't believe what she was seeing. She swore she'd never go into the Wickham house again.

"After the door slammed, I came out and went down the front steps and around to the side of the house. I stopped by the first window, where there is a small light outside. For reasons unknown, I reached down to the ground, like I was going to pick something up. All of a sudden, I felt something near me, around me and possibly go through me. It was as if something was coming right through the house and out toward me," said Paul.

"It's almost like you were being led to that area to find something," I said.

"I had the distinct sense the spirit there was a woman, around fifty-five, sixty age-wise, and that she was a vibrant woman. I believe that something happened to her that was unfair, which made her restless and bitter," stated Paul.

"I never felt threatened. I believe she was hardworking and kind, but I think she's just angry and wants to make her presence known," said Paul. "Another time I was in the house with Mike's daughter, who was working on a project in the hearth. All of a sudden, the office door clicked open for no reason, and a few minutes later, the front door slammed. She ran out of the house. She inspected the area and had no explanation as to why that happened. She just couldn't believe it."

Paul continued, "I feel the spirit is calm now; that she's more at peace. I believe this may have something to do with the renovations and the care we've given to the house. Her energy is good. I feel that she was just angry and was letting out her frustrations."

CHAPTER 24
SWEET HOLLOW ROAD

MELVILLE

Imagine a long and narrow winding roadway surrounded by woods on either side, where ghosts and tales of terror abound. One such roadway is in the West Hills/Melville area of Huntington and is known as Sweet Hollow Road.

The number of stories I have come across regarding this place is incredible, including many versions that have been passed on and changed through the generations. When traveling along the roadway, especially on a moonless night, it is easy to get the jitters. Just when and where these hideous tales originated is unknown.

In the early 1800s, the area that stretched from today's Jericho Turnpike at West Hills through Broad Hollow Road in Melville was known as Sweet Hollow. At the time, the area supposedly had an abundance of wild honey. Another story claims that a farmer was traveling there with a barrel of honey when it fell and broke, "sweetening the hollow." In either case, it was the talk of honey that caused the locals to name the place Sweet Hollow.

By 1854, the town was beginning to develop, and the name was changed to Melville. The long stretch of trails through the woods, which eventually became a road, kept the name Sweet Hollow. Houses can be seen through the trees and are set away from the road. The surrounding area is composed of a public riding stable, a state park and county parkland with trails and a cemetery. There are places along the road where one can pull over and venture into the park, where all sorts of strange things have been said to occur.

One of the most well-known tales in the area is the story of the Lady in White. It is said that sometime between 1840 and 1851, a hospital was located near the crossing at Mount Misery Road. It mysteriously burned down, and many patients and staff were trapped inside. It was rebuilt fifteen years later. Only five months after the rebuilding, it supposedly was torched by an insane woman and burned to the ground again. The Lady in White, also known as Mary, was said to have been a patient at the hospital. It is rumored that moans, screams and cries for help can be heard and that small burning specters can be seen. Other stories claim that the "Lady" or Mary was pushed out of a car on Sweet Hollow Road by a jealous boyfriend. While her injured body lay in the street, she was hit and killed by another car.

Then there is a tale that there was a school at the end of the road, and the teacher who taught there killed all the children. Another version is that the school burned down, killing all the children, and still another claims that a camp counselor killed a group of children there.

An even earlier story goes back to the late 1600s and talks about Mary being a witch who was hanged and buried in the area.

In many of these cases, there have been reports of a "veiled lady in white" wandering about the road and in the woods, especially near the area of Mount Misery Road where the hospital was. The lady is said to appear and walk right out into passing cars, terrifying their drivers until she quickly disappears. Some say, if she was the woman who was hit by the car, that she roams the street looking for her killer.

Another source I came across mentioned a lady in red who was actually a gypsy and is said to occasionally roam the area, as well as a man in a checkered shirt who walks the woods at night, carrying an axe in his hand.

The most hideous ghost I heard about was that of a slain police officer. As the story goes, there is a police officer who stops cars parked on Sweet Hollow Road. The officer seems normal until he turns around and has blood on his uniform, and the back of his head is missing. An officer is said to have died in the area while on duty. When and if this ever happened, no one seems to know for sure.

Non-human ghosts are also said to haunt Sweet Hollow Road and include a black Labrador, a horse and a mysterious dog-like creature.

The "Black Dog of Misery," as the Labrador is called, is "an evil creature rumored to be a harbinger of death." It is quite rare for anyone to see the dog, but if you do, it's supposed to mean that death is on the horizon.

The ghostly horse has been seen and chased into the woods near the crossroads of Mount Misery Road and Sweet Hollow. Once it enters the woods, it simply vanishes.

In addition, there have been sightings of a dog-like creature that digs along where the woods meet the road and then stands on its hind legs and walks back into the woods.

One of the most recent ghost stories is about a teenager or several teenagers who hanged themselves from the Northern State Parkway overpass in the 1970s. If you honk your car's horn three times right before going under the overpass, it is said you will see the kids. A different version states that two boys were killed when they were hit by a car on Sweet Hollow Road. According to the story, they were unaware of the car heading toward them because the driver didn't beep the horn. They say that today, if you don't beep your horn before going under the overpass, the ghostly boys will jump in front of your car.

Finally, there is the story of a thirteen-year-old girl who was beaten and strangled in 1976. Her murdered body was found along the road. Supposedly the killer was never found, and the case remains unsolved.

The Northern State Parkway overpass where a teenager was said to have hanged himself.

As a teenager, I heard a story that if you drove your car in front of the cemetery on Sweet Hollow Road exactly at midnight, your car would shut off on its own. Having nothing to do one night, a friend and I tried it, but nothing happened.

Joe Giaquinto has experienced some unusual things during his investigations there. He says there are two recurring cold spots in the nature preserve, one near the entrance and another near a tree where the spirit of a woman forms on moss growing on the tree. The cold spots were felt by him and several others in his group. In some photographs he took alongside the road, faces appeared, as well as in the woods, where a hideous goblin face could be seen. A goblin-like creature was also found on the surface of a tree trunk when photographed.

So as you travel along this deserted, winding roadway, be alert. Perhaps you, too, will be able to add your own ghostly version of the unexplained.

WILLIAM SIDNEY MOUNT

STONY BROOK

For many years, I had heard that the William Sidney Mount house in Stony Brook was haunted—not only by Mount himself but also by Revolutionary War soldiers, a ghost named Elizabeth and possibly a not-so-friendly ghost who has been known to visit the Country House Restaurant just down the road.

Owned by the Ward Melville Heritage Organization and run by the Long Island Museum of American Art, History and Carriages, the Mount house is not open to the public. During my research, I could not decide which was more interesting—the house or the man who had lived there. Mount was not only a famous artist but also a spiritualist. He believed in ghosts and had his share of paranormal experiences.

William Sidney Mount was born on November 26, 1807, in Setauket. He went on to become a renowned American genre painter. William's brother Henry encouraged William, while still a child, to develop his artistic talents by using him as a helper in his painting shop. Before long, William began painting scenes from everyday life. He later studied at the National Academy of Design in New York and was made a full Academician by 1832.

Mount was also a musician and inventor who enjoyed fishing, walking, sailing and hunting, all of which he could do in his own backyard. According to the National Historic Landmark Statement of Significance, which designated Mount's farmhouse in 1965, "His genre scenes reflect his individualism, insistence on realistic portrayals, and his reliance on his own region and its people for subject matter." Rather than work in a studio, he

preferred to travel in a horse-drawn cart he invented himself. It became his "studio on wheels." It had a stove and a ventilator, a window and a skylight. The largest collection of his works can be seen at the Long Island Museum of American Art, History and Carriages in Stony Brook. At least 150 paintings and 400 sketches are on display there, as well as a collection of Mount's diaries that document his time spent in the farmhouse from 1830 to 1880.

The 1725 farmhouse is a wonderful example of American vernacular architecture and is the place where most of Mount's paintings were created. By 1965, the house had been placed on the National Register of Historic Places. In 1971, the homestead was given National Landmark status and, in 1981, State Landmark status. Mount's studio was on the third floor. According to his paintings, the house once had skylights.

The house was built by Eleazer Hawkins and was formerly known as the Hawkins-Mount Homestead. It served as a post office, operated by Jonas Hawkins, and later as a tavern. Hawkins's daughter Julia married Thomas Shepard Mount, a farmer and innkeeper from Setauket. They lived in Setauket and had five children. When William was seven, his father died suddenly, and Julia moved her family back to her parents' home in Stony Brook. During this time, the house was enlarged to eighteen rooms.

The house is yellow, which is believed to be the color it was when Mount lived there. Twentieth-century renovations began when philanthropist Ward Melville purchased the home in 1945. During this time, the Victorian gables that had been added sometime after Mount's death were removed. Ward Melville was a collector of many of Mount's paintings. Eventually, when the museum acquired it, the house and barns began to be restored to the historically correct time period.

William Sidney Mount died in Setauket at sixty-one, on November 19, 1868. His paintings live on, and so, too, may his spirit—Mount had a great interest in the paranormal. In fact, early in his career, his paintings dealt with death, ghosts and the supernatural. It is not known why Mount was drawn to these things, but according to his spiritualist diary, he was actively involved by 1854. In a May 6, 1854 entry, Mount wrote, "It is true spirits can and do communicate with mortals, and all cases evince a desire to elevate or progress the Spirits of those with whom they are in communion."

A few paragraphs down, he writes, "Mediums have written upon subjects with which they were not acquainted, in languages they did not understand, in a style of letter or character that they had never used before, and with a degree of rapidity which cannot be imitated by any living penman."

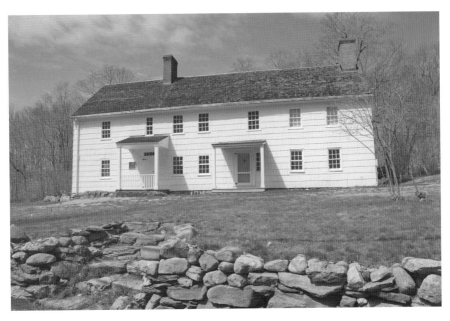

William Sidney Mount house, once lived in by the artist.

He adds, "Some Mediums see spirits, and describe their appearance so accurately that their identity cannot be doubted. Others have heard spirits speak, and many are impressed by Spirits in an unmistakable manner."

While taking a walk through Setauket in March 1854, William decided to visit one of his aunts. On his way, he encountered an old woman. She had had an amazing experience that had brought her great comfort. Apparently knowing Mount's beliefs, she told him her story. Mount was so moved by it that he wrote it in his journal entry on March 11: "She related that she had heard her son John who was dead distinctly speak to her, and she had often felt his head against her cheek. She…believed that the spirits of our departed friends are around us."

Mount had become part of what was called a "Miracle Circle." He explained, "Ministering spirits are sent by the Divine Being, our heavenly Father." Mount was referring to séances. He was a very good friend of Thomas Hadaway and attended many séances at his house (now the Country House Restaurant) and in New York City.

In a diary entry from November 26, 1854 (Mount's birthday, incidentally), he went on to explain events that had taken place within "the circle." During the séance, the Jacobean playwright Ben Jonson came through. Mount

described "other manifestations of unseen presences that night: the center or middle table kept moving for some time—pencils and letters were handed to different persons by invisible hands. I had my foot taken hold of by a spirit hand. A gentleman was requested to place his hand under the table; it was grasped by a cold spirit hand. Raps were frequent, and we felt touches. An autographed letter was received with nearly all the names of those present and they declared their signatures perfect—but not one had any knowledge of having signed it."

Without a doubt, Mount believed he communicated with the spirit world and in doing so became closer to God. Mount had a great love for God but a loathing for organized religion; he thought it was narrow-minded, and he did not believe in the fire and brimstone of his day. Mount believed God to be a loving God and forever with us. Some argued against these beliefs.

Mount was told the following story during one of the "circle" meetings, and he was impressed with how it ended. A woman was attending a conference in New Hampshire, and her only purpose there was to argue against spiritualism. Mount noted in his diary, "One lady, who was a bitter opponent…felt impelled to look the matter in the face for herself. The result was a long and beautiful communication from the spirit of her daughter, which affected her even to tears, and she left the medium a full believer in spiritual intercourse, saying she would not take a hundred dollars for the consolation derived from that interview. So much for clerical opposition."

The most intriguing aspect of Mount's beliefs was that he was receiving professional guidance from beyond the grave from the famous Dutch painter Rembrandt, who had died in 1669. Rembrandt came through to Mount by way of letters given to him by a medium called Nozen. Apparently Nozen had the gift of automatic writing. In the first letter, Rembrandt "wrote" to Mount, "You are the best national painter of your country…what I would state is that your pictures are, generally speaking, of purer cast than those of your contemporaries, and better calculated to inspire the judicious portion of your countrymen with a commendable pride for national talent."

In that letter as well as the second, Rembrandt gave Mount advice on painting. He "wrote," "There is somewhat too much of a sameness of design in most of your pictures…you are too prone to repeat the same subject in a different point of view." Rembrandt encouraged Mount to have confidence in his work: "Without a proper degree of confidence in ourselves we cannot arrive at that degree of perfection at which a true artist aims." The rest of the letters reveal specific suggestions in achieving brilliant color contrasts, as well as secrets Rembrandt used in his own works. One letter ended with, "On

some future occasion I will commune further with you. In the interim, receive the best wishes for your spiritual and artistic progress from…Rembrandt."

Shortly afterward, however, Mount became disenchanted with spiritualism. Many people thought that since he was an artist his beliefs were eccentric, while some believed he was hallucinating. Other skeptics claimed that "the letters from the spirit of Rembrandt actually represent long-deliberated thoughts on aesthetics in general and painting in particular" and that "Mount cast them in the form of communications from the spirit world simply as a striking literary device."

By April 1855, Mount, greatly discouraged, wrote to Thomas Hadaway. He began, "Believing you to be a sincere spiritualist searching after truth fearlessly wherever it may be found…" He wrote about a medium, Mr. Stewart, who attended the "miracle circle" and was writing a book disclaiming spiritualism. Mount continued, "[Stewart wants] to show spiritualism to be a Humbug, as he had deceived many prominent individuals interested in spirit manifestations and intended to bring their names before the public." Mount was terribly upset by this. He wrote, "If the report be true, I am sorry for him, and I hope God will have mercy on his soul." Mount wasn't sure what to believe anymore. He no longer wrote about spiritualism in his diaries. He remained a skeptic of traditional religion, but his love for God endured.

William Sidney Mount died of pneumonia just weeks after his brother Shepard, to whom he had been very close, passed away. It is possible that Mount maintained some glimmer of spiritualism. He wrote in his diary, "On his deathbed, Shepard seemed to be gazing with admiration into the spirit world."

Is it Mount who haunts the old farmhouse? Is he upset that he pushed aside his spiritualist beliefs while on earth and is somehow trying to make amends by helping others on their own spiritual journey?

Before knowing anything about Mount or his beliefs, I had come across a *Newsday* article from October 1998, entitled "In Spirited Company." The writer mentioned several haunted places on Long Island but claimed that Elizabeth Mount, first cousin of William Sidney Mount, is the one who had haunted the house. It wasn't until after William's death, however, that the ghost of Elizabeth was seen. The article states that in the late 1960s, a family who was living there at the time experienced paranormal phenomena. They had a five-year-old daughter named Elizabeth who claimed that "a woman dressed entirely in white appeared at the foot of her bed" one night. The young girl apparently had been unhappy living in the old house. She told her parents that when the woman came to visit her, she said that her name was Elizabeth too, and she welcomed the girl to the house and told her that she would be happy

William Sidney Mount self-portrait, 1832.

living there. The parents dismissed the claim as a dream. Shortly thereafter, phenomena began to occur, such as faucets turning on by themselves.

A past president of the museum (then called the Museums at Stony Brook) accused *Newsday* of starting the whole "ghost thing" because of an article it had written a few years before. The past president said that tenants after that family had no such experiences and that she herself had lived there for some time with nothing unusual going on. Still, the stories continued. A woman I interviewed for another story told me that she had been friends with the family who had reported the ghost. Here is what she had been told—directly from the family:

"They all had psychic experiences in that house. They all had seen [apparitions of] people in Revolutionary War costumes, but they didn't tell their youngest daughter because they didn't want to frighten her. She was eight years old. One day the girl came to her mother and said, 'Who is that standing at the top of the stairs in that funny blue dress?' The girl saw her, but the mother didn't."

Bob Willemstyn, owner of the Country House Restaurant, swears the house is haunted by two spirits. Bob claims that on occasion, a belligerent presence is felt at his restaurant, which is also haunted by the benign ghost of Annette Williamson, who died during the American Revolution. Bob says he knows when "the bad spirit from down the road" makes an appearance and even thinks it may be Mount.

"When he's around, a lot of stuff starts to break," Bob said, "including wine bottles in the basement. They're just thrown off the shelves."

On a few occasions, several staff members have claimed to have seen a black hooded or cloaked figure sitting at the bar. When they go to retrieve Bob and come back, the figure is gone.

I spoke to Joe, who tried to make sense out of who may be haunting Mount's house. Mount was a kind-hearted, religious man who loved life and his work. It doesn't seem reasonable that he is a bad spirit, if he is around.

"Spirits are the same people they were when they lived on the earthly plane, the same personalities," Joe remarked during our discussion. "I feel that if Mr. Mount is the one who occasionally visits Country House, it is because he is looking for his good friend Thomas Hadaway. I think Mr. Mount is frustrated because he wants to get his beliefs across. He knows they're true now, and he's upset that he let it all go when he was alive. So maybe by knocking things over and breaking things, he wants people to know they can communicate with him—but it does seem like he's frustrated."

We walked around the Mount house, trying to get a sense of things. As we did, a remarkable phenomenon occurred. On one side there is a small screened porch. As I was photographing the back of the house, Joe yelled out from a few feet away, "Look over, quick!" I saw that the previously closed screen door was hovering open, as if beckoning us to come in. There was no wind, hardly even a breeze. The door swayed slightly for a few seconds and then closed gently.

I went over, pulled the door open and let it go. It immediately slammed shut, so there was no way the door could have been opened and stayed open. During our walk around the house, Joe had his recorder on. After our investigation, we went back to listen to what went on before the door opened by itself. On the recording, we heard Joe say, "I think Mr. Mount is here. He was very unhappy with what happened with the spiritualist movement. He got disenchanted with the whole thing." A voice can be clearly heard saying, "True," following Joe's statement.

Within a few minutes, the screen door had opened. "Did you see the door open?" Joe asked me, and I said yes. "The door opened and closed for us," Joe said. "We just had a phenomenon. The door beckoned us. I think Mr. Mount opened the door for us. Thank you, spirits. Do you want me to take a picture?" A spirit answered, "Okay."

On the recording, Joe went on to talk about a "different breeze, a cold wind. We have spirits around us now." As soon as he said that, I said, "Joe, look!" Up in the sky were two hawks. "One for each of us," Joe remarked. "The spirits are with us."

After we finished listening to the recording, I asked Joe if he believed the EVPs and the door opening was the spirit of William Sidney Mount. He answered, "Mr. Mount would have the most to gain by letting us know it was him. There were a lot of related events that in context, taken together, give a body of evidence."

Was William Sidney Mount communicating with us? I hope he is at peace, knowing that his beliefs in the afterlife and the spirit world have been confirmed.

CHAPTER 26
OLD BETHPAGE VILLAGE RESTORATION

OLD BETHPAGE

On 209 acres in Nassau County there sits a mid-nineteenth-century colonial farming village, complete with a general store, blacksmith shop, church, tavern and farm with live animals. Once you leave through the back doors of the modern visitors' center, you immediately travel back in time on dirt roads and tree-lined paths, while you pass open fields, farms, horses and homes now deemed historic.

The Old Bethpage Village Restoration opened to the public in 1970. It showcases approximately fifteen nineteenth-century buildings from various areas of Long Island. These houses, such as the Benjamin house, came from as far east as Northville on Long Island's North Fork. Other homes came from Smithtown, Woodbury and Hempstead. These wonderful examples of history were brought to the site and were meticulously restored and preserved for future generations to enjoy.

Some claim that by moving the houses, the unrestful spirits of those who once lived there have come back to make their presence known. It has been rumored that many of the houses and buildings at the Old Bethpage Village Restoration have been haunted for years. Eyewitnesses include both patrons and employees who have experienced all kinds of paranormal activity.

It was a crisp fall day when Joe and I set out to tour some of the old houses. I had been there many times as a child, and it still looked as if time stood still. It was a week before Halloween, and there was already a

spookiness in the air. We met with longtime employee and museum guide Joanne Graves, who has been working at the village since 1995, and Rich Gisonda, a seasonal guide who has been employed there since 2001. They were a wealth of knowledge when it came to both history and ghosts.

Although most of the buildings at the Old Bethpage Village Restoration have had some sort of ghostly activity, we concentrated on three houses: the Hewlett house, the Conklin house and the Williams farmhouse.

The first house we came across on our journey was the Hewlett house from Woodbury, which was brought to the site in 1968 before the village was open to the public. It is named after the family who lived there, and it was built by Captain Charles Hewlett in 1794. He was a Loyalist and fought alongside the British during the Revolutionary War. After the war, like many of the Loyalists, he was briefly exiled. He then came back and built his house in 1794. It is restored to 1840 when Captain Charles Hewlett's son Lewis lived there. Lewis had inherited the house from his father. Lewis's wife died by 1840, so he lived there alone with his younger sister, who had never married. Lewis was about seventy years old at this time. He did share his home with several African American farm laborers who had a separate upstairs wing off the kitchen.

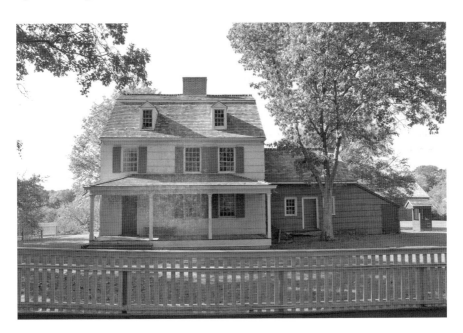

Hewlett house.

"We've gotten EVPs there [in the laborers' quarters]," said Joanne. "I was with the maintenance man, and we got an EVP of a man saying, 'Go down!' when we were going up. I guess they didn't want us up there. Before I started working here, I came with my daughter. I didn't know any of the stories about the house. We were at the tail end of a tour, and as I got here to this spot, I felt very lightheaded."

"What is this room?" I asked.

"It's the dining room, but it was right over here," Joanne pointed to a small area heading toward the kitchen. "So I was feeling really lightheaded, and my daughter grabbed my arm. She was about fifteen at the time and said, 'Let's get out of here!' I said, 'You feel something too?' My daughter said, 'Let's get out of here now!' A lot of young girls don't feel good right here at the entrance to the kitchen."

We walked through and into the kitchen, and then we moved toward the back where the laborers stayed. Joe looked up a very steep and narrow set of stairs that was more like rungs on a ladder. He poked his head up and looked around the loft area that had been the living quarters for the laborers.

"We've gotten a lot of orbs up there," Joanne said.

"I just heard a man's voice," said Joe. "I think he just said, 'Go!' We're just here to say hi. Is that okay with you?" Joe said, speaking to the spirit. He paused, listening for a response. "Okay, he said yeah, it's okay. He's talking. He still feels this is part of his life. And he just wants to let you know he's here. He doesn't like people climbing up into his bedroom. His wife—there were married people up here?"

"Yes," replied Joanne.

"In 1840, there were two couples, actually three African American farm laborers, two women and a son. They would have lived up there," said Rich.

"He doesn't like people just walking up there," said Joe. "And this is where you got the EVP, 'Go down'?"

"Yes," Joanne replied.

"The temperature is dropping—a lot," I said.

"Yeah, they're coming to listen," said Joe. "They're here."

"Not long ago, we had three girls come through on a tour," said Joanne. "I think they were in their early twenties. They came up to me at the end of the tour, and one of them said she was poked in the back. She didn't say anything to her friends. One of them said they saw someone behind her, and the other girl said she had her ear flicked."

"I just saw a figure," said Joe. "I just saw the shadow of a figure here. I think it's a young male."

"I keep feeling something behind me," I said.

We continued along on our tour of the house, passing a portrait of Captain Charles Hewlett in the parlor. Joanne and Rich continued to tell us stories about EVPs they've gotten in the house, including the sound of footsteps coming down the stairs when no one else was there. A female employee who had been doing cooking demonstrations in the house several years prior was in the kitchen alone when she felt someone pull her shoulder back. She turned and saw that her co-worker was in another room. She happened to look up and saw the initials LH branded into the ceiling. She had never noticed it there before. From then on she felt the ghost was that of Lewis Hewlett.

When the house first arrived on the property, security guards would often see a woman in white circling the home. One security guard entered the house when he heard the alarm system going off one night. He went upstairs to turn it off when he heard two people talking downstairs. He thought he was going crazy. No one was in the house. He ran to the front door to leave, and the door would not open, so he jumped out the window. The next time he came to the house, the sound of a man laughing could be heard when he was leaving.

A docent, who was a complete nonbeliever, heard someone say, "You can't go up." After that incident, she didn't want to work in the house anymore. Besides getting EVPs and orbs, Joanne witnessed a candle popping out of a candle holder in the kitchen for no apparent reason.

Leaving the Hewlett house behind, we made our way over to the Conklin house, a small, one-and-a-half-story saltbox construction, which is situated toward the center of the village. It was built circa 1820 by Thomas Hallock from Smithtown. Thomas had a tavern, and the house was actually a part of that complex. Joseph Conklin, a stagecoach driver from Greenport, would often stop at the tavern and spend the night during his two-day trek to Brooklyn. It was there that Joseph met his wife, Thankful, who was Thomas Hallock's niece. They ended up buying the house from her uncle in 1853. Their daughter Sarah was born in the house. Apparently they had a son while living in Greenport, but he was not listed on the census after the age of seven.

"A lot of visitors see spirits here," began Joanne. "Two different ladies at two different times saw a little girl about eight years old. One saw her sitting out on the porch with one of the docents. The other woman saw her sitting on the steps. They both said she looked very sad. Frequently a docent will hear children running upstairs and think kids got in without their parents. When they go up to reprimand them, there's no one there."

Conklin house.

Many people have seen apparitions in the house. A visitor once saw a woman standing at the top of the staircase and thought it was a docent. The docent who had been working on the second floor had already left, and that area had been closed to the public. Joanne told us about an eight-year-old boy who was with a school group who had an experience a week before our interview. As the group was leaving the house, he asked the gentleman who was giving the tour, "Who's the yucky lady upstairs?"

"It's been a consistent story over the years," said Rich. "When visitors come here, they sense a logical presence of someone on the second floor."

Several people have also seen a woman sitting in the chair by the fireplace on the first floor, and a woman hired to do inventory heard her name being called when no one else was in the house. A twenty-three-year-old woman who could see spirits came to visit the Conklin house with her mother. As a child, the young woman recalled seeing a man in spirit upstairs. She came back to see if he was still there.

"She said to me, 'He's still here,'" said Joanne. "He told her he wants us to get out. He was not angry, but he was saying that this was his house and this house shouldn't be here."

"So he was upset that it had been **moved**," I said.

"Yeah, it made me feel sad," Joanne replied.

Right after this conversation, Joe saw a figure out of the corner of his eye.

The last house on our ghostly tour was the old Williams farmhouse. The Williams family had been the sole proprietors of the house, which had been built in stages from 1820 to 1850. It started out as a much smaller home, a center hall with several rooms, and then the family expanded it over time. It was originally located in New Hyde Park, and it has been restored to about 1860 when Henry Williams was living there. Richard Williams, Henry's father, built the house.

"What kind of phenomena have you had here?" Joe asked.

"We've heard footsteps walking in the hallway," said Joanne, "and the sound of someone coming in and no one was there. There's been things moved around as well."

A docent had reported that an iron had somehow moved from one room to another and that a picture that had been hanging over the mantel was moved. Another woman who had worked there heard a voice saying, "Get out of the house!" She ran out and was very scared.

"The cleaning ladies were here, and they were working in the sitting room," said Joanne. "One of the ladies started dusting the teacups. She

Williams farmhouse.

heard a voice say, 'Put my teacup down.' She asked the other woman she was with, 'Did you say that?' She said, no, she didn't. She wasn't in the same room when it happened." Joanne continued, "I heard about this story, so one day when I was in the house I took a recorder and put it by the tea set and started recording. I got an EVP saying, 'Take the box up and go,' the box being the recorder."

Henry's sister Ester was a spinster, and she could always be found at her sewing table. One day a docent was working at the table, which dates back to 1860, when she kept hearing noises upstairs. They were subtle at first, and then they got louder and louder. She went to find Joanne, who was outside, and the two of them went upstairs together. The trunk wasn't moved, but it was open and the fabric was strewn about the room. The women thought that it must be Ester. Several people have heard the sound of children laughing in the house as well.

As our interviews and investigations came to a close, Joe and I surmised that the ghosts of the Old Bethpage Village Restoration continue to keep watch over the homes they once lived in and loved.

CHAPTER 27
GLEN COVE MANSION

GLEN COVE

It is interesting to note that no matter how many times a home changes hands, sometimes the original owner or owners just refuse to leave—that is, if we're talking about the spiritual world. A spirit or energy can attach itself to a place just because it meant something to them at one time.

In the case of the Glen Cove Mansion in Glen Cove, the Pratt family seems to be in no rush to leave.

Charles Pratt was born in 1830 and came to Glen Cove around 1890. He was a pioneer of the U.S. petroleum industry and became one of the founders of John D. Rockefeller's Standard Oil Company in 1874. Pratt was also an advocate of education and founded and endowed the Pratt Institute. Like many successful philanthropists in his day, he wanted to build a summer home on Long Island's Gold Coast. He happened upon a tract of land in the northern part of Glen Cove, just south of Dosoris Island. He purchased more than 1,100 acres, where he would build his mansion and, later on, the homes and estates of his children. John Yapp Culyer, a civil engineer and landscape architect, was hired to set out the roads and sites for the family houses and service buildings. Pratt's dream was to have his entire family living close by. The site became the largest estate compound on the Gold Coast.

Not long after having purchased the property, Charles Pratt passed away. He had spent his last days living in the former residence of John Coles and had used it as a summer home while the various other Pratt homesteads were being built. Mr. Pratt had renamed Coles's homestead "Manor House,"

and Pratt's wife, Mary Helen Richardson Pratt, remained in the home after her husband's death in 1891. Even after the other Pratt estates were built, Manor House served as the center of Pratt family life. When Mrs. Pratt died, her son John Teale Pratt, an attorney, philanthropist and executive with Standard Oil, lived in the house for a while until he had it taken down and had his own residence built on the same site.

The two-and-a-half-story, twenty-three-bay, long brick Georgian Revival building was designed by noted architect Charles Adam Platt and built on John Teale Pratt's property, which still consists of fifty-five acres. A magnificent cement and limestone portico extends the full height of the building and is composed of Corinthian columns that support a triangular pediment. The interior contains an impressive foyer with Ionic columns and a large, elegant double staircase. An Olympic-size pool, which was installed when the house was built, remains on the property today. It was, and still is, a very regal and handsomely made house. John Pratt used the name of the original home that his father had lived in, calling it the Manor House.

The Pratt family continued to build beautiful summer homes that were used by Charles Pratt's children and then his grandchildren.

John Teale Pratt died in 1927, and his family and widow, Ruth Baker Pratt, remained in the house. Ruth Baker Pratt was the first Republican

A partial view of the Glen Cove Mansion.

congresswoman from the state of New York, representing the city's "Silk Stocking" district. She died in the house she loved in 1965.

The staff at the Glen Cove Mansion, formerly known as the Harrison Conference Center, believe the house is haunted by more than one ghost, the main spirit being that of Ruth Baker Pratt.

Michelle Laredo Torres, director of conference planning, told me that many of the guests have reported seeing an older woman in the former servants' wing, which is now used as a recreation and lounge area.

"For years I've heard from meeting planners or guests that they've seen somebody sitting in the corner up here in the old servants' wing. They see a full apparition, and they always say it's an old lady sitting in the corner in a high back chair, and she's smiling," Michelle explained. "These people had no prior knowledge of the story of Mrs. Pratt. It's been reported consistently over the years."

Lisa Jordan, director of sales, told another story. "We were having a meeting in the Magnolia room, Mrs. Pratt's old bedroom, and it was in the summertime. It was very calm outside. There was a pause in our conversation during the meeting, and all of a sudden through the fireplace came this loud whoooosh-ing sound, even though there was no breeze. We all said, 'Mrs. Pratt. Meeting adjourned,'" she laughed.

Even people on the staff who haven't experienced anything themselves have heard stories of some sort. Lana Lamplough, who has been with the mansion for over twenty years, relayed the following incident.

"I'd heard a story about a former co-worker who was a manager on duty and had stayed overnight here. She was in bed, and all of a sudden, she heard the shower running. She looked around, jumped up, went into the bathroom and the shower was running full force. It wasn't like it was dripping—it was running full force." Lana continued, "The woman was befuddled and scared, not knowing what caused this. She turned off the water and said, 'Maybe it's Mrs. Pratt.' She went back to bed, settled in and it started running again, full force. It happened a few times. Finally she called engineering, and they came down. Of course, they could find nothing."

Executive Chef Brendan Slaven heard a story from one of the former Harrison house bartenders. He said, "She actually saw her [Mrs. Pratt] up here during the slow season in January. Nobody was in the building, and she was closing up the bar when she literally saw a woman in a white dress walk across in front of the bar. She said to her, 'Excuse me, ma'am, the bar is closed. You're going to have to leave.' But she just kept going until she disappeared."

The upstairs room where Mrs. Pratt has been seen.

The ghost of the woman is not the only apparition that has been sighted at the mansion. At one time, there was a rumor that Mrs. Pratt's son had committed suicide in the house by hanging himself. This story is untrue. However, no one has been able to figure out who the "man in brown" may be.

Front desk supervisor Shirley Jimenez recalled a time when she felt the need to call security. "I was working at the front desk late at night," she told me. "No one was supposed to be there at the time. I saw a man in brown clothes pass by the front desk, and I said, 'May I help you?' He didn't answer, so I started screaming into the radio, 'Help! Somebody's here!' They searched for the man, but nobody was there. I thought maybe I was just seeing things because I was working alone and I was scared. But as it turned out, someone from housekeeping saw the same man heading toward the administration office on the same night. So I knew it wasn't just me—two people saw him. The other woman said he was just looking around. Security never found him."

Andrew Schmidt, night auditor, saw a different type of apparition. "I was doing the night audit," he said. "When things get very quiet and you're by yourself, you start to hear and see things that you question: 'Am I seeing this or not?' We're talking between two and three in the morning. I could

be standing there, and out of the corner of my eye I see things pass in the doorway, in the hallway. I go out and I look around and there's nothing there. I'm right at the front desk. When things pass, the overhead speakers, like clockwork, get very staticky and they skip out. At the same time, I get goose bumps up and down. Every time, every night, the same time, the same activities," he paused. "So I don't know. Maybe I'm getting a visit. I'm not sure. It's just a strong presence, a tingling feeling, shadows and things you hear down the hall when there's nobody around." I asked Andrew if he saw the shadows head on or out of the corner of his eyes. "Yes, out of the corner of my eyes," he replied. "Peripheral vision. They just pass. Some are fast; some are slow, like they're just drifting along. They're black, like a shadow. You can make out the form of a body, but there's no solidness to it. It will just zip past the doorway or float past."

What Andrew described is the phenomenon known as shadow people. Andrew had never heard of the term before, yet he described exactly what they are and how you see them.

Michelle and Lana have not seen shadow people, but they recalled times when they experienced unusual things while working late.

"I used to work late a lot of times," said Michelle, "and when I was alone, I'd get the feeling like someone was behind me. I would turn around and nobody would be there. I don't work nights anymore," she laughed.

Lana told me, "There was a time I was here late at night, and I was alone in the building. I heard one of the office doors close. My first thought was 'Oh, somebody's in the building.' My ears pricked up, and I went to the office and I looked in, and of course nobody was there. So I shut the door and went back to work. I heard it open and close again, so I said, 'Okay.' I went back to the office, and I made sure all the windows were closed, because I thought perhaps a draft had closed the door. All the windows were closed, and I actually closed the door and pulled it really tight, just in case the latch wasn't working right. I tugged at it to make sure it was securely closed." Lana continued, "I went back to my desk—and it happened again. So I had to accept the fact that someone was with me. I wasn't alone. I wasn't scared though. I'm open to things now. I figured it was just Mrs. Pratt."

Other things have happened at the mansion that no one can figure out. Jaime Bellmore, food and beverage supervisor, told me, "In the Meadow Room at the same time every day, I think it's at 3:00, one window pane fogs up like someone is standing outside and breathing on it. It occurs every day at the same time, no matter what time of year it is. It's been going on for years." She continued, "Downstairs in the basement where our offices are,

doors open and close on their own. The basement's weird. It's definitely kind of creepy down there."

Lisa Jordan added, "There was an incident in the Forum Meeting Room downstairs. The story was told to me by someone in engineering. There are windows with walls covering them now. They were sealed up, but there's a space in between. Some of the staff were standing outside, looking up at the Forum Room. They noticed that a light was on in the window—except there are no lights between the wall and the window. You can't get access to it, either, so it would be impossible for someone to be in there. They never figured out what it was."

"Everyone who works at the mansion knows about Mrs. Pratt," Shirley Jimenez remarked. "Anything that goes on that can't be explained, they blame Mrs. Pratt. The most active areas are probably the third-floor servants' wing, Mrs. Pratt's bedroom and the Meadow Room. Lights will dim at times, and music on the stereo will go up and down in volume."

The elegance of a bygone era remains today in this beautiful home that is both a hotel and a venue for weddings and conferences. It has become one of the premier conference centers in the country, and it has garnered awards annually since 1985 in both hospitality and in food and beverage. It has even attracted movie producers from Hollywood, who have used the mansion as a set for major films, including *North by Northwest*, *Sabrina* and *Where's Poppa*.

Descendants of the Pratt family get together yearly and visit the old home, which holds many memories. If Mrs. Pratt is here, why would she want to leave?

BIGGS HOUSE

SETAUKET

The Thomas Biggs house, a private home located in Setauket's historic district, was built circa 1680. It is one of Setauket's earliest homes, and it has remained in the same family for over three hundred years. It is presently owned by Therese and William "Bill" Brewster Seydel. Bill is a descendant of Caleb Brewster, the famous spy from George Washington's Culper Spy Ring. Joe and I headed out to Setauket to learn more about the historic residence and its ghosts.

John Biggs, father of Isaac Biggs, more than likely built the original saltbox home using hand-hewn beams, still featured in the oldest part of the house today. It is believed that Isaac, who signed the Articles of Association during the Revolutionary War, was probably the first person to live in the house full time. Historical records indicate that Isaac was the builder, but considering Isaac died in 1793 at age sixty-five, having built a house circa 1680 would not be possible. Isaac's son, Isaac Biggs Jr., married the daughter of Nathaniel Brewster, who was the first minister of Setauket. The Biggs family remained in the house for many years during the early eighteenth century. One of Setauket's founding families, the Jaynes, was the next family to own the house, and then it was passed along through family lineage to the Brewsters, Smiths and Seydels.

"The first Seydel in this house was my great-grandfather, Herman Seydel," said Bill during our interview. "Herman married Sarah Billings Smith, and it was her family's house. Herman and Sarah had two sons, Harold and Charles. Harold was my grandfather. Harold had moved off Long Island,

Biggs house.

but he would come out and use the house as a summer home after my great-grandparents passed away in the mid-1920s."

"My grandfather had two wives," said Bill. "The first was Estelle Ford Seydel. She died giving birth to my father. My grandfather remarried Elizabeth Green. They used the house as a summer house and then lived here full time. My grandparents had the house when I was a kid growing up. I grew up in Long Beach and came out here as a child on weekends and during the weekdays in the summer."

"How did the house come into your hands?" I asked.

"My father was an only child. I'm an only child, and Charles had no children. So it went from Herman to Harold to my father, Robert, and then to me."

Therese and Bill moved into the house in 1995 and have raised three children there. Several expansions have taken place throughout the years and by various owners.

"The oldest part of the house consists of the original wood-burning kitchen," said Bill. "Directly on the side of that wall is the green room, which we used to call the Washington room, and the small room called the borning room. There are very steep stairs, which lead up to the attic bedroom."

Bill continued, "Sometime around the late 1800s, the house was expanded out from the front. The dining room was added, as well as a bathroom and the bedrooms upstairs. The present kitchen, which we gutted, was here in the 1800s but was a separate building connected by a breezeway. It was used as the summer kitchen. Eventually the buildings were connected. Sometime early 1900s, probably mid-'20s or '30s, there was a porch that was blown out, which made the living room bigger. There was another screened-in porch added, which is now a glass-enclosed porch. We enclosed the porch with glass around the time we moved in."

Further research revealed that around 1910, the north wing, which was built circa 1700, was demolished. Along with the south and west wings, the north wing was rebuilt in the Greek Revival style. The Biggs house today sits on approximately four acres. The land once extended to what is now Route 347. Several outbuildings existed on the property and included a barn, cottage, corncrib and outhouse. Only the barn and cottage remain. When Therese and Bill moved into the house, they found a branding iron from Isaac Biggs in the original fireplace kitchen. Lots of old documents, including papers dating back to 1863, have been found in the house, as well as Confederate stamps.

A long, historical lineage is not the only thing fascinating about the house. Several spirits may have visited the old homestead on more than one occasion, including that of a woman who never even lived in the house. As Joe and I sat with Therese and Bill in the kitchen, Therese began to tell us about experiences she's had in the house that cannot be explained.

"When we were dating, Bill had said there were things that would happen [in the house]," began Therese. "I saw a shadow in the mirror. I saw the reflection of a woman, and I thought it was Bill's mother. Bill said that was impossible. She was asleep upstairs. That was the first time."

Therese continued, "When my daughter was about two or three, she was sitting on my bed watching TV while I took a shower. I came out of the shower, which was adjacent to my bedroom, and she was looking up at the ceiling. I walked in and said, 'What are you doing?' and she said, 'I wonder what that lady is doing?' and I asked, 'What lady?' and she said 'That lady' [and pointed]. I'm like, 'Okay, you're freaking me out. Let's go,' and I took her out. This happened several times," said Therese. "Then I finally decided to ask her some questions. 'What is she doing?' I asked. She said, 'She's looking for her babies.' I asked, 'What's her name?' She said, 'Sealy.' 'What does she look like?' She then told me she looked like her friend who was black. I spoke to a neighbor who lived up the block whose family has been

here for a long, long time. At first he looked at me skeptical, and then he said there was a woman, Sarah Ann Sells. Her name was not Sealy. She did something with babies, but he wasn't quite sure what. The information at the library said she was a very kind, old lady who used to feed the kids peanut butter and jelly sandwiches on their way to school."

"Did your daughter ever mention her or see her again when she got older?' I asked.

"No, and she doesn't ever remember it," said Therese. "She's now sixteen."

"She was never scared of her?"

"No."

I decided to do some additional research on Sarah Ann Sells. I was put in touch with a local historian in Setauket named Carlton "Hub" Edwards. I told him the story and asked him about Sarah. As it turns out, he actually knew her when she was alive. She was a midwife and delivered babies, but she was also a mother's helper. Apparently she was quite popular, and she was known in the community as "Aunt Sarah." She was of Native American descent, so her skin was dark, just as Therese's daughter had described. Her nickname was not Sealy; instead, it was Sarry—a name easy enough for a two-year-old to get confused. I asked Carlton where Sarry had lived when she was alive, and he told me about a house that used to be on the corner of 25A and Gnarled Hill Road. Oddly enough, it was less than a mile away from the Biggs house. Sarah Ann Sells died in a nursing home in 1964 at age ninety-five.

Is it possible that thirty-five years after her death, Sarah Ann Sells came back to her hometown looking for children to care for? Did she take it upon herself to care for Therese's daughter for those few minutes when Therese was in the shower? Spirits do have the ability to come and go from the other side, so I believe that anything is possible.

Throughout the years, Therese has experienced other phenomena as well. She's heard the sounds of chimes in her house (she did not own any chimes), she has seen shadow people passing by, she often hears whispering when no one is at home and a Bernese mountain dog she once owned awoke and growled and then followed something in the room that was not there.

Many years ago, Therese found her son, who was about three, in the old fireplace kitchen. She looked at him and told him to come to her. Before he did, he turned around, looked up and said, "Bye" as if someone was there.

On another occasion, she and Bill were lying in bed watching TV when they heard the distinct sound of the old heavy door opening in their bathroom. There are two doorways in that bathroom that connects rooms.

The sound of it opening is very distinct. They believed it was one of the children getting up in the middle of the night. When Bill went to check on them, they were all sound asleep. He got back into bed, and it continued to happen until Bill said out loud, "We're going to sleep now. Please stop." Sure enough, it did not happen again.

"I've never doubted. I'm a firm believer," said Bill. "I don't think it's bad. I actually think it's a good thing. It's family. They're not out to get me. I really have a very nonchalant attitude about it. I don't go looking for it. When stuff happens, I just say, 'It must be the ghost.'"

Joe and I spent some time walking around the house to see what we could pick up. Therese asked a question in Joe's EVP recorder: "Who's here with us?" Two rapping sounds were immediately heard. Whether it's family from long ago or Sarry, the energy at the old Biggs house is all good.

Chapter 29

The Italian Grandfather

ELMONT

People often ask me what made me decide to write about ghosts. Did I believe in them? Had I had experiences? The answer is yes, I believe that ghosts exist, and yes, I have had some experiences. My interest was piqued long ago by a story told by my mother and my aunt, who is married to one of my father's brothers. It was the first "true" ghost tale I'd heard. It forever stayed with me, and I would like to share it with you now. What follows is the hair-raising true story of what my aunt, uncle and mother experienced in the family home in Elmont, many years ago.

Right after Christmas in 2007, Joe and I went to visit my aunt and uncle to interview them. My mother joined us at their house out east. Over lunch, the three of them told us the tales I remembered from my childhood.

"My parents purchased the house in Elmont around 1950," my aunt began. "It was only a year old then, and they owned it for over thirty years. It was a Cape Cod with an unfinished two-room attic that they later made into an apartment. I grew up there with my parents and my two sisters. I was the middle child."

My aunt continued, "My father had seven brothers, and when they were young, his mother—my grandmother—got encephalitis, a brain disease. She was hospitalized and then institutionalized. I don't know what happened to my grandfather—why he left, where he went—but the children were taken away and were all separated: one went to a foster home, and the others were raised in orphanages. Their mother only spoke Italian, so they could never communicate with her in the institution. She stayed there for the rest of her life and died there."

My aunt paused. "All I know," she went on, "is that my father and his brothers believed their mother was dead during the time she was in the institution. When my father and mother got married and eventually purchased the house, my father, over a ten-year period, found all his brothers. My father was the second eldest. The two youngest brothers moved in with my parents and lived upstairs in the attic—and then they found my grandfather and he moved in. I think he lived in that house maybe less than a year, and then he died. I don't know if he died in the house or not. It was 1951–52, so I was probably around five. I remember him vaguely. He had throat cancer so he couldn't speak, and he would whistle. He would sit at the top of the steps, and I would call him. He would whistle to me. I also remember there was a farm I used to walk to with him.

"As soon as the two boys were old enough, they moved out, and a couple years later, the upstairs was turned into an apartment," my aunt continued. "The first people to live there were my older sister and her husband, then another couple, and then your parents," she nodded at me. "My husband and I moved in in June 1972 and moved out by September of 1975. After that, my younger sister and her husband moved in. They were the last ones there, and then the house was sold.

Present-day photo of the Elmont house where my aunt grew up.

"I remember an incident in the house when I was a teenager," my aunt went on. "I probably was around eighteen, and I was dating my husband-to-be. My parents went out, and I was sitting at the kitchen table talking to someone on the phone. Nobody was living upstairs then. But I heard somebody walking around up there, so clearly, definite footsteps. I got scared because nobody was home. It was a summer night, and the front door was open. I ran out the back door to get my neighbor, a friend of my father's. I yelled out, 'Tony, somebody's in the house!' He ran over, and as he was running upstairs, he said, 'I hear them, I hear them,' but when he got upstairs, nobody was there. And it wasn't as if it almost sounded like footsteps—it was definite sounds of people walking back and forth up there."

"This would happen all the time," my mother added.

"Yes," my aunt agreed. "But that was my first experience."

My mother turned to my aunt and said, "I don't know how many times I'd come home from work and put the key in the door and your mother would say, 'What are you doing?' I would say, 'I'm just coming home from work.' 'No, you've been home.' I'd say, 'But I just got home,' and your mother would say, 'I heard pots and pans.' She always heard that. I don't know how many times she said that to me."

"And my mother was a true nonbeliever," my aunt responded. "She didn't want to accept this at all. She used to think that my father and my sisters were crazy because they believed. Well, one day I was sitting at the kitchen table, looking down the hallway. I saw my mother come out of the bathroom, and she looked to her right, which was the entrance to a bedroom—she did a double take. She looked again, and her face went sheet-white, and she came running into the kitchen.

"I said, 'What's the matter, Mom? What's the matter?' and she said, 'Oh…nothing.' I said, 'Mom, what did you see?' She said sternly, 'I didn't see anything. Nothing!'"

My aunt continued, "She just wasn't going to share it with me because she didn't want to believe that anything was there. She was afraid because she thought my father was being called. My father had horrible, horrible nightmares. He had a vision that he was going to die. My mother said a prayer to his mother, 'Take your husband. Leave mine alone.' The next night, my grandfather died. She felt that my father's dead mother wanted him."

My aunt went on, "My grandmother died way before my grandfather. My father used to see her after she died. I remember a story my sister told. They were on the parkway; my father was driving, and my mother was in the

front seat. My sister said that suddenly my father went into a trance and was driving off the side of the road. My mother was screaming at him, pushing him. But my father said, 'Don't you see my father? Don't you see him? He's calling me!' My sister was in the back seat saying, 'Mommy, it's Grandpa. He wants us.' My mother didn't see him, but my sister did. So my mother always thought his parents were coming to get her husband."

"My father-in-law used to sleep sitting up with the radio on all the time," my uncle said. "He was afraid to fall asleep, because when he did, his father would be calling him. That's why my mother-in-law was always saying, 'Leave my husband alone.'"

"My mother did tell us things after we all moved out," my aunt added. "My mother had so many experiences with my son, she had to become a believer. My older sister always saw something—my younger sister also. I never did, except for the thing I told you, hearing the footsteps and seeing my mother. When I moved back in the house when I was an adult and married, and I had my son, then a lot of things happened."

Before talking about her own experiences, my aunt recalled a strange story. "There was another incident that happened before I was married, although I didn't see it. We had a connecting gate in our backyard to our neighbors. Many years after my parents had been living there, new neighbors moved in next door, people my parents didn't know. One day they came to the front door of my parents' house and said to my mother, 'Look, we don't mean to be nosy, we don't want to intrude on your lives, but I don't know if you're aware of it or not, but I guess it's your father or your husband's father—we see him in the backyard every night. He's got that little sleeveless shirt on and it's freezing cold out. Are you aware that he's getting out at night? Does he have some kind of dementia? Is there a problem?'

"My mother said, 'No; he's dead. What does he look like?' They said, 'He's a short little man, he always has a sleeveless T-shirt on with suspenders and he's out in the freezing cold, so we're concerned.' My mother said, 'Well, my father is gone and my husband's father too.' She wasn't going to get into it, so she said, 'I don't know who you're seeing, but it's nobody we know.' They had described my grandfather to a T.

"My younger sister was dating a man she eventually married," my aunt continued. "One day they were sitting out back, and her future husband said, 'Oh my God, did you just see that man who just walked by?' and my sister said 'no' and he described my grandfather. So other people saw this vision. It was not just the people who lived in the house, and it wasn't just people in the family."

My aunt continued, "When we moved in with our son, he was maybe six months old, and I had my first experience with a smell. He had a fever and was very sick. I had been up with him for hours, rocking him back and forth, and I was very concerned because I couldn't get his fever down. At one point, I smelled something—a smell you would associate with someone very old. I felt like it was surrounding me. It was the strangest feeling, but then it dissipated. I looked down, and the baby's fever had broken. He was perfectly fine. So that was my first experience as an adult. It was more about my son than it was about me," my aunt observed.

"Another time we had gone to a basketball game, and they gave out regulation basketballs in a net. My husband built shelves on the wall, and we had the net with the ball hanging on the wall. It was the winter, so no windows or doors were open. Now, our son was talking in full sentences. He was saying the alphabet at fourteen months. But he wasn't capable of getting out of his crib yet. We walked into the room one night because we heard a ruckus going on, and we see this ball swinging back and forth. We said, 'Now how can this ball be moving?' There was no open window, no draft—and it was swinging! And the baby's standing up in his crib across the room, giggling! I asked him, 'What's so funny?' and he said, 'The ball.' We said, 'How did you make the ball move?' and he said, 'Mikey made the ball move.'"

My aunt paused and said, "My grandfather's name was Michael. Our son would say his name all the time: Mikey, my friend, Mikey. My mother told us, years later, that when we went out on Saturday nights and she babysat, she'd hear him up there playing, laughing. He was always sleeping before we left. Then she would hear footsteps going into his room, clear as a bell, and she'd hear him laughing. It happened about seven or eight times. She wouldn't leave the baby by himself, so she'd go upstairs and take him out of the crib. Even if he was sleeping, she'd take him out because she knew 'Mikey' was going to wake him up anyway. It was then that my mother started to be a true believer. But my son doesn't believe. When you tell him the story, he thinks you're absolutely out of your mind. He's a complete skeptic."

She continued, "We had an incident with him at a funeral parlor when one of my uncles passed away. He was about three years old and was sitting in the lobby with my father and one of my uncles. I wouldn't bring him where the casket was. He said to my father, 'I've been here before,' and my father said, 'No, you haven't.' He had never been to a funeral parlor. But he told them if you go down the stairs, there's a bathroom, and if you go around the hall there's some kind of office over there—and he described

the whole layout of the place. So they took him by the hand and brought him downstairs, and there was the bathroom right where he said, but the office wasn't there. So they went into where the office was and they asked if there had been an office in that other section—and the man said yes, about twenty or thirty years ago. The whole place had been renovated. Now, he had described the building as it used to be, and yet you talk to my son and he's the world's biggest skeptic!

"I had another experience with my older sister at the house," my aunt went on. "It was snowing, and we both decided we weren't going to work that day. I wasn't living there at the time, but my husband was gone for six months with the National Guard, and my parents were in Vegas, so I was staying with my sister because she was living in the house. Your parents were living upstairs in the apartment at the time," she said to me. "So my older sister said, 'Well, I guess they didn't go to work either, because I can hear them upstairs.' I said, 'I know, I hear them too,' but I looked out and their car was gone. 'Michael must have gone, and Deanna must have stayed home,' I said. My sister said, 'Why don't you go up and get Deanna, and I'll put on a pot of coffee.' So I went up and knocked. Deanna didn't answer. So I'm knocking and knocking. Finally, I opened the door and was yelling, 'Dee? Dee?' but she wasn't there. That's how clear those footsteps sounded—we were both sure somebody was there."

"There was no explanation for it," added my uncle. "Yet I didn't believe any of it. The only time I believed is when I saw it."

"When you saw the ball moving?" I asked.

"No. When I saw the ghost," he replied. "I always got up for work about a quarter to five. Well, one day—you know when you're in a room and you feel like somebody's staring at you? And you look? So I was asleep, and I felt something in the room. I woke up and looked at the end of the bed. I saw this image of a man with baggy pants on, a strapped T-shirt and a rope-like belt, like an immigrant would wear. And I saw the face, but it was like a cameo, an oval shape, but it had no eyes or anything. It just stood there. I didn't feel afraid. I stared at him and I said, 'I don't believe this,' then I looked at the clock and saw that it was 4:30. I decided to get up, and when I turned around and looked back, it was still there, but then it broke up into like..." he couldn't describe it. "It just fizzled and went away. I got up, and I didn't tell anybody until I got to work. I told my friend John, hoping that he wouldn't think I was crazy, because his brother was a priest. He thought maybe we should get the house exorcised. I got all the information from John's brother, and then I

told the family about a week later. Knowing how I felt about it, they took it seriously and they said they'd have the house blessed."

At this point, my mother picked up the story. "Your father and I moved there in 1964 and stayed for three years," she told me. "Some of the happiest times in my life were there. The year we moved in I became pregnant. I was twenty-two, and it was summer. I was three months along, but I was in the process of miscarrying. I had been back and forth from the hospital, and your father brought me upstairs to the apartment and put me to bed. It was so hot; there was no air conditioners then. So I'm by myself, lying down, and exactly what your uncle just described is what I saw at the foot of the bed. Was I upset? Yes. I was losing the baby, I had labor pains, then I see this vision. He had the white T-shirt on. I couldn't make out his features, but I knew it was a man. Now here I was, twenty-two, thinking that I was dying—that it must be someone coming to get me, but I wasn't afraid. This was the bedroom your uncle saw the vision in years later. Then it just broke apart and left. That's when I got afraid—when he was gone. I remember your father coming up. I was such a mess. I told him I saw something. He said, 'Well, it's hot, you're upset; you're just imagining it.' He told me not to say anything to the family. He tried to convince me that it was just my imagination. I said, 'I know what I saw.' It wasn't until a good six months later that we were all downstairs, and they started talking about things that had gone on in the house. I looked up at your father and then I decided to tell them what I saw. I never saw it again. That was the only incident."

"Once my husband told me he saw something, then I believed it," my aunt added. "He had never believed anything before."

My uncle went back to his story: "So after my incident, the family called the church, and that's when the priest came. He listened to all the family stories. He said, 'In my opinion, there's a spirit here but it's not at rest. We want the spirit to rest.' So he blessed the whole house and left, and after that, nothing but bad things happened."

"My mother had a stroke, my father lost his job, somebody else in the family got ill—it was just one thing after another," my aunt interjected. "We had a very happy life until we exorcised the house, and after that, the house brought no joy. It became a sad, horrible place to live. My sisters seem to think—their theory is that we opened a portal. If it was a way for him to leave, we opened a way for somebody else to come in, and my sisters felt that evil came into the house. We had no idea that exorcising the house would be bad. We wanted to put my grandfather at peace. We thought this was a good thing for his spirit. We didn't expect anything bad to happen."

"After the exorcism," she continued, "we still had experiences in the house, and none of them were good. I experienced something in that house after that that was evil—pure, unadulterated evil—and so did both my sisters at different times."

"Her father went to work out of state," my uncle added, referring to my aunt, "and her mother went with him. Her father asked us to settle the house for them; it was vacant at the time. So we put it up for sale. First we had to get certificates of occupancy for some work he had done, and the house had to be cleaned out. Your aunt and I were always back and forth with the house, and she was there alone a lot of times, and when she was she always felt fear."

"It could be as you said, that somebody just slipped in," Joe interjected. "But the purpose of an exorcism is to cleanse the house, to bless it, to keep evil spirits out. Another possibility is that he was protecting you from this other spirit that perhaps was there all along. Your grandfather left, which maybe he didn't want to do, but the bad guy was still here. The house may have had a bad spirit in it from the start."

"That's very good, Joe," said my aunt. "Maybe that's what happened, because my older sister swears that she saw other people in that house. Both my sisters always felt there was something else in that house. They didn't feel it was just my grandfather. Because our experiences were mostly good, we didn't give it a second thought. We were just a really happy Italian family who loved one another desperately," she said. "I do agree with Joe that there may have been something there and my grandfather was protecting us. I don't think that something came after he left."

"There was a time we played around with the Ouija board," my mother added. "I remember we used to do that with your sisters," she said to my aunt.

"I think it was a bad thing that we brought in that Ouija board," my aunt remarked. "They should never have played around with that thing."

"That also could have opened a portal," Joe said. "I think the problem with a Ouija board is that because it has a negative connotation, it tends to attract bad spirits. Also, people want and expect drama with it, so they tend to attract spirits that are very aggressive, very powerful."

"Prior to the Ouija board, the exorcism," said my aunt, "my parents had put the house on the market several times, over a period of thirty years. There were many times when they tried to sell it, but something always happened. There was always some reason it wouldn't sell. It was like that house didn't want to get sold. I always felt it was because my grandfather was there and he didn't want us selling the house.

"So getting back to when we tried—every time we had a buyer, something terrible would happen and the deal would fall through. One time my sister asked me if I could go over and show it to some people. I went over by myself. I showed the people the house, and they left. I went around making sure the lights were off and checking everything, and I had this overwhelming sense—I remember because it's giving me the shivers—that if I didn't get out of the house right away I was never going to get out. Something was holding me there. I went to the front door, and I was trying to put my hand on the knob. I couldn't get my hand to touch that knob to turn it. I finally turned it, I ran out the door, got in the car and I didn't even feel safe until I pulled out of the driveway. I was terrified!" my aunt exclaimed. "So I called my sister and told her, 'I'm telling you right now, under no circumstances will I ever go in that house alone, ever, ever again!' and she said to me, 'And I'm going to tell you why you won't do it,' and she described exactly what I felt—that overwhelming sense of fear, not being able to put my hand on the knob, terrified of never getting out of the house—and I said to her, 'How do you know?' and she said, 'Because it happened to me.' She also told me it happened to our other sister."

My aunt paused for a moment. "I really felt that the house had turned bad. We finally sold it in the early 1980s. A young couple bought it, and the man's name was the same as my father's. They had three daughters. That's all we knew about them. He was probably twenty years younger than my father. My father had a heart attack on Labor Day weekend. Seventeen days later, he went into a coma and then he died. We found out later on from neighbors that the man who had bought my parents' house had died; he had had a heart attack on Labor Day weekend too."

We all sat in silence; it was such a strange coincidence.

"I have no idea how long the mother and the daughters stayed in the house after that," said my aunt, finally. "I never knew what happened to them or to the house afterwards. None of us ever felt the house was evil prior to the exorcism," she emphasized. "We were a very happy family. Yes, we heard the ghost, we saw the ghost, we smelled the ghost, we felt his presence, but none of us ever felt threatened, ever, ever, ever."

"The grandfather had to have been protecting you," Joe repeated.

The house in Elmont still exists. My mother and I took a drive over to see it several weeks after the interview, but the house had changed. During the time the family owned it, it did not have an awning, a brick porch or brown siding. Even with the changes, my mother knew without a doubt that this was the house. Seeing it brought back a lot of memories for her. She hadn't

been to the house in forty-four years. No one appeared to be home. We sat in the car for a moment and just stared at it. Whatever has gone on there since the day my aunt and uncle sold the house remains a mystery. Was the house forever "unsettled"? Have the subsequent owners experienced anything? Was the house an open portal, a vortex to another dimension? All these years later, hearing the stories again and writing them down brings it all to life once more and still creates a chill that tingles down my spine.

CHAPTER 30

IRVING

HUNTINGTON

The story of Irving is one of the most amazing ghost stories, and it involves the relationship between a little boy and his imaginary friend. Irving was definitely a friend to the boy, but not an imaginary one. Irving was a ghost.

On April 6, 1997, I was doing a book signing at the historic Conklin house in Huntington for my book *Huntington's Past Revisited*. The Huntington Historical Society was having an open house at Conklin, and my signing was set up in the barn.

A woman came in and said, "You're that 'ghost' writer, aren't you?"

I laughed.

"My friend has a ghost in her house. His name is Irving," she said.

A few more visitors arrived for the signing. About forty-five minutes later, another woman came in and asked, "You're that author who writes about haunted houses, aren't you? I have a ghost in my house. His name is Irving."

This caught my attention right away. How many ghosts named Irving could there be in Huntington? I said to her, "A woman was just in here a little while ago talking about her friend who had a ghost named Irving. Look in my guest registry. I believe she signed it."

"She's a friend of mine," the woman said after looking at the registry. "She knows all about Irving. Do you have some time? I'll tell you about him."

Things were winding down at Conklin, and no one else was in the barn. I said, "Sure, I'd love to know about him."

After hearing her story, I decided it was one of the most incredible stories I'd ever heard. I told the woman, "When you sign your name to my registry,

write something in my book so I'll know how to contact you one day, if I ever decide to write another book." Next to her name and address she wrote, "Ghost Irving" in parentheses.

I tracked her down in 2005 with much effort. I wanted to include her story in my book *Ghosts of Long Island: Stories of the Paranormal*. I found out that she was living in Texas. She gave me two new pieces of information—Irving's last name and where his cemetery plot was located.

Irving has become one of Huntington's legendary ghosts. Here is the story, as told to me by Cheri Chapman so many years ago.

Cheri and her family had moved into a house in Huntington sometime between 1966 and 1967. The house, which was built in 1940, was within walking distance of the Huntington Rural Cemetery, located on a quiet street. The Chapmans began fixing up their new home, and strange things started to occur. They had a lot of problems with the plumbing and the electricity. Water would run for no reason, and lights would go on and off or flicker. She had plumbers and electricians in, and nobody could figure out what was causing these things to happen.

At the same time, her young son, who was four or five, started talking about an imaginary friend. Cheri and her husband didn't think anything of it. All children have imaginary friends at some point. They had just moved, and it was probably a big adjustment for him. They were also so busy fixing up the house that perhaps their son was bored and just needed a friend.

Whatever the reason, the young boy said he did all kinds of things with his friend. One day he told his mother about some things he had seen in the attic. One of the items was a birthday present he had asked for. It was a truck that had been hidden in the attic. Startled, Cheri asked how he could possibly know this. Her son replied, "I go up there with my friend." Cheri stopped for a moment to reconsider this "imaginary friend." "What's his name?" she asked her son.

"His name is Irving," the boy replied.

As time went on, the relationship between the boy and Irving continued. So did the strange activity in the house. Still, the Chapmans never put two and two together. The boy spoke about Irving all the time and how Irving talked to him and played with him. Cheri became concerned when her son told her about the trips they took.

"Where do you go?" she asked.

"We float out of the attic, and we go to where he lives—in the ground."

"What?" Cheri was stunned. What was her son talking about? "What do you see?" she asked.

"I see the bones and the dirt," he said. "At first I was a little scared, but Irving talks to me and tells me it's okay."

She began to worry that her son might be going crazy.

Memorial Day weekend came around, and Cheri and her family decided to attend Huntington's annual parade. Because their house was so close to the cemetery that connects with New York Avenue, the Chapmans cut through the cemetery on the Oakwood Road side to get to the parade route on New York Avenue. Halfway through the cemetery, Cheri's son yelled, "Wait, that's where Irving lives!" The boy pointed to a grave up on the hill.

At that point, her son and his imaginary friend had Cheri's full attention. "Where?" she asked. "Show me."

The young boy led his mother up to a tombstone. "Here," he said. "This is where he takes me."

Cheri looked at the tombstone, and to her astonishment, it read RIGGS, ROSE and IRVING.

How could this be possible? she thought. She had never taken her son into the cemetery. Nor did he know how to read. It was the first time she and her husband ever considered the fact that Irving could be a ghost.

The boy got older, and things continued to happen in the house. The Chapmans raised five children there. Cheri recalled a time when she was cleaning out the basement and thought that one of her children had come home.

"I heard the front door open, and from the basement I could hear someone walking around upstairs. I ran up to check, and nobody was there," she said. "I thought it was one of the kids, but it wasn't. My children would say to me, 'Don't worry, it's only Irving.'"

Cheri had always confided in a friend she worked with about her son's imaginary friend Irving. One day her friend was cleaning out the house of an aunt who had recently died. There were several boxes in the aunt's attic, many of them containing photographs. As the woman was descending the stairs, a photo slipped out of the box. It was a picture of a man. She picked it up and asked her other aunt (the woman's sister), "Who is this?"

"Oh, that's Irving Riggs," she replied, "our grandfather. He loved children."

The woman was shocked. Could this be the same Irving—Cheri's son's imaginary friend? When she spoke to Cheri, she found out that the friend was definitely Irving Riggs.

The woman brought the photo over to the Chapmans' house. Cheri was amazed. During all these years, the house had been haunted by Irving, but the man had never even lived there. Was it possible that the proximity of

Above: The gravestone in the Huntington Rural Cemetery.

Right: Undated photo of Irving Riggs.

the cemetery had caused him to come and visit her son because he loved children? It seemed impossible, yet there were too many coincidences.

Cheri and her friend sat over tea and talked about it for a while. The friend left the photo with Cheri, who pinned it to the bulletin board next to the phone in the kitchen. A few hours later, her son, who was now about seventeen years old, arrived home. He called out, "One minute, Mom, I just have to make a phone call."

With that, Cheri, who had been sitting in the living room, heard the phone drop to the floor. She went into the kitchen to find her son standing there with the photograph.

"Where did you get this picture?" he asked.

"Why?" Cheri replied.

"Do you remember my imaginary friend, Irving? Well, this is him."

BIBLIOGRAPHY

The Cutchogue–New Suffolk Historical Council Archives. Information on the Wickham Farmhouse and the Old Schoolhouse. Cutchogue, New York.

Flanagan Brosky, Kerriann. *Ghosts of Long Island: Stories of the Paranormal.* New York: Maple Hill Press, 2006.

———. *Ghosts of Long Island II: More Stories of the Paranormal.* New York: Maple Hill Press, 2008.

———. *Huntington's Past Revisited.* New York: Maple Hill Press, 1997.

Hampton Bays Historical Society. *Villa Paul Restaurant: Three Generations and Forty Nine Years.* New York: Hampton Bays Historical Society, n.d.

Horton, Gene. "Gene Amman's Bayport House, Now Known as the Grey Horse Tavern." *Bayport–Blue Point (NY) Gazette,* May 2011.

Morris, Deborah S. "Huntington Station Mystery of the Murals." *Newsday,* March 22, 2011.

The Old House Society. "An Introduction to the Old House 1649." Cutchogue, New York.

Planting Fields Foundation Archives. Coe family papers and resources. Oyster Bay, New York.

Sforza, Alfred V. *Portrait of a Small Town: A Pictorial and Personal History of Huntington Station.* New York: Maple Hill Press, 1996.

Starkey, Joanne. "Casual, Friendly and Local—Dining/Bayport." *New York Times,* September 21, 2008.

Studenroth, Zachary N. *Images of America: Cutchogue and New Suffolk.* Charleston, SC: Arcadia Publishing, 2013.

Three Village Historical Society. *The Setaukets, Old Field and Poquott.* Charleston, SC: Arcadia Publishing, 2005.

Tyler, Beverly C. *Walk Through History: A Guided Walking Tour of Brookhaven's Original Settlement in Setauket.* Lawrenceburg, IN: R.L. Ruehrwein Publisher, 2005.

ABOUT THE AUTHOR

Photo by Tom Decker Studios.

Seven-time award-winning author and historian Kerriann Flanagan Brosky has been featured in numerous publications, including the *New York Times, Newsday* and *Distinction* magazine. She has appeared on CBS's *Sunday Morning, Ticket* with Laura Savini, *News 12 Long Island* and *The Thinking Writer* in East Hampton for her previously published nonfiction books. Kerriann served on the board of trustees as first vice-president for the Huntington Historical Society for six years, and she served as a trustee for the Greenlawn-Centerport Historical Association for three years. Kerriann is the recipient of the Top Advocate for Historic Preservation and Education Award from the Oyster Bay Historical Society, the Huntington Heritage Education Award from the Town of Huntington and the Woman of Distinction Award from the New York State Assembly. She is currently a columnist for *Village Connection* magazine and a contributing writer for *Edible Long Island*. Kerriann is president emeritus of the Long Island Authors Group and is a well-known speaker who draws standing-room-only crowds to her lectures. Kerriann lives in Huntington, Long Island, and when she's not writing, she enjoys spending time at the beach with her husband, Karl, and their two sons. Please visit her website at www.ghostsoflongisland.com.

ABOUT THE CONTRIBUTOR

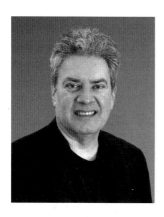

Photo by Tom Decker Studios.

By day, Joe Giaquinto is a computer guy; at night, he is a ghost hunter. He has experienced paranormal phenomena for over thirty years. In 2005, Joe discovered his gift of mediumship. Today, he uses his intuitive gifts for group and private readings and for analyzing and corroborating paranormal evidence. Joe Giaquinto graduated from Adelphi University. He currently runs a freelance computer consulting/web-design business. His professional memberships have included the American Society for Psychical Research, Association TransCommunication, Forever Family Foundation, Hampton Bays Historical Society, First Parish Church and the Ghost Hunters of Long Island. Joe has appeared on numerous cable TV and radio shows and in online and print newspapers. He has given professional presentations, lectures and workshops for private organizations, historical societies, public libraries, holistic learning centers and private businesses. Visit Joe Giaquinto's website to learn more: www.joegpi.com.